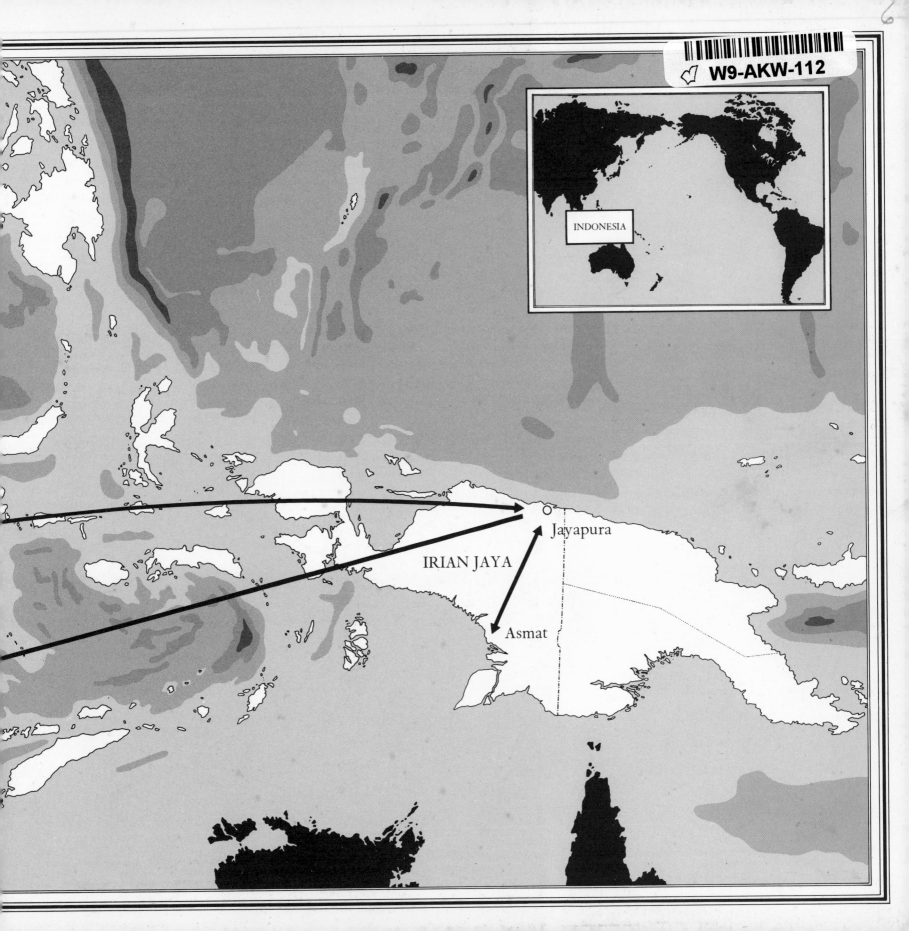

INDONESIA

IRIAN JAYA

Jayapura

Asmat

The Soul of Indonesia: a cultural journey

Louisiana State University Press Baton Rouge and London

The Soul of Indonesia:

Text by Umar Kayam

a cultural journey

Photographs by Harri Peccinotti

To the memory of R. M. T. Tb. Sastrosoekotjo
father, friend, guru

Text © Umar Kayam
Photographs by Harri Peccinotti

Editor: Gregory Vitiello
Design & production by Birdsall & Co.
Printed in Great Britain by Balding + Mansell Limited
Typeset in 12/14pt Van Dijck series 203
© Mobil Services Co. Limited

First published in the United States, 1985,
by Louisiana State University Press
Baton Rouge, Louisiana 70893

Library of Congress Catalog Card No.: 84-82424
ISBN: 0-8071-1241-0

This limited edition published by Mobil,
June 1985

Foreword

MINISTER OF EDUCATION AND CULTURE
OF THE REPUBLIC OF INDONESIA
JAKARTA

A society's cultural identity may be immediately apprehended from its artistic creations, and specifically the traditional artistic creations that have long been recognized as an integral part of that society's culture.

But cultural identity does not explicitly or exclusively relate to the past. Neither is it based on a static or unchanging image of cultures and societies. Cultural identity, in the same way as culture itself, is dynamic. It is expected to develop parallel to the society to which it belongs, and which likewise grows, develops, and changes continually.

Viewing culture and cultural identity as forever changing dynamically, in many quarters the fear is expressed that the traditional arts may be doomed. However, in the evolution of the arts in Indonesia, the phenomenon is seen that Indonesian culture and cultural identity have survived for centuries because of their adaptability, their ability to assimilate and integrate new inputs, both from within and outside the community itself, while retaining their individual personality. As expressed in the Constitution of the Republic of Indonesia, culture is indeed seen as dynamic. At the same time it is explicitly mentioned that in this dynamic growth the traditional core should be retained and indeed form the basis on which growth and change are encouraged. Looking at culture and cultural identity in this way, traditional arts in a changing culture need not be antagonistic. It is for the Indonesians to create the conditions for the dynamics of arts, including traditional arts, in their changing world.

I thank Mobil Oil for giving the opportunity to Mr. Umar Kayam to illustrate these dynamics in Indonesia's changing society.

Jakarta, October 25, 1984

Nugroho Notosusanto
Minister of Education and Culture

Acknowledgments

To prepare a reportage of this kind one needs the cooperation and support of many people and sources. Traveling long distances throughout the vast archipelago would not have been possible without the support of a strong financial source, as well as the permits and advice from government officials. Nor could we have hoped for the lucidity, coherence, and organization of a handsome book without the help and assistance of people such as a competent editor, a talented photographer, and many knowledgeable people in the regions.

In preparing this book I have been fortunate to receive all the support and assistance from the necessary sources and people. Government officials at the central and regional levels have been kind and cooperative not only in their prompt assistance with formal paperwork but above all in their sound and sensible advice in our travel plan and our arrangements to meet with local artists and experts. In this respect I am most grateful to the Indonesian Institute of Sciences in Jakarta and the governors of Aceh, North Sumatra, West Sumatra, Jakarta, Yogyakarta, Bali, Irian Jaya (especially deputy-governor Sugiono, who despite his very tight schedule made time to accompany the trip to the Asmat region), South Sulawesi, and East Kalimantan. My work on this book would be inconceivable without the generous assistance of Teuku Sofyan and Djakfar Ismail of Lho Seumawe, the *bupati* of Central Aceh, the *bupati* of Nias, Chairul Harun of Padang, Sriyono and S. M. Ardan of Jakarta, Linus Ag. Suryadi of Yogyakarta, Nyoman Mandra of Kamasan, the *camat* of Agats, Mochtar and Arsal Alhabsji of Ujung Pandang, and Mustafa of Samarinda.

For the section on *The Sacred Fish of Sungai Janiah*, I owe special thanks to Chairul Harun, who has provided most of the information needed. The same gratitude goes also to Usman Pelly for his deep insight into the condition of *pinissi* making, 10 years ago, at Tana Lemo.

To Gregory Vitiello, Mobil Oil Corporation, who has encouraged me to write this book and then patiently and sensitively edited my "Javanese-English" into a more sensible and readable English, I owe more than just thanks. I am grateful to Harri Peccinotti, who expertly and sensitively took the photographs, and his assistant Genevieve Hamelet, who diligently made field notes, for their warm and delightful company and for their patience in following my erratic travel strategy. My admiration goes also to Derek Birdsall, who has designed the book imaginatively.

My colleagues at the office of the Centre for Cultural Studies, Gadjah-Mada University, and at the Faculty of Literature of the same university, have been very generous and patient in freeing me to do this project and finish the book, while I left my routine work and chores in disarray. I owe them a great deal of sympathy and thanks.

Yus, Sita, and Wulan, my nuclear family, have shown patience and understanding in following the slow process of my writing and frequent travel for this project. I am most grateful to them.

Finally my very special thanks to Mobil Oil Indonesia, which commissioned this book and provided financial support throughout. Mr. R. C. Mills, former President and General Manager of Mobil Oil Indonesia, Inc., his successor W. L. Mason, and their colleagues, Messrs. A. B. Salaki, Ariono Suriawinata, and K. I. Mahmud, lent not only professional interest but also genuine and warm sympathy to the project. For their generosity and patient encouragement I owe many thanks. And for K.I.M., who was appointed by Mobil as my travel companion, I am grateful for his endurance and wit.

Umar Kayam

Introduction

What happens to traditional arts in newly established nation-states? Do they manage to retain much of their original shape and function for the community? Or, over time, will they more or less be absorbed by the new national culture or, worse, wither away from the scene, lacking the viability to resist various pressures?

These are legitimate questions voiced by many people, reflecting a grave concern of those caught in the middle of the dynamics of change. Though they try heroically to adjust to it, such people nevertheless feel the pains of change and never really understand how to cope with it.

Most new nation-states have been formed out of many regionally based cultural milieus that were formerly strung together into a colonial empire with geographic boundaries decided by the colonial powers. Nonetheless, each region has had its own development and history, within its own context. The development eventually led to a certain kind of cultural identity which gave distinction to that particular region. The colonial powers, out of pragmatic considerations and calculated strategy, did little to disturb the native cultural textures. In certain cases where the cultural root was conducive to the strengthening of the colonial administration and bureaucracy, the colonial power even encouraged the cultural status quo and helped the tradition to flourish. After independence, when it came time to form modern nation-states, the cultural textures were still agrarian and traditional with sporadic Western penetration at a very thin layer of the society.

The arts in the cultural milieus vary but share the main features of a traditional agrarian society. Thus the dances may encourage rain, build solidarity, or seek to establish a reunion with the spirits of one's ancestors. The theater may be a medium for instruction on community values and norms. The music may be instrumental in the ritual chasing of evil spirits. Oral poetry may serve to tame crocodiles and tigers. In short, the arts are *community*

arts which were born and developed in the community and which function for the community. Although particular works were created by individual artists or artisans, they were claimed by communities and even in certain cases by kings, local gods, or ancestral spirits.

Traditional arts vary in accordance with the social and cultural conditions of the societies. In cultural milieus which have not developed into complex social organizations, the arts are more simple, spontaneous, and straightforward. Conversely, in communities which have evolved into more complex social organizations, the arts themselves have become more complex and sophisticated. In Indian-influenced traditional kingdoms, for instance, the king was the *dewa-raja*, the god-king who personified one of India's *trimurti* gods, Shiwa, Wishnu, and Brahma. Since he was perceived to be the center of the cosmos, the arts served him — and the harmony of the cosmos — and were incorporated in the more complex magico-religious belief system.

But development, cultural or not, does not take place in clear-cut stages as some economic strategists may suggest. It proceeds fluidly and involves a long borrow-and-give process. Consequently, every stage of development carries mixed features, such as in feudal societies in which the simple traditional community arts have existed side by side or layer by layer with the sophisticated palace arts.

* * *

When a new nation-state emerges, it inherits cultural milieus with uneven conditions and histories. In the process of change, diverse communities must agree to a common platform: to form a nation-state with a central government, national boundaries, a national language — a single nation.

They soon discover, however, that the creation of a nation-state is not so simple. Some new nation-states have difficulties in implementing the new national language; some experience vicious civil wars over disagreements regarding the concept of a central government; some wage war over power among dominant tribes. Some observers say that those are growing pains that every nation-state must experience. The problem seems to originate in the differing value systems, world views, and even artistic concepts that have been accumulated over generations; these differences are deep-rooted and not easily accommodated to new concepts of modern nationhood and statecraft.

The arts are faced with the same problem. Traditional arts which were indigenous to agrarian societies must now compete with new concepts of arts designed for more urban, industrial societies which are conversant with modern idioms and technology. It is difficult to pinpoint how the traditional arts can best accommodate themselves to these new demands and pressures. We might ask how our national dance, theater, literature, or music might look, but the answers to such questions are vague and speculative due to the magnitude of problems involved.

The question is actually the other side of the coin to the first question posed in this introduction. How traditional arts face change will establish how they might best be incorporated into the new arts.

But since development does not take place in clear-cut stages, the dialogue, even the polemics, between the traditional and new elements is a fluid one. Certainly this is not an *ad-hoc* process, since the arts are but one string – albeit a very important string – in the network of society.

* * *

This book is a cultural reportage, devoted to witnessing the "practice of change" in Indonesia. In it, we are concerned with how the traditional arts are able to answer the demands of new nationhood through their creativity. The book also focuses on how people, as inventors, sustainers, and communicators of the traditional arts, develop strategies to accommodate the change. To achieve this perspective, I have traveled all over the archipelago and spent time in towns and villages talking to people, observing their arts and rituals, and even witnessing "command performances." I have asked people about their lives, their villages, what their arts still mean to them, and whether the arts deserve to endure. I also asked whether the new arts have a place

in their hearts. (Most of the time I did not have to ask the question, though. The new arts were so obviously penetrating the local arts.) The people I interviewed in the villages included peasants, vegetable vendors, village elders, religious leaders, schoolchildren, teachers, and, of course, local artists, artisans, and bureaucrats. And in towns and provincial capitals, I met with intellectuals, artists, and bureaucrats.

The selection of people and traditional arts, as well as the questions and locations, were both random and deliberate. Some planning and budgeting of time were necessary. But usually I let my common sense guide my decision according to condition and situation. This method seemed sensible since the whole archipelago is presently in the middle of the dynamics of change; therefore wherever you go, whomever you talk to, you find the vibrations of change and dialogue.

Since this will not be a scholarly or academically oriented book, no theories, grand or small, will seek to be verified or proven. Nor will new theories be offered. It is a reportage and my only wish is for it to be lucid and informative, albeit open-ended.

However, the random and spontaneous way of picking people, locations, and questions cannot accommodate the vastness of the archipelago (about 13,000 islands), the richness and variety of the cultural milieus (about 300 ethnic groups), or the colorful mind and languages (about 250 regional languages) of the people. Of necessity, certain arts and certain ethnic groups have not been touched upon, such as the Batak, Sunda, Ambon, Manado, Timor, Sumbawa, and Lombok cultural milieus. Also, the deliberate limitation of the book to discuss for the most part only one kind of traditional art in each of the chosen cultural milieus may occasionally shortchange the rich variety of the local arts in a specific milieu. We did not seek to investigate some of the nation's more widely known arts – batik and Balinese dancing, for example – when another, more deeply ingrained art (from the village's perspective) served our purposes better.

From the start, the shortcomings have been fully realized. However, I will consider the book successful if it adds perspective to the magnitude of the problems of change confronting traditional arts and societies.

I hope, too, that it will be a forerunner to future reportage covering more cultural milieus and more traditional arts.

Bawömataluö, hill of the sun

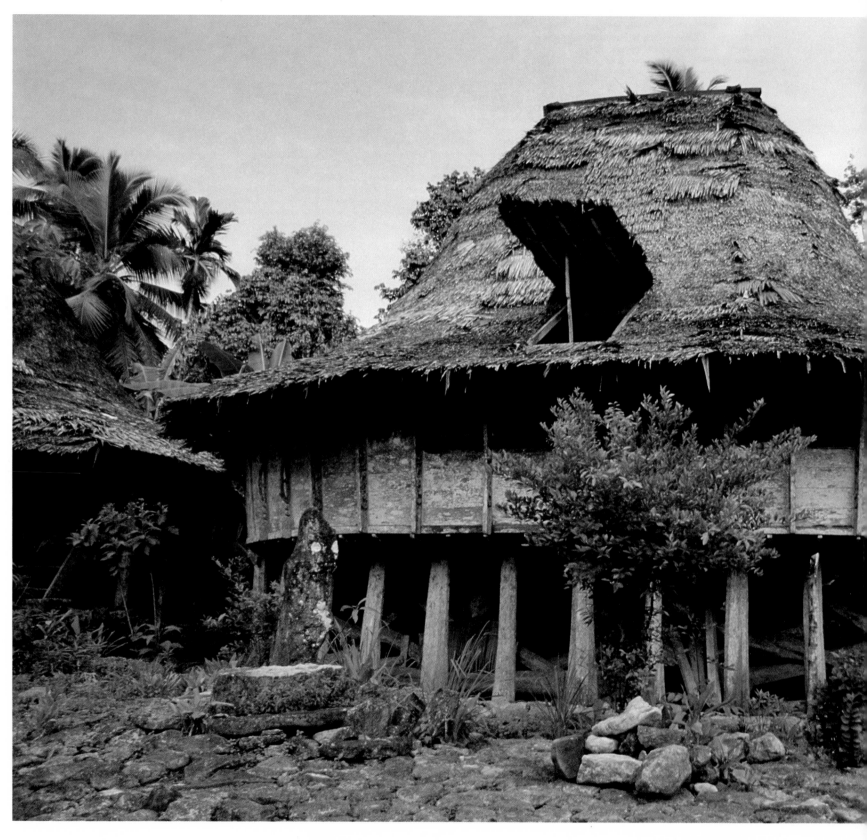

Traditional house, North Nias

Bawömataluö

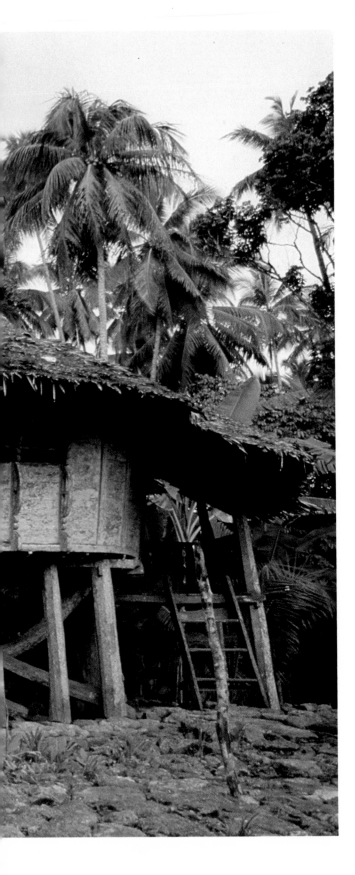

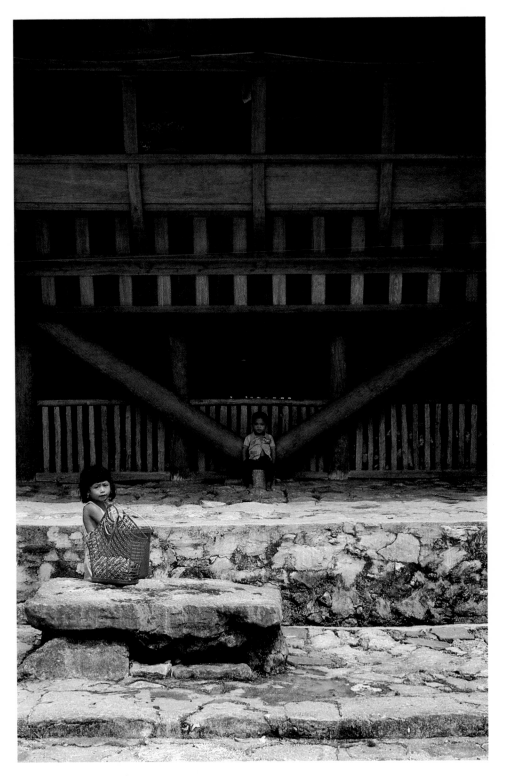

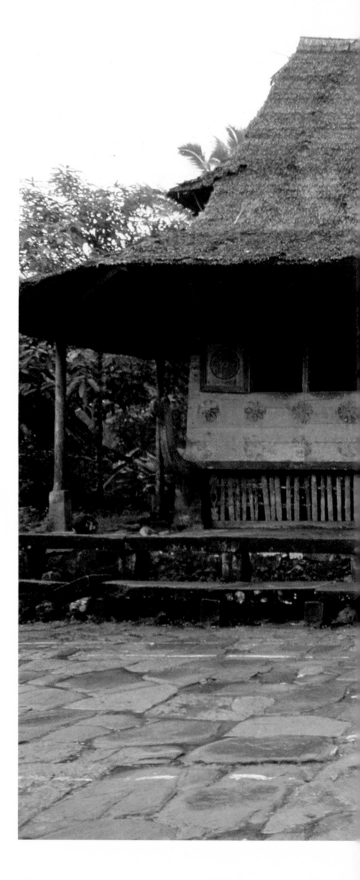

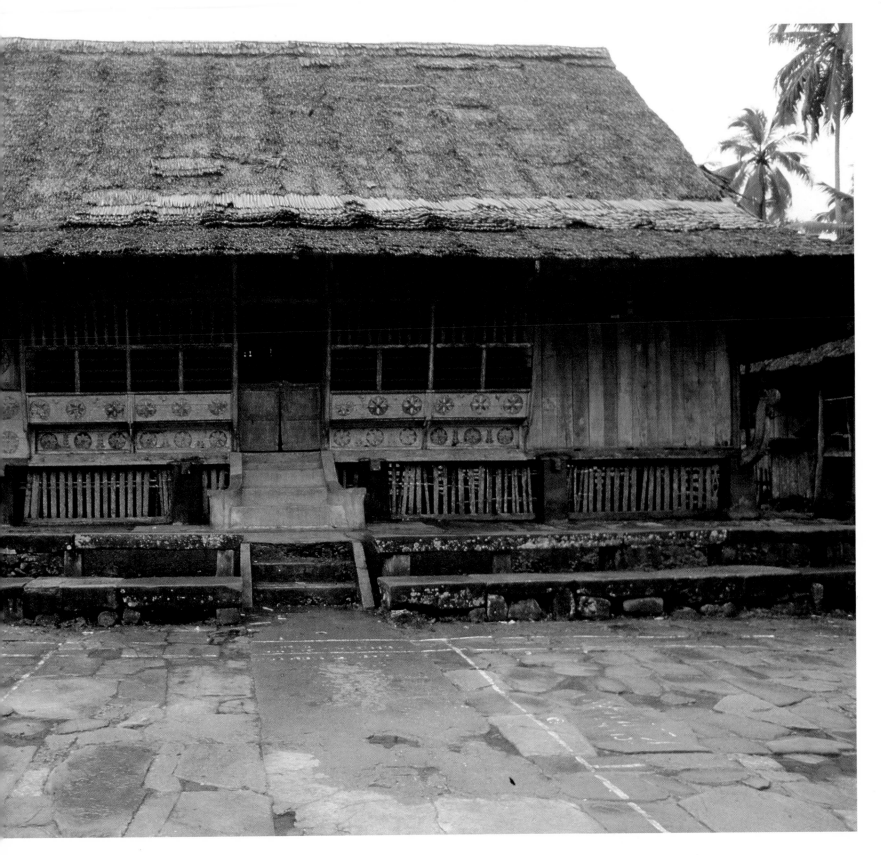

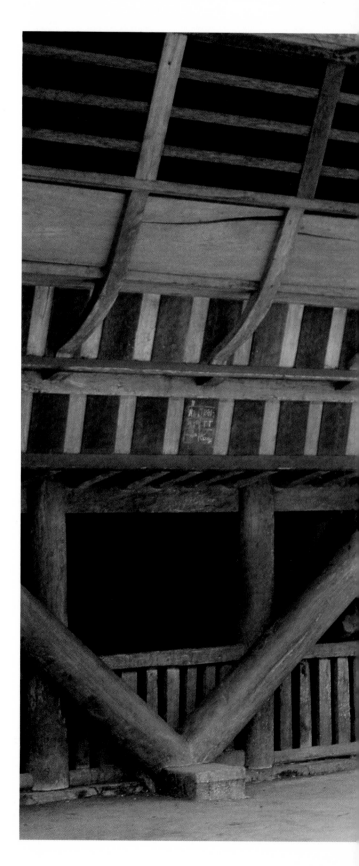

Pillar base, Bawömataluö

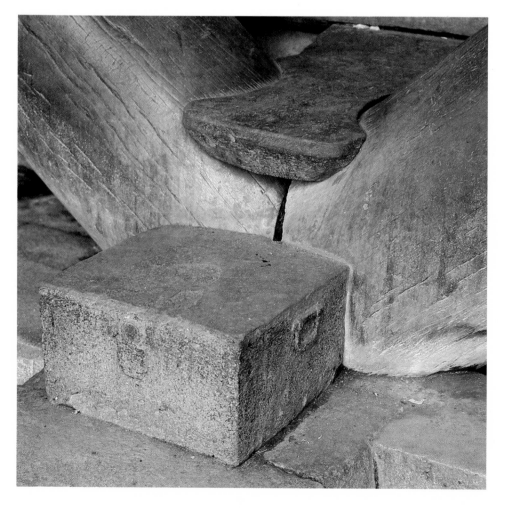

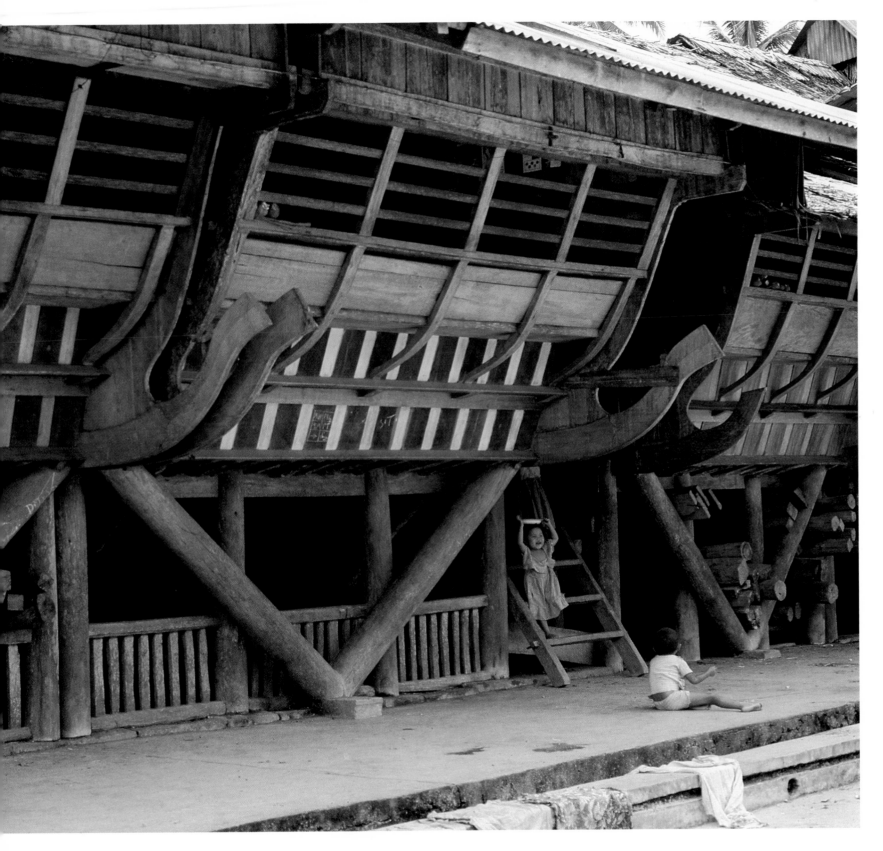

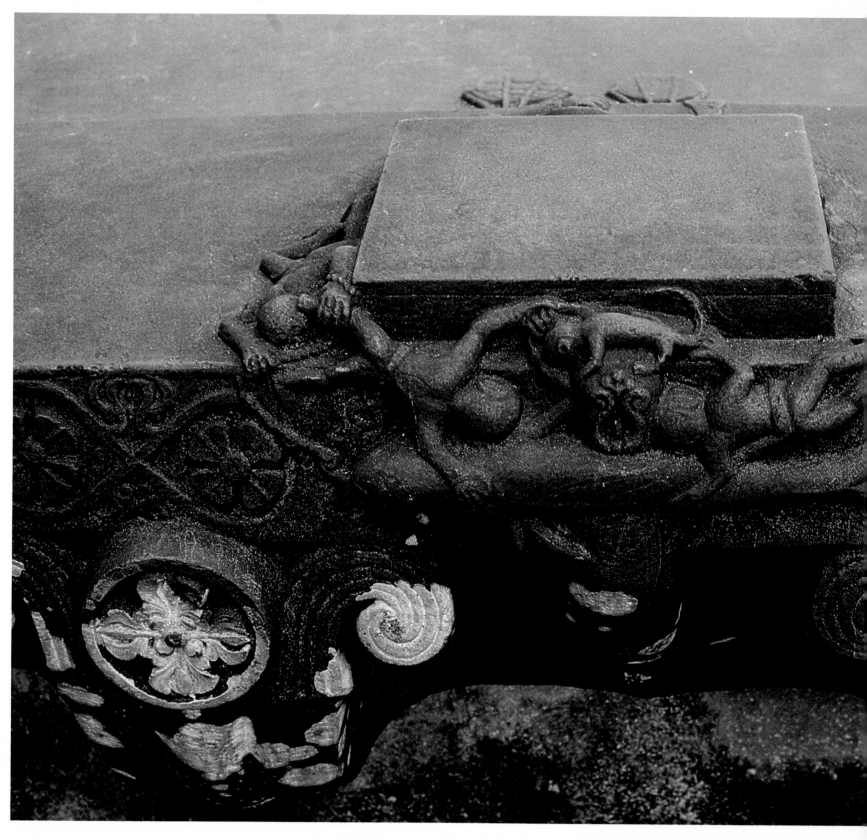

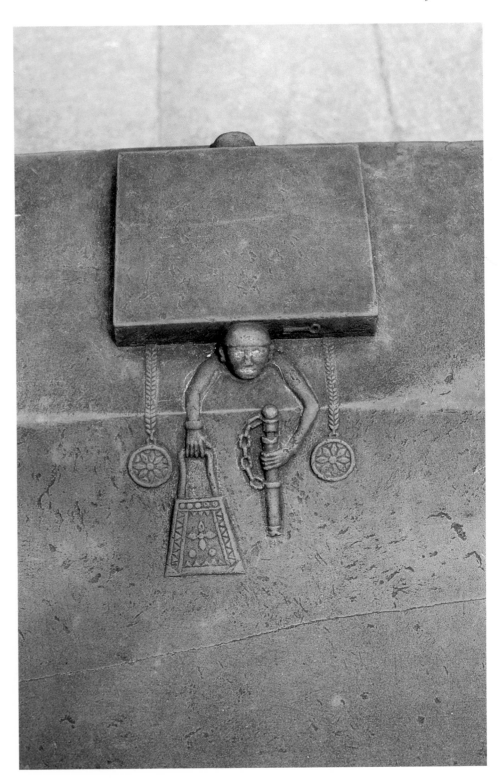

Coronation stone slab, Bawömataluö

17

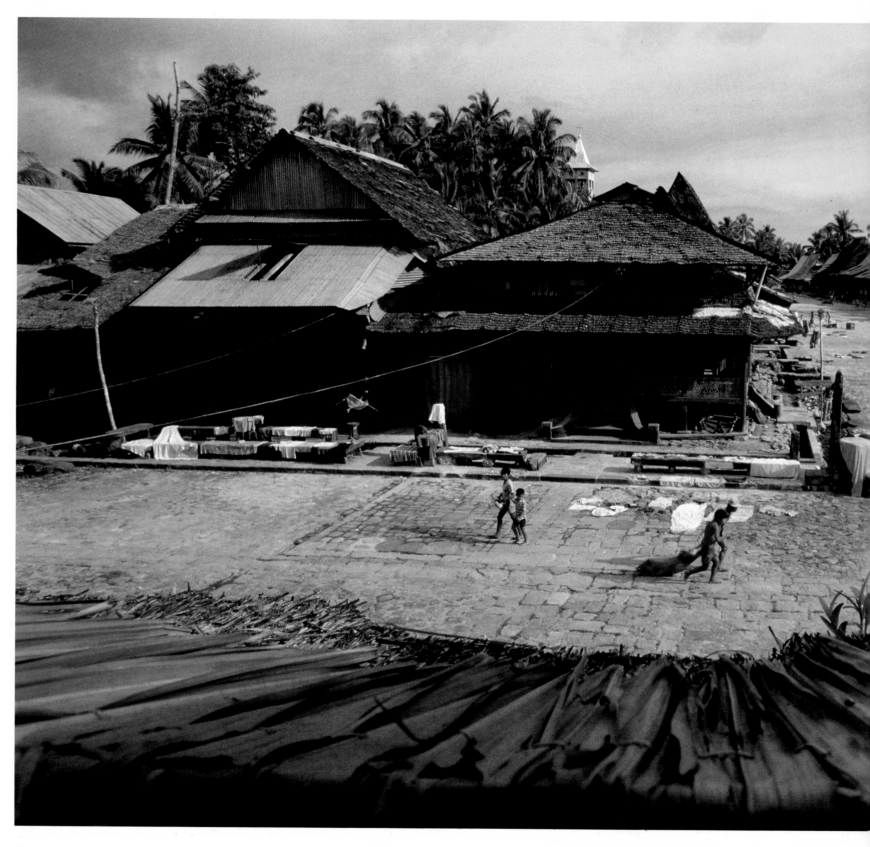

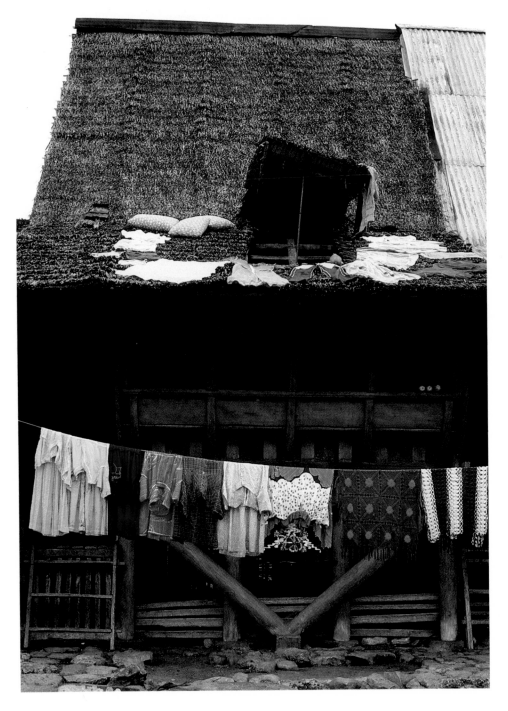

The Faguele *offering dance*

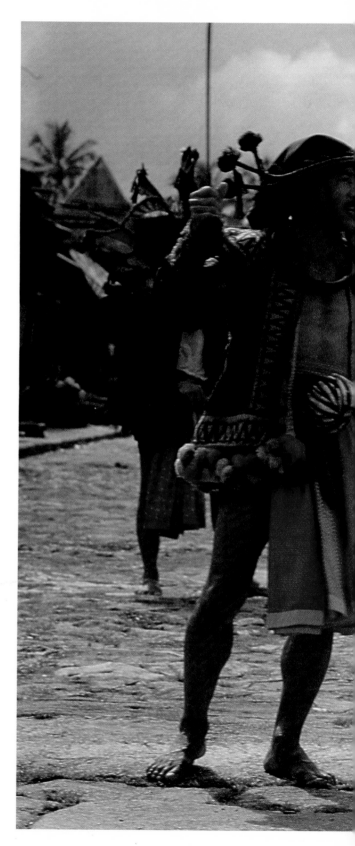

The Foalö *war preparation dance*

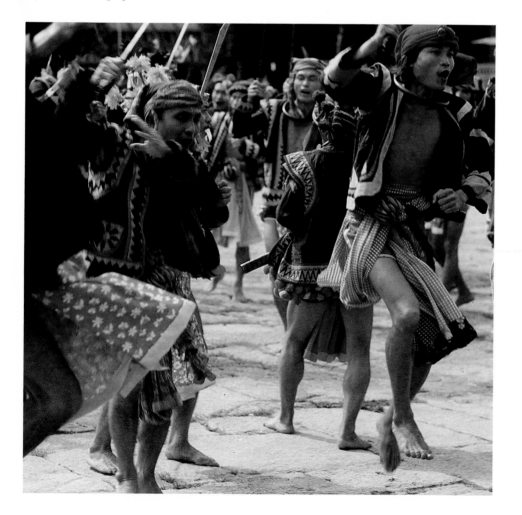

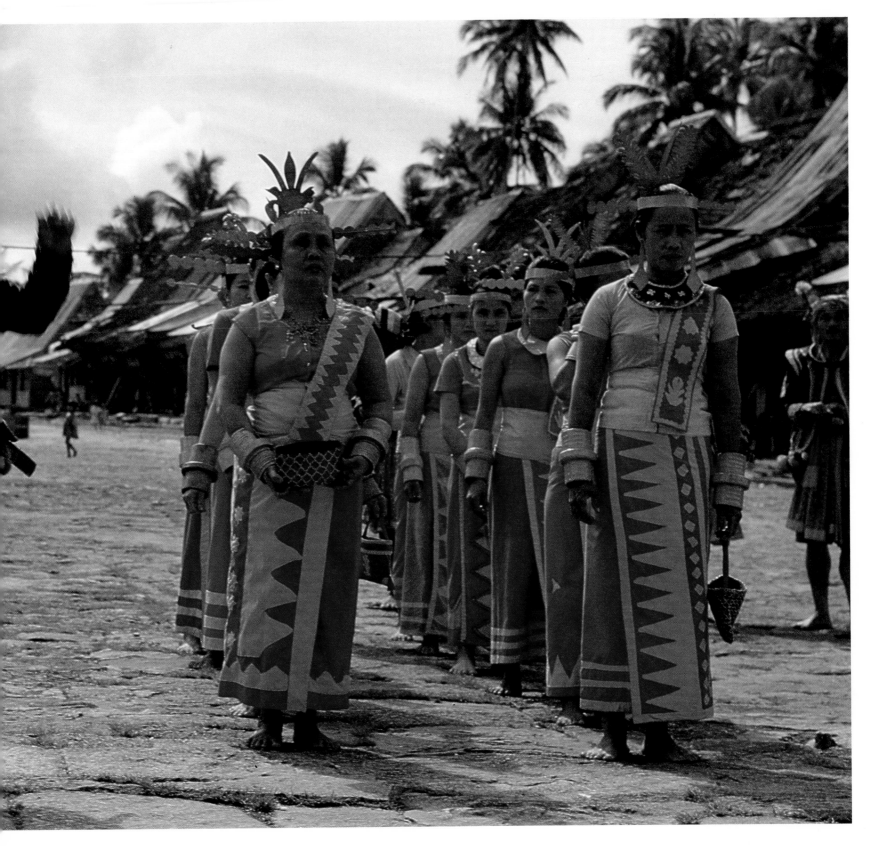

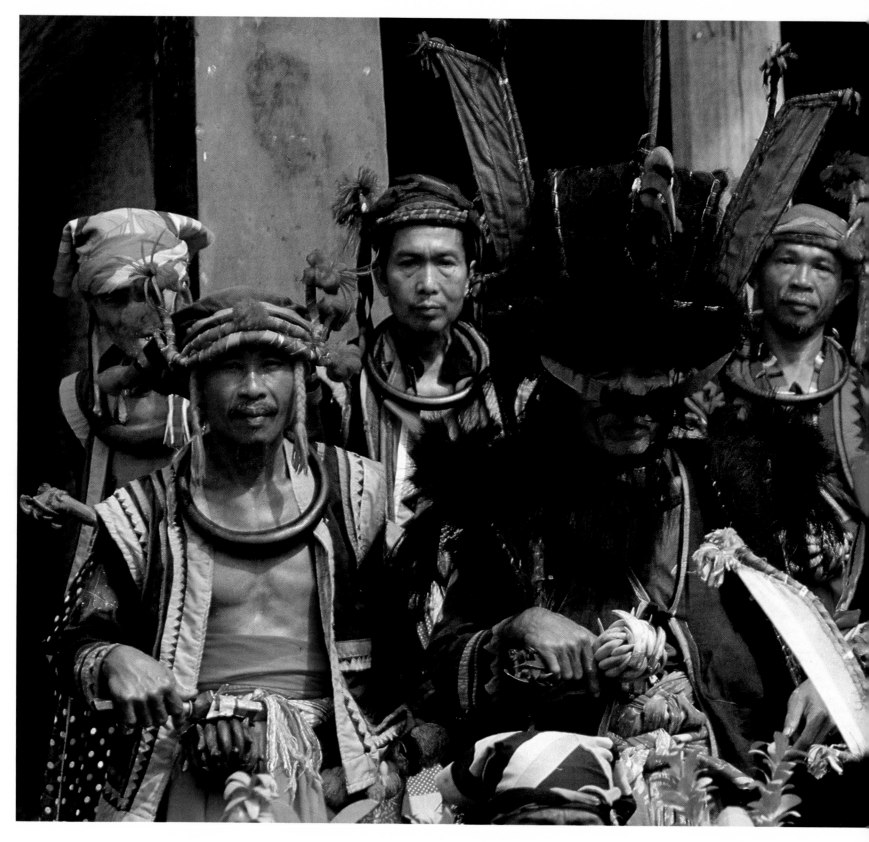

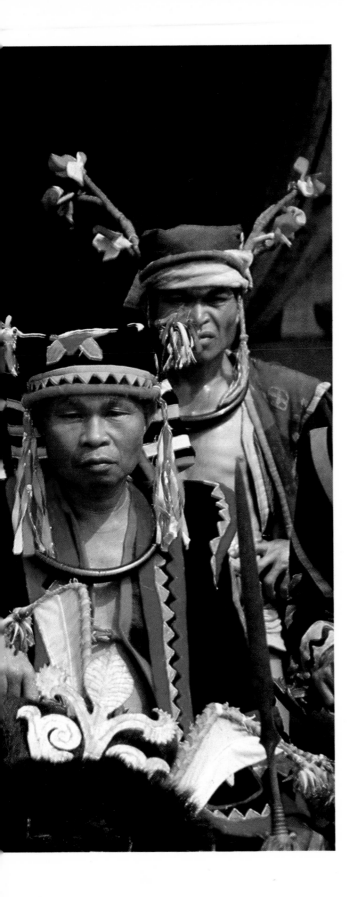

War dancers in Bawömataluö

Hombo batu, *the stone-jumping ritual*

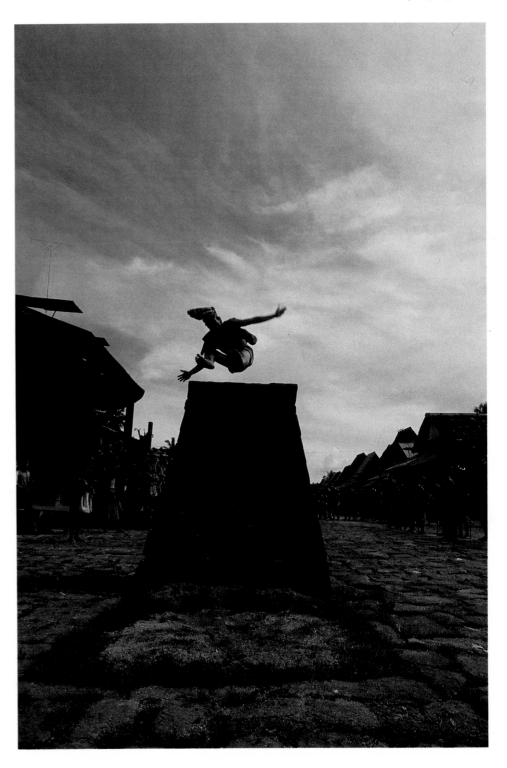

Bawömataluö: the corridor

Bawömataluö, hill of the sun

In Nias, Bawömataluö means the hill of the sun. The village lies indeed on the top of a hill. You have to climb very steep but neatly paved tiers of stairs to reach the village gate. And once you have reached the gate you feel as if you have touched a plateau where the sun is only one stone's throw away. In the evenings when you sit at the village gate and stare at the limitless sky and the infinite stars, you feel as if you were not sitting on a hill but on a spaceship. In Bawömataluö, the sun and the stars are inseparable and reachable village properties.

From the gate a long, straight, stone-paved street intersects the village's rows of traditional houses. When you walk along the street, pigs and dogs occasionally block the middle of the road, nonchalantly ignoring you and stubbornly retaining their place in the sun so that you have to make a little "detour" to the village. Sometimes, however, you will gain a concession as one of the animals gets up slowly and lazily moves away with majestic reluctance.

People greet you, stare at you, then ignore you while they remain immersed in their chess games, their sculpting or weaving. But enterprising and somewhat insistent young men and children follow you closely, cling to you, and try to persuade you to buy their "contemporary antiques" of sculptures and weapons – all of them "precious heirlooms."

* * *

The island of Nias is about 100 kilometers from the west coast of Sumatra. Presently it is a *kabupaten* (region) of the province of North Sumatra. The 100 kilometers' distance from Sumatra must have meant total isolation for the small island in the past. The language spoken in Nias does not have any resemblance with the major languages of the western coast of Sumatra such as the Batak, the Aceh, or the Minangkabau languages – a sign that in the past only very sporadic (if any) communication existed between the two islands. Linguists speculate that the Nias people may have followed a different migration route in the far distant past, bypassing Sumatra to settle here. The existence of some similar words in the Nias and Northern Sulawesi languages has led to speculation that the two ethnic groups might have common origins. But no one has a conclusive idea of where those origins might be.

According to informed speculation, Nias at one time was also touched by large waves of migration of Melano-Polynesian and probably also Indonesian-Oceanic origins. Subsequently, somehow Nias was left isolated. Apparently new contacts with Nias from the "outside" world did not resume until the end of the 19th century. First, of course, were the slave traders, then the missionaries, and finally the Dutch colonizers.

Now, the island is a *kabupaten*, with a capital town Gunungsitoli where all activities of the local government and commerce are concentrated. The whole population of the island is now about 350,000 people, over one half of whom live in Gunungsitoli. Most of the others live in the second largest town of Teluk Dalam at the southernmost tip of the island and in villages along the coast and in the hills. The mountainous terrain, with many ravines, gorges, and rivers, and one very badly maintained road between

Gunungsitoli at the north and Teluk Dalam at the south, must have isolated the various regions of the island from each other. The difference between the northern and southern cultures of the island is manifest in the architecture of the houses. The northern traditional houses are round while the southern traditional houses are rectangular in shape. The people speak different dialects and can barely communicate with each other (though the southern people claim that they understand the northern dialect better than the northern people understand the south).

The arts and culture and, above all, the architecture that have made Nias famous are found in the south. This tradition can be seen in the villages of Bawömataluö and Hilisimaetanö, which formerly warred with each other, but which are now at peace. But the "cradle" of Nias culture is, in fact, Gomo, a village located near the Gomo river to the north of the two other villages. Many local people claim that the original ancestors of the Nias came from the area of Gomo. It is also considered their sacred place and the location of their important statues, stone seats, and *menhirs*, the tall, erect stones that had symbolic significance in prehistoric times. Replicas of the Gomo statues, seats, and *menhirs* now stand at the office of *bupati*, the regional head, in Gunungsitoli, as symbols of power. Unfortunately Gomo itself is now mostly in ruins and the road to it has practically vanished beneath lush vegetation that has made it almost unreachable except by helicopter or on foot.

* * *

In front of the village chief's house at Bawömataluö are huge carved megalithic stone slabs and *menhirs*. According to the village chief, the stone slabs were used by former chiefs on significant occasions such as prestigious feasts at which many pigs were slaughtered; for formal announcements of importance or urgency to the community; and for viewing the dances. The *menhirs* were erected for such occasions as the commemoration of births and deaths, the installation of chiefs, and war victories. There are also stone slabs and *menhirs* in front of other houses, which apparently belong to other, previous chiefs.

The stone slab in front of the village chief's house has very strange carvings. It depicts whales and young men swimming and a figure chained in irons. What makes it strange is that it does not symbolize megalithic signs or the local environment. It seems to represent more realistic European drawings. Moreover, iron was not known during the megalithic era. The village chief agreed that the carvings are anachronistic to the Nias cultural environment and conceded that the stone slabs might not be very old. They could have been made for the village chief during the first contact with foreign ships which carried iron chains.

Apparently it is still customary for the Nias people to erect *menhirs* and establish stone slabs. Last year, the present village chief erected a *menhir* to commemorate his anniversary as chief. As yet, there is no cultural gap – at least technically – between present sculptors and their forefathers in the remote megalithic past. The only problem in stone carving today is the scarcity of large stones, which arises because construction companies in Gunungsitoli need more stones from the rivers in the south for their works.

The shape and style of the stone slab and the *menhirs* are still traditionally retained. The stone slab is rectangular in shape and is two to three meters long and one to one and a half meters wide. Surprisingly, the strange carvings of whales and iron chains have not been copied or repeated in contemporary stone slabs. The slabs follow more the older styles which are crude and plain. The *menhirs* are clearly phallic in shape symbolizing men's fertility and potentiality.

There are only two long streets in the village of Bawömataluö. The two streets actually form a T, which is the shape of the village. The streets are curiously wide for a village of only 20 meters. And they are paved with big stone slabs. None of the villages in the north of Nias have the layout or main road similar to the two villages in the south. Nor is there evidence in the eastern part of the archipelago, which was also touched by the megalithic culture, of this kind of village layout or of the large stone paved "highway" that one finds in Nias (though larger *menhirs*, as well as dolmen and sarcophagi, were discovered there).

The rectangular-shaped houses are wide and tall. They stand on at least 12 big pillars for the average household and more for the houses of village chiefs. Each house consists of two stories. The first story serves as sitting room and for guests; the second story contains the living quarters of the family. It has high ceilings and ample ventilation to circulate fresh air through the house. The roof is of thatch but recently about 30 percent of the people have switched to galvanized iron. Despite the heat of the iron, these people feel the new roof will help to elevate their social status. Moreover they calculate that in the long run galvanized iron will be more economical. Except for the thatch or galvanized iron, the houses are all of wood, and are built to resist earthquakes.

Across the street from the house of the village chief is an all-purpose house, used for men's gatherings, for village deliberations, and village trials. Traditionally, only 20 *si'ila*, the upper layer of the society, could represent the community in the village deliberations and trials. They had to be descended from other *si'ila*; they also had to have good judgment, good relations with the village chief, and enough wealth. *Sato*, the working class, and slaves were ineligible.

Today, these trials are only for routine legal problems. At least theoretically, the community is no longer divided sharply into *si'ila* and *sato*, and certainly there are no more slaves. The village organization has adjusted to the present public administration.

In another spot near the house of the village chief there is a mounted pile of stones about 2.30 meters high. In front of the mounted stones one piece of stone is placed. During festive occasions young men do the *hombo batu*, the jump over the stone, by stepping onto the smaller stone before trying to clear the pile. In contemporary Nias, the *hombo batu* is just for athletic entertainment, but in the past it may have been part of initiation rituals for entering manhood. It may also have been tied in with military exercises, since villages were constantly at war and were usually surrounded by high fences.

Bawömataluö has 3546 inhabitants, three elementary schools, and one junior high school. It has one Protestant church and one Catholic church. The German Protestant mission arrived on the island in 1912, while the Dutch Catholic mission started its work in 1937. Today, the Protestants still have a clear majority of about 80 percent over the Catholics in the village.

* * *

The most important dances in Nias have traditionally been the war dances, which is understandable in view of the villages' turbulent past. The dancers, 46 men, would come out in new, bright red, yellow, and black war costumes with shields, swords, black hats, and vests made of sugar-palm fibers, shouting rhythmically and dancing in round configurations. Then they would shout again. This is the *Foalö* dance which depicts the preparation for a war and the fierceness with which the one side lures its enemy out. The fight itself is depicted by the *Fatele*, in which the choreography stresses the art of individual fighting within the context of a mass dance configuration. As the fight reaches its climax in a chaos of bodies, it merges into the *Famanu* dance – the most important of the dances.

Another all-male dance, not devoted to war, is the *Fahizale*. It depicts the period following harvest when the people have time to visit another village. The dance rhythm is of course slower and less fierce and the mood is more friendly, but the dancers still carry the swords out of their scabbards. Apparently wars are still their most important inspiration. Their former wars with the neighboring village of Hilisimaetanö remain fresh in the minds of these dancers of Bawömataluö.

A female dance, the *Faguele*, depicts a welcome accorded to visiting dignitaries or other important guests. Ten female dancers dressed in bright yellow and red costumes stand in rows and then move rhythmically toward the guests seated in the place of honor. After the dance the guests are offered betel nuts and *sirih* leaves.

All of these dances and the stone jumping are now a "show package" for visiting tourists. Since the tourists only spend several hours at Bawömataluö they are offered a digested version of all Nias dances during their brief stay.

* * *

Pig, rice, sweet potatoes, and vegetables are the diet of the villagers. But since pork is very expensive, people tend to eat meat once a week. Therefore, Saturday is an important day for the village: it is pig slaughtering day. On Saturday pork is served for lunch and dinner.

On Saturday, from early in the morning pigs are pulled along the paved street to the butcher, who, while the owner watches, skillfully jabs his sharp iron stick into the pig's heart. In a matter of seconds the pig dies. Then with equal skill the butcher rapidly slices up the pig. Meanwhile customers arrive to buy pieces of pork for their dinners. The owner will interrupt his game of chess to weigh the meat with a traditional (and unreliable) stone scale and nonchalantly receive the payment from the customer – an assured profit for the weekend.

Pig-raising appears to be a lucrative and secure business for anyone with a bit of capital and room for a pen, yet it remains concentrated in a few hands.

There is far more interest, from the village chief to the *si'ila* and *sato*, in developing tourism as a major source of income. The island is small, only about 5000 square kilometers, and cultivated land is shrinking due to the population increase. Also, the people are faced with the demands of adjusting to the new life style of a modern nation-state. The village chief, and many of the local elite, send their children to Medan, the province capital of North

Sumatra, and to Jakarta to study in high schools, academies, and universities. More cash income is needed to finance this expensive education. Relying on agricultural income is considered too conservative and insufficient to meet the new demand.

Moreover, the spiritual link to the traditional religion and its rites has been cut since the first German Protestant mission arrived on the island at the turn of the century. Many statues and effigies were destroyed and most of the important *adu*, ancestor figures, were taken from the island and put in various museums or private collections in Europe.

Soba, 25, is considered the finest sculptor of the south. He is still carving *adu*, the male nude ancestral figure in a squatting position. But Soba's only emotion for his sculpture is as a piece of art. Soba, who lives with his sculpting brothers and father, is a devout Christian. Also, Soba is very enthusiastic about promoting tourism for his island and village. For him the logic is simple: more tourists represent more chances to sell his works.

Contracts that have been put forward by travel agencies to arrange "show packages" have been heartily welcomed. The islanders would be able to get new dance costumes and cash money for the expensive maintenance of the "traditional" infrastructure of the village.

* * *

When dusk is about to arrive, the Hill of the Sun changes colors in several minutes. Suddenly it petrifies into a yellowish scene – as if taken from an old forgotten color photo album. The long paved street looks like a strange corridor cutting the equally strange row of architecture to the south. The houses which symbolize the cosmos, the upper, middle, and underworld, look glued to the long corridor.

Long before any other part of the Indonesian archipelago dreamt about towns or cities, the Nias megalithic genius had conceived the forerunner of a fort-town sustained by a strong agriculture.

One wonders if fate had decided otherwise for Nias, what would have become of this island which is now trying to establish its identity among the other elements of the new mosaic of the archipelago.

But "if" is something that history would always like to avoid...

The Seudati and Didong

The light drizzle does not seem to bother the 10 men in white trousers, long white shirts, red *tengkuluk* (folded hats) and *rencong*, the traditional Aceh daggers, on the folded red sarongs on their waists. They stand neatly in two rows, while the spectators, children and adults, sit under the trees surrounding the makeshift arena. Under the soft twilight rays they look like figures in blurred, surreal village paintings from the past.

Cot Batee, a small village of 520 people in the North Aceh region of the province of Aceh, is having a *seudati* dance performance. The village has invited two *seudati* groups to perform, one from the village itself, and another from the neighboring town of Bireuen. The local group, under the leadership of Syech Him, is newly formed and consists of young men from the village. The Bireuen *seudati* group, under the famous Syech Rasyid, has been in existence since 1950 and has enjoyed a considerable reputation at the provincial and national level. (The *syech*, from the Arabic word *syaikh*, is the leader and "stage" director of the group.) Syech Rasyid is 65 years old now but looks much younger than his age. In his *seudati* costume he is still dapper and good looking and once the dancing begins, he is as lithe as ever.

When the host signals to the two *seudati* groups that the performance can begin, they stand and form two rows facing each other. The *syech* then leads his group in greeting the other dancers and the spectators. Through this gesture, they request permission to perform and beg forgiveness if the performance is not up to expectations. They also seek to assure the rival group and the spectators that their rhymes and songs will not be loaded with black magic spells, but are simply meant to entertain.

The other group then answers their greetings, recognizing in this way that the performance is an entertainment and not a contest of magic. The group also begs forgiveness from the spectators if its performance disappoints.

The group of Syech Rasyid starts with the *saleum anak syahi*, a song of greeting by the principal singers of the *seudati*, the two *anak syahi*. The *syech* then leads the group of dancers who sing a chorus as they move slowly but rhythmically. The two *anak syahi* do not dance but concentrate on the lead song, taking signals from the *syech*. The *syech* chooses the repertoire of the songs, which consist of religious messages, a narration usually concerned with local history, and romantic songs meant to cater to the young spectators. But the songs do not always fall into clearly defined categories and often they are intertwined. The *syech* also decides on the choreography, which basically consists of 12 variations.

This evening Syech Rasyid has chosen an episode from the 1945 revolution when the rest of the archipelago had fallen in Dutch hands and Aceh alone remained republican territory. During these difficult years, Aceh continued to be prosperous and even managed to buy an airplane for the Indonesian republic by selling "national bonds" to the local people. After the revolution, the bonds were to be exchanged for cash; however, the republican government did not manage to keep this promise. The narration also reports on this failure, and about the people's disappointment when Aceh did not initially gain provincial status from the central government but was put under the province of North Sumatra. But now the people are happy because Aceh is a province.

The narration is accompanied by the dancing which changes configurations and also varies in tempo from rapid to slow. Occasionally the dancers do the *peh dada*, beating their chests with their hands several times, which produces a peculiarly hollow sound. They also perform the *keutep jari* movements, snapping their fingers, which conveys a crisp sound. The combination of sounds, done interchangeably and rhythmically, along with the complex

movements, makes the *seudati* a rich – if exhausting – dance.

The narration is not always limited to history lessons, but often serves as social commentary. The criticism embedded in this commentary may be very sharp and sometimes even contains personal attacks. Nowadays the government also uses *seudati* as a means of conveying information on birth control, health, the environment, and local government policies.

The lighter and more delightful part of the *seudati* is the *cae*, the rhymes, which are usually based on romantic poems. The *cae* is also used as a means of bantering with spectators, especially the women in the audience. Here, the role of the *syech* is a strategic one, because he is the center of attention. Often *syechs* will flirt with the spectators and have even been known to acquire new wives through their impromptu *cae*.

Snouck Hurgronje, the noted Dutch specialist on Aceh, has interpreted the word *seudati* from the Arabic word *ya sadati*, which literally means *oh, my masters*. According to Hurgronje, the words are a lover's laments to his audience, based on Arabic love poems. At the turn of the century, when Hurgronje visited Aceh, he saw none of the complex configurations the *seudati* uses now. Instead, the performers remained seated while reciting the *seudati*.

Djakfar Ismail, writing in 1983, speculates that the origin of the *seudati* dance was the *saman*, which in Arabic means "eight." The number signified the eight dancers in the original composition of the *seudati* or the *saman*, while the two *anak syahi* were additional singers to the group. In this interpretation, the *seudati* had its origins in *saman* as a medium for spreading the message of Islam. Whatever its origins, the present *seudati* has emerged as a combination of dance configuration, storytelling, recitation of love poems, and a sprinkling of religious pedagogy.

According to Hurgronje and other sources, originally the *anak syahi* were beautiful children specially recruited and trained to perform all sorts of "acrobatic miracles" to the delight of the audience. Nowadays this practice has vanished. The contemporary *anak syahi* are young male adults who specialize only in narrative singing a la *seudati*.

The all-white costume is also a recent development. Formerly, until some time in the 1930s, the costume was black and the *tengkuluk* was not as fancy as it is now.

As with other folk dancing, the *seudati* has undergone changes too, despite the strong traditional Muslim influence in Aceh. Younger, better educated *syechs* have formed their own *seudati* groups. They have created new configurations and picked up melodies from contemporary popular music, especially the *dangdut*, the Indian-inspired popular music.

The secular trends present in *seudati*'s earlier development have been accentuated of late. Its function as storyteller and social commentator remains strong, though the religious pedagogy has diminished. In certain villages *seudati* performances are not tolerated due to their profane character. Also, devout Muslim peasants often disapprove of performances that last until dawn.

Nevertheless, *seudati*, especially in the Great Aceh, Pidie, and North Aceh areas, flourishes, with its own enthusiastic following. In North Aceh alone, there are 24 active *seudati* groups. And throughout the region, during public holidays, harvest times, and important family and village rituals, the *seudati* is still the popular folk entertainment.

The *seudati* has also grown commercially. Accordingly, the performers have fixed honoraria for their performances. The most popular group charges Rp. 500.000, while the lesser ones get a minimum fee of Rp. 350.000. The *syech* and *anak syahi* are the best paid, sometimes earning up to 300 percent more than the players.

Following the performance by the Bireuen *seudati*, the group from Batee gets up to dance. Its configurations are less classical than those of the previous group – more in line with the newer choreography. Here the *kisah*, the story, is about the changing morality of contemporary youth which tends to neglect its religious teachings. Although instructive and pedagogical, this *kisah* seems predominantly satirical.

Meanwhile, the drizzle has turned into heavy rain. The *seudati* stops, and the performers disperse, running for shelter at the home of their host. The spectators, children and adults alike, also look for shelter. They will wait patiently for the rain to stop before the *seudati* is resumed later that evening.

* * *

Takengon, the capital town of Central Aceh, lies deep in the hinterlands of Aceh by the beautiful lake of Laut Tawar. It is a fertile region and supplies coffee for most of North Sumatra. It is also the land of the Gayo, the dominant ethnic group of the region. Although geographically and administratively part of the Aceh province, the Gayo have their own language and traditional arts. But since the 12th century, Islam has penetrated the region and by now the Gayo, like all Acehnese, are Muslims.

Didong is Gayo's favorite traditional art. It features a choral group of 25 to 30 people who sit in a circle and sing about every imaginable thing – legends, historical facts, contemporary events,

local government information, advice for youth, and social satire. Though some of the songs are composed in advance, many are composed spontaneously during the performance. Performances are mostly done by competitive groups which contest their wit and agility in bantering stories, jokes, and satires. The spectators encourage the players by shouting remarks and comments that inspire and even instigate the manipulation of the lyrics.

Like most traditional arts, *didong* is a community art, which is believed to predate the penetration of Islam to the region. The function of the art, like community art in general, is to bring the community together and share the members' perceptions of their cherished values and norms. After the arrival of Islam, *didong* conveniently served as a venue for the teaching of the religion. *Didong* is more flexible than the *seudati* since it can be performed outdoors as well as indoors, in a large hall, or in smaller rooms. *Didong*'s "stage director" is the *ceh*, probably a corrupted word from *syech*. The *ceh* directs the chorus, the repertoires, and the subtle body movements of the performers. *Cehs* enjoy a high reputation not only among the members of the group but also among the community. The most highly respected and awe-inspiring among them is the *guro didong*, who is considered the community "art treasure." There are now only three *guru didongs* left in the whole region. *Guru didong* is a *guru* in the real sense of the word: teacher, wise man, elder statesman, and perfect master not only in *didong* but also in traditional dances connected with Gayo myths.

The *guru didong* is also the name of an art form which only the guru may perform. For this reason, a *guru didong* must be a man of many parts, not only reciting the classical narratives but also dancing the classical dance. According to speculation, *didong* was preceded by *guru didong*, which was originally a religious ritual in which the priest (the *guru didong*) had the mandate of the whole community to conduct the ritual.

Didong has not only developed into a popular community art but a more commercial one as well. Formerly the *penemah langkah* (honorarium) was mainly symbolic. Nowadays a top *ceh* and his *didong* group may demand about Rp. 250.000; a lesser group will earn about Rp. 150.000. Tickets for a *didong* performance range from Rp. 1000 to Rp. 1500, with a V.I.P. ticket selling for Rp. 5000. The village government likes to use *didong* performances as fund raisers for their development programs to construct bridges, clean ditches, or restore local mosques.

But people have begun to see the fee, the *penemah langkah*, as a heavy burden. Increasingly, they are turning instead to cassettes performed by *didong* superstars. This phenomenon is also happening in Java where the cost of *wayang kulit*, the shadow play, is steering people to cassette performances instead. But despite this development, *didong* remains popular, with about 30 groups in the region actively engaged in *didong* performances.

* * *

Lukup is a village about 20 kilometers from Takengon. It is considered an old village and still manages to retain its Gayo character. Houses with traditional Gayo architecture, woven mats with traditional designs in the living rooms, people with traditional dress are still seen in the village, in the rice fields, and on the coffee plantations on the rims of the hills.

Pak Armas, a local building contractor, invites several superstars from the four most popular *didong* groups to sing in his house that evening. The performance is held in a spacious all-purpose room, which might be used as sleeping quarters, dining room, or a cozy place for intimate family or community deliberations. Mats with beautiful local designs have been spread on the floor. And a group of old ladies has started to beat the gongs. Gradually the room fills with people. The *didong* players take their places in the center of the room. After the host, Pak Armas, gives the signal, a member of the Winarbujang group begins to sing. The essence of the song is again a request for forgiveness for the show's shortcomings and assurances that the performance is meant as an entertainment, not as a magic contest. The singer performs with confidence and the singers from the other groups (who on other occasions are serious and formidable competitors) join him in a beautiful chorus. Then a member of the Terunajaya group sings. His song is about the beautiful lake, Laut Tawar, with its famous *depik* (*respora rectosona* in Latin), fish which are one of the region's well-known delicacies and sources of protein. The singer from the Kabinet group picks up the song and continues to praise the beauty of the lake but also laments that man's carelessness has caused it to deteriorate. Then young *didong* performers from Laksana sing about the 1945 revolution, the 1945 constitution, and the five year plan. They sing with gusto but lack the elegance of the Gayo classical style sung previously by their older competitors. Their repertoires, composed by them in contemporary language, are sung coquettishly.

The spectators follow the singing attentively and applaud with delight at phrases considered relevant to their situation.

While they perform, the singers sit upright on the mats but are

relaxed enough to let their bodies move from time to time. Their movements are very subtle, like the paddy in the rice field when it is blown gently by the wind.

Pak Armas also invites Ceh Zahak to give a demonstration of the art of *guru didong*. Ceh Zahak dances and sings beautifully about the white elephant myth. His songs are distinctively different from the regular *didong* songs. Then, playfully, he also dances the *ujung lebuh* dance. The *didong* singing lasts until midnight at Pak Armas' house, unlike regular performances which continue until dawn.

* * *

The road from Takengon to Bireuen and Lho Seumawe, from the Gayo lands to Aceh proper, curves precariously, but the scenery is breathtakingly beautiful: blue mountains, pine forests, rice fields, gorges, rivers, and sporadic tranquil villages. It is rather hard to imagine that among those tranquil villages and fertile rice fields lives an ethnic group whom the Dutch feared most and never really managed to subdue.

But if we listen and watch the gusto with which the performers sing the lyrics in *seudati* and *didong*, lyrics which blend strong religious conviction with sensuous love for the beauty of their habitat and environment, lyrics reminiscent of their historic grandeur, then perhaps we can gain a better sense of the Acehnese and the Gayo character.

The Acehnese have every reason to be very proud of their land's history. When Marco Polo passed through this region in 1292 he found Perlak to be a prosperous trading Islamic sultanate. Apparently not long after that the small Islamic sultanates in such regions as Perlak, Samudra Pase, Bonua, Lingga, and Pidie were unified under one kingdom, Aceh Darussalam, with its capital Banda Aceh Darussalam. The new sultanate reached its peak of power under Sultan Iskandar Muda (1607–1636), as its navy controlled all coastal areas of Aceh and the Strait of Malacca. Control of the waters also brought the ports and trade vessels under the Sultan's power and the resultant tolls he imposed provided one of his indispensable revenues for his state's treasury. During this period Aceh also excelled in statecraft and culture.

The kingdom also maintained diplomatic relations with foreign countries which continued until the last Sultan, Muhammad Daud Syah. Even after his capture by the Dutch in 1903, the Sultan still managed to write a letter to the Japanese emperor via the Japanese consul general in Singapore asking for help. Obviously Aceh was one of the most advanced, sophisticated, and international regions in the Indonesian archipelago, contrary to its recent image as one of the "most isolated" provinces of Indonesia.

When the Dutch declared war on April 1, 1873, it was in essence a declaration of war on a sovereign state. Unlike some regions in the archipelago which were overrun and subdued by the Dutch, the Aceh conflict was conducted by both sides as real war. The Aceh cabinet was reorganized into a war cabinet headed by a war minister. And the Dutch forces were led by some of their ablest generals. Both involved modern weaponry and employed thousands of soldiers. The war was considered one of the longest ever conducted in the archipelago. Despite the final success of General van Heutz in pacifying Aceh 40 years after the declaration of the war and the subsequent establishment of civilian administration, the Acehnese never considered the war with the Dutch over until the Japanese occupation came in 1942.

Islam, adopted as the state religion during the time of the Perlak sultanate in the 12th century, was developed further in 17th century Aceh Darussalam, and served as an inspirational force in almost every aspect of life in Aceh. It was incorporated in the Aceh constitution and in the Acehnese law; it was the inspiration of Aceh's literature and certainly it had inspired the people to wage a *perang sabi*, a holy war against the infidels. It is understandable, then, that the role and influence of the *ulamas*, religious leaders, was very important and was central during the Aceh war. The Dutch could only break Aceh's force after they managed to break the bond between the *ulama* and the *uleebalang*, traditional chieftains, and confined the *ulamas* to religious teachings in their respective villages. But the *ulamas* remain important today as religious leaders as well as village and regional leaders.

This role was evident in the *Darul Islam* rebellion, when influential *ulamas* sought to establish an Islamic state of Aceh. The rebellion lasted for about 10 years before the Acehnese agreed to come to terms with the central government.

Now Aceh is a province in the Republic of Indonesia — perhaps one of the more unique provinces in the republic. Its historical grandeur and even its difficulties in accommodating to the new format of the new nation-state have made it such.

Now, in meeting the new demands of the nation-state, Aceh has every reason to be optimistic. It has the wealth of natural resources, history, experience, courage, and determination.

Syech Rasyid of Bireuen did not sing in vain about Aceh's achievement during the 1945 revolution when he performed with gusto and pride at the *seudati* dance in Cot Batee . . .

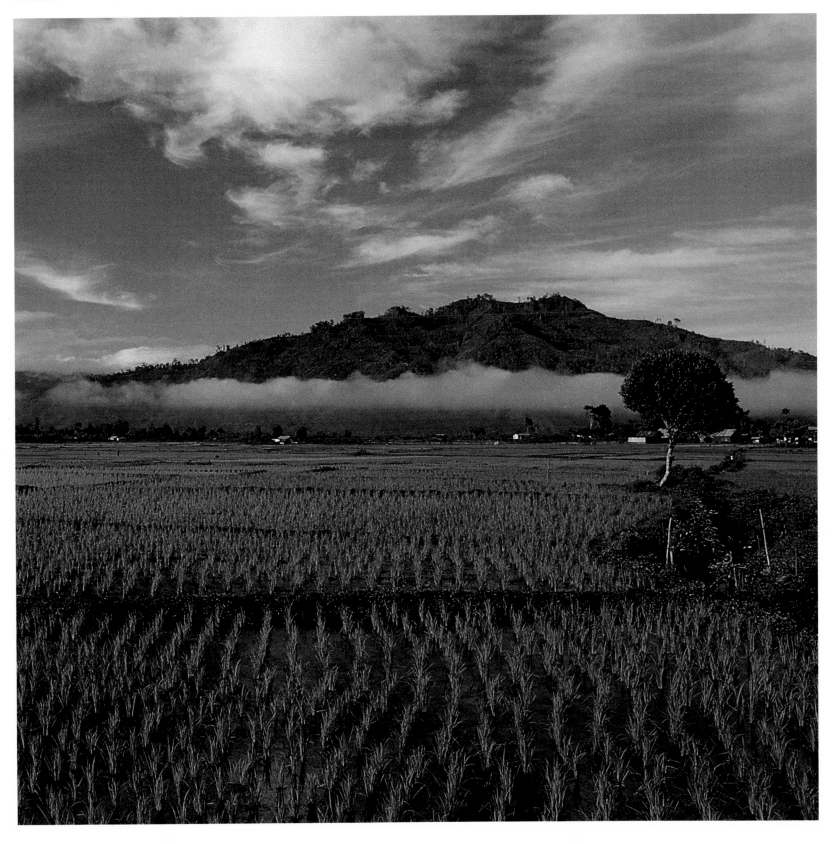

Ujung Lebuh *dance,* Takengon, Central Aceh

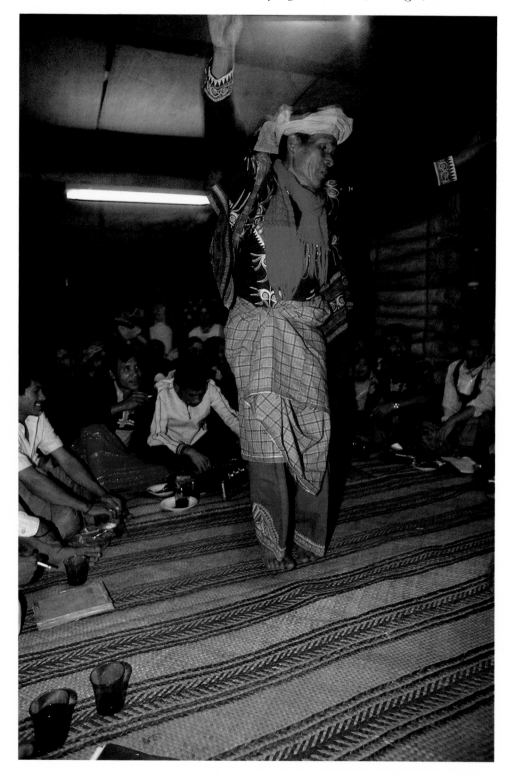

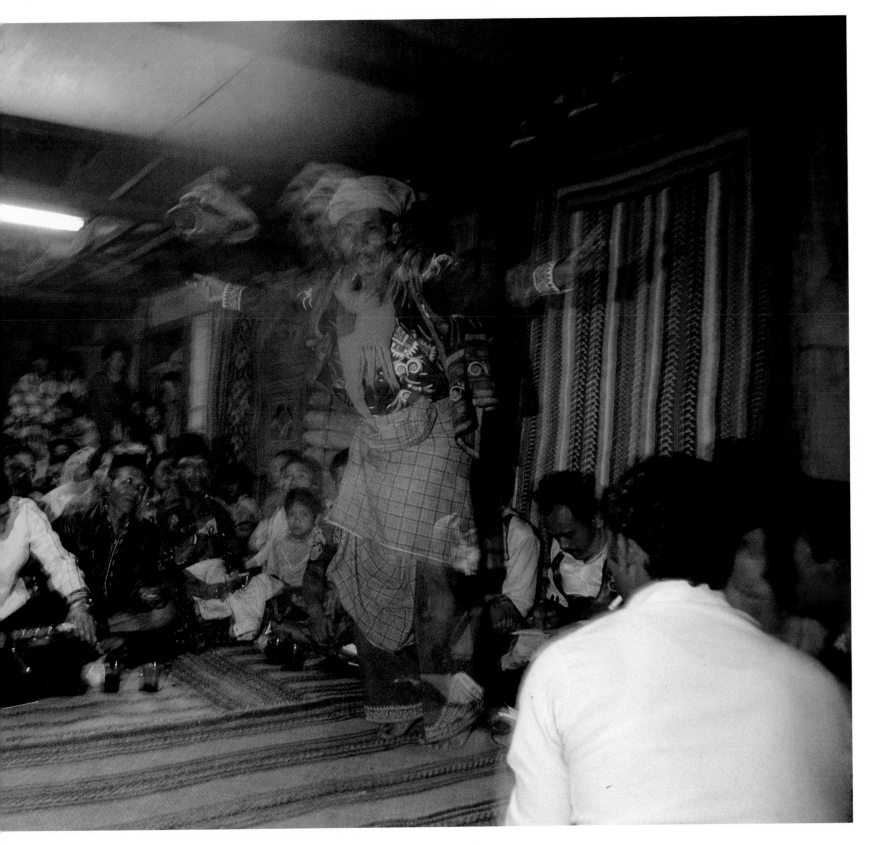

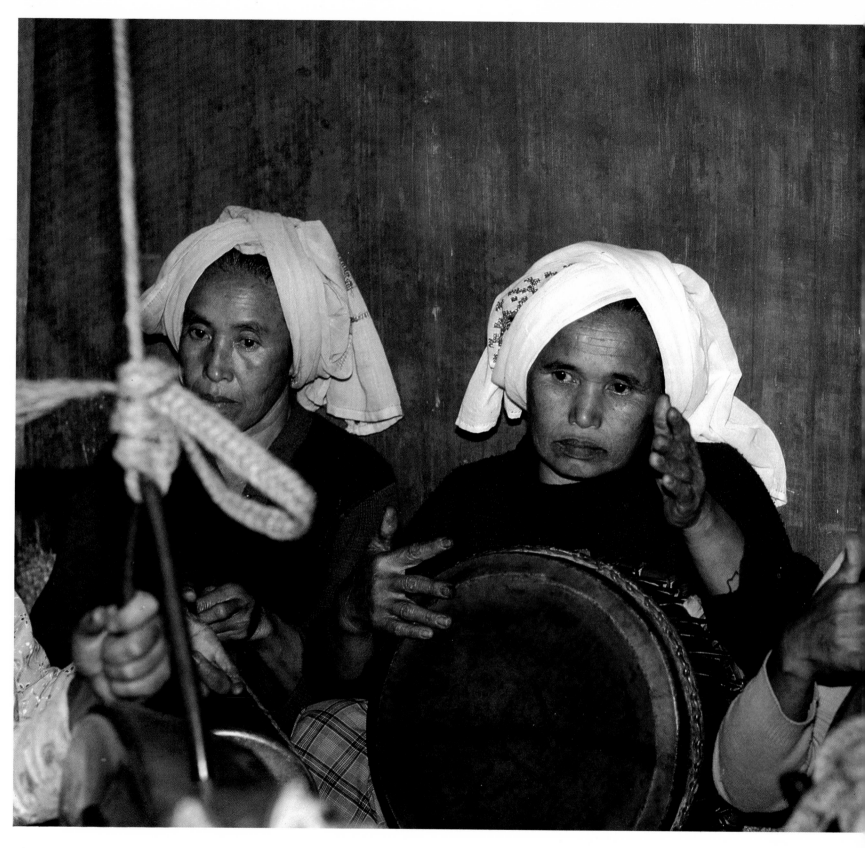

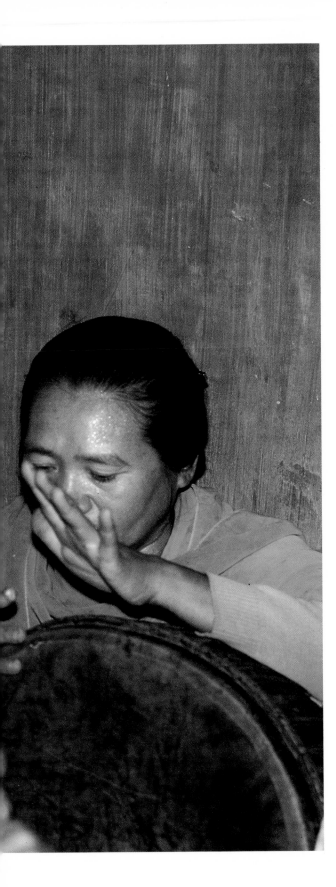

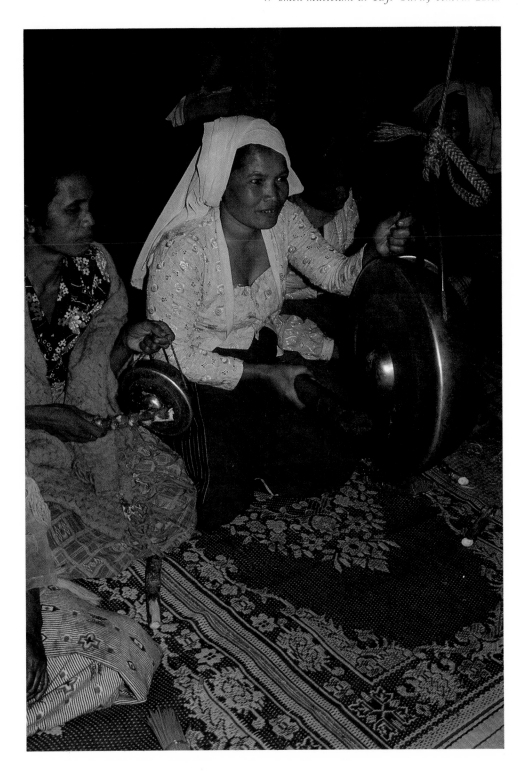

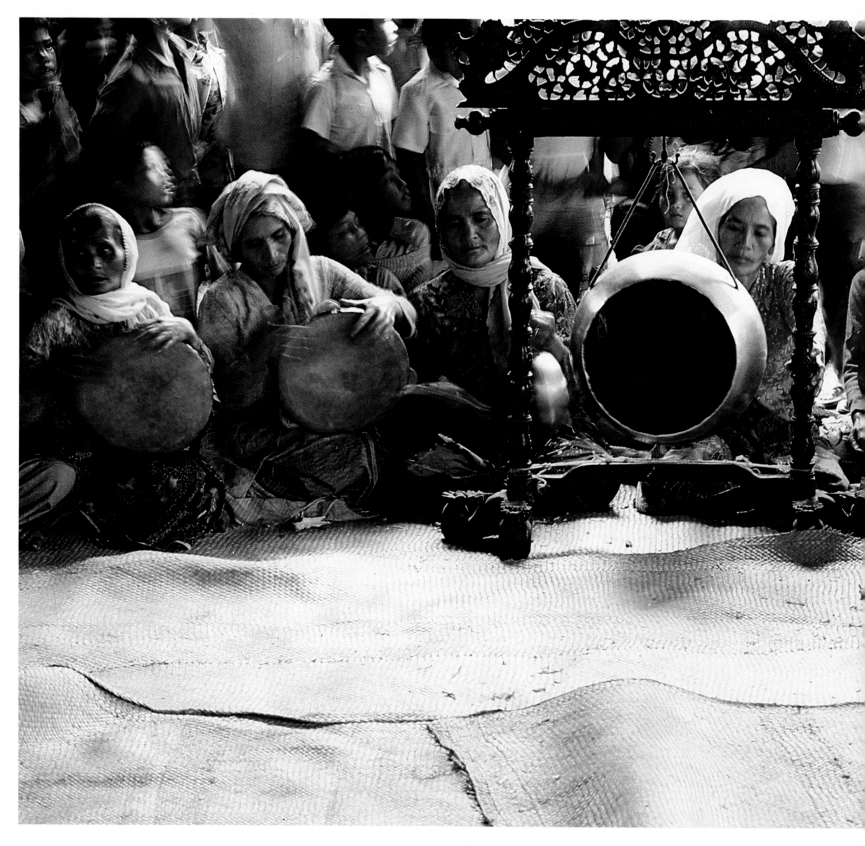

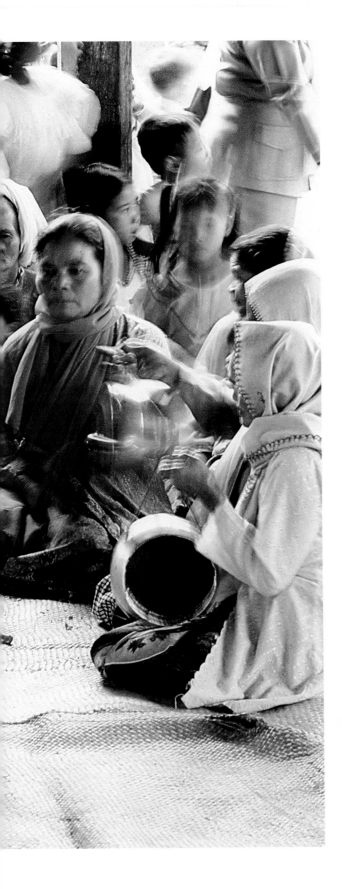

Women musicians at Reje Guru, Central Aceh

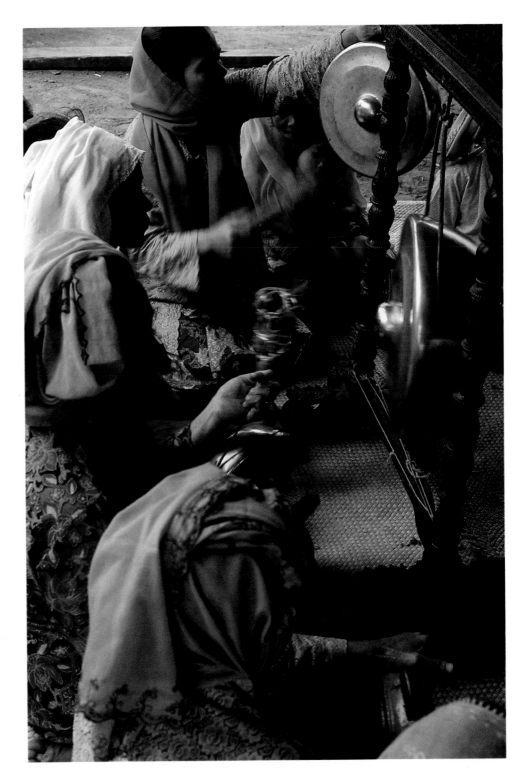

Shaman *Gayo dance*

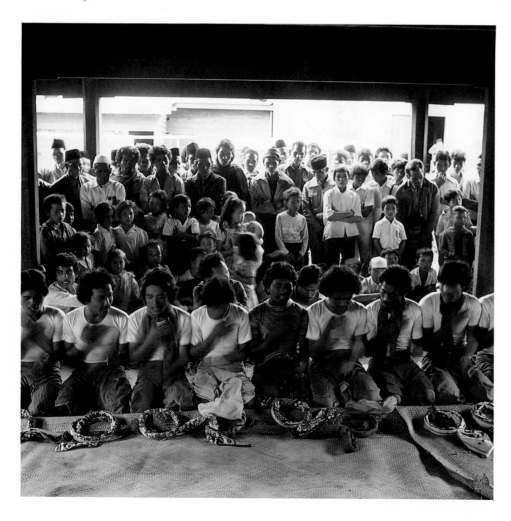

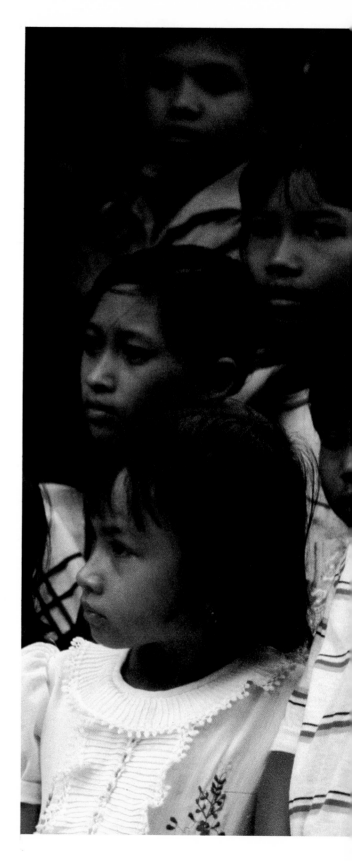

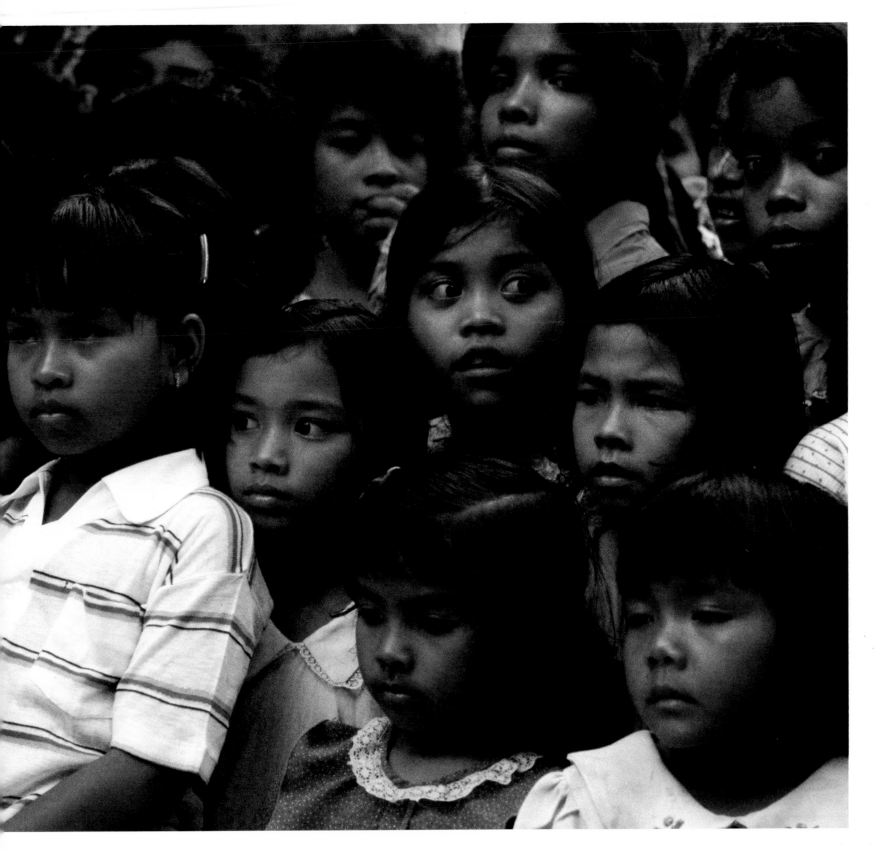

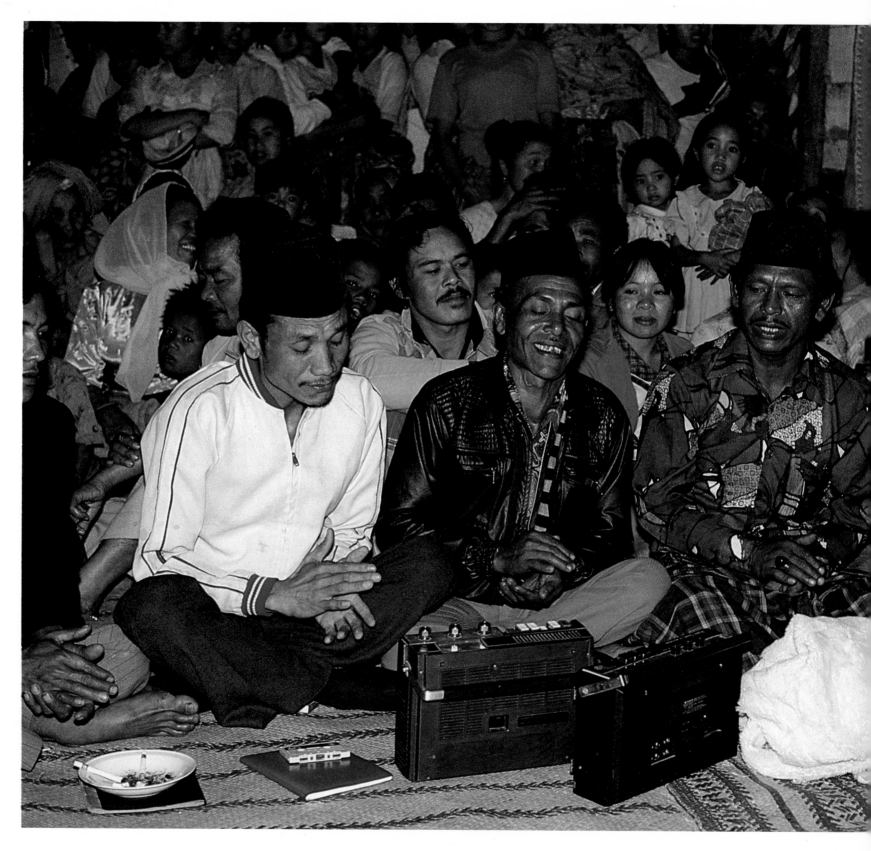

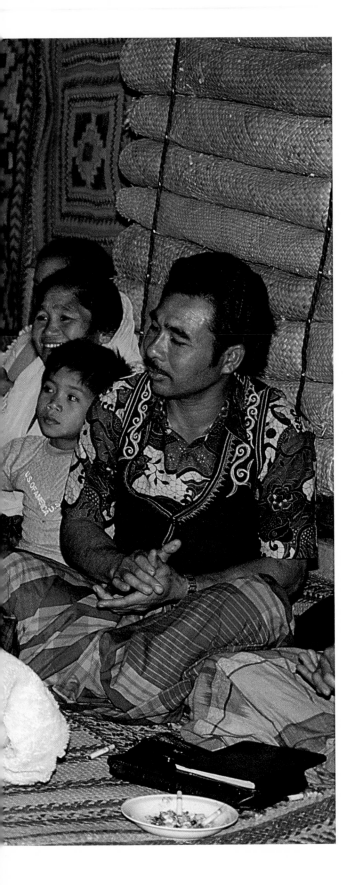

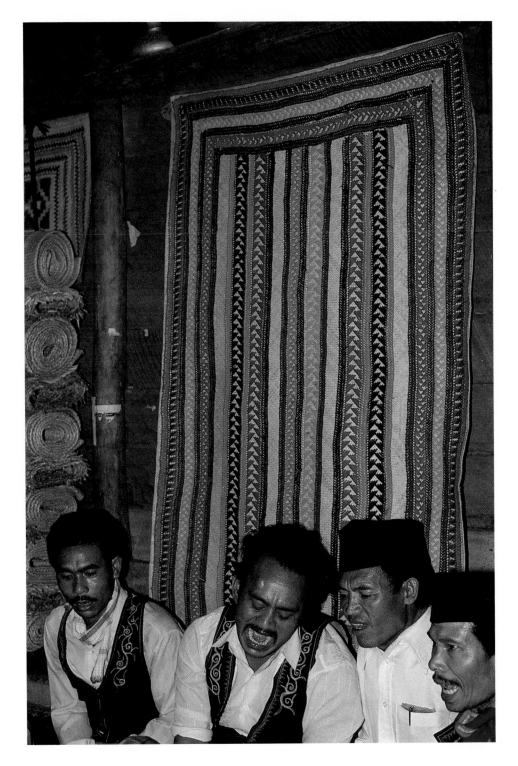

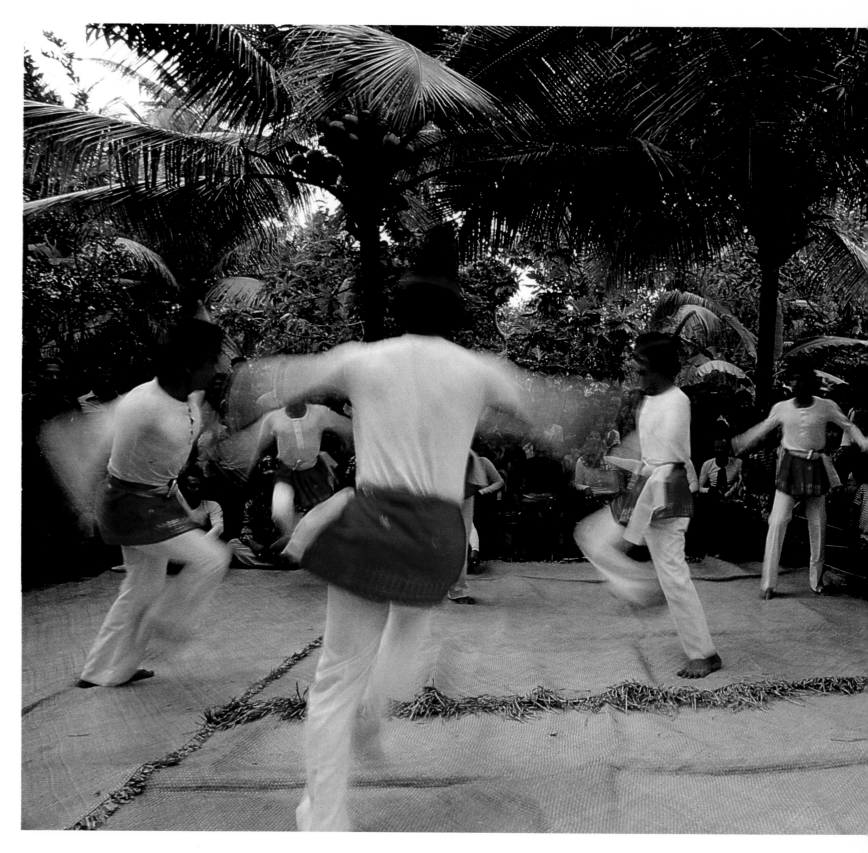

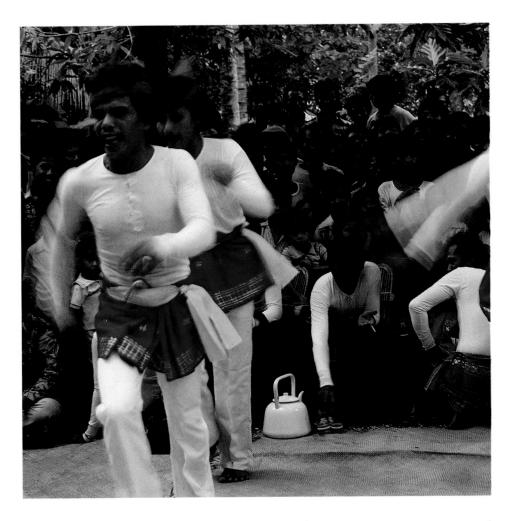

The 'Sacred Fish' Randai

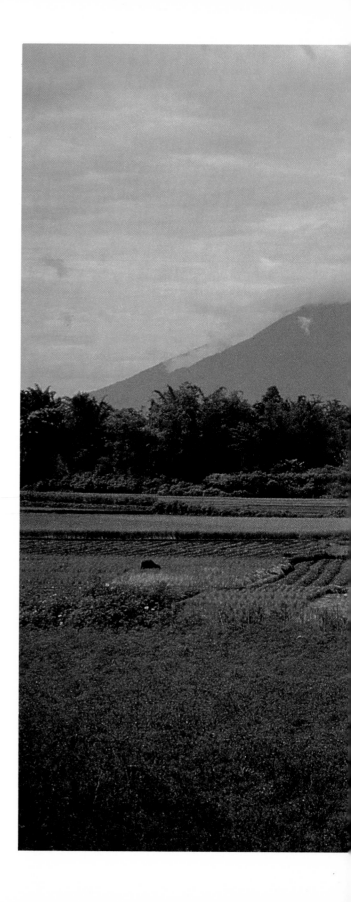

Rice fields, Sungai Janiah

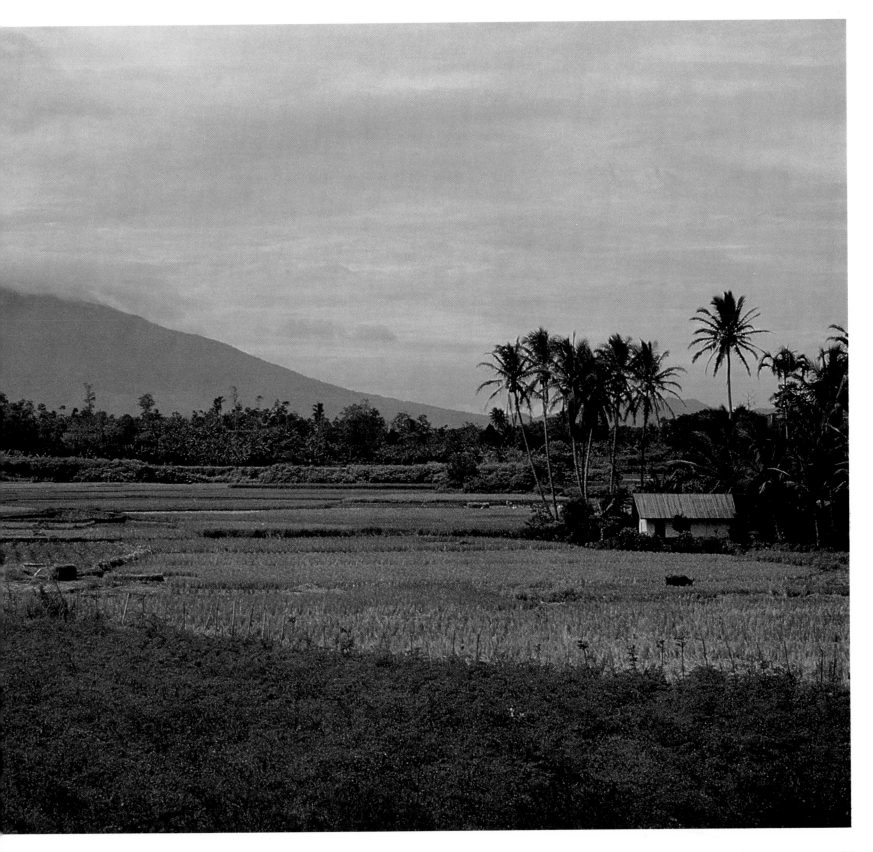

Ulua ambek randai, *Tarok, Pariaman*

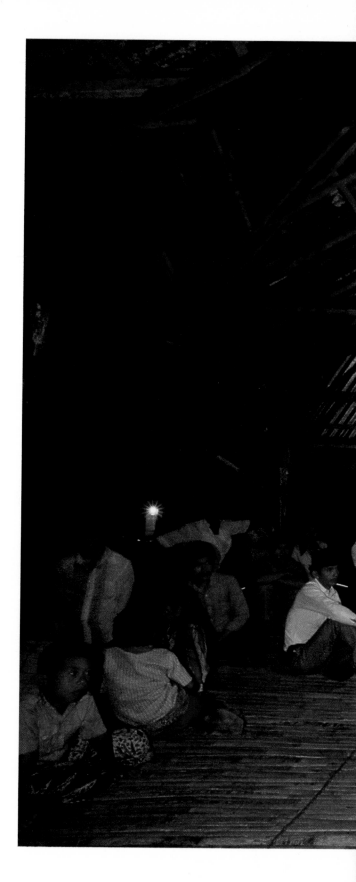

Children watching Si Malanca, *Sungai Janiah*

48

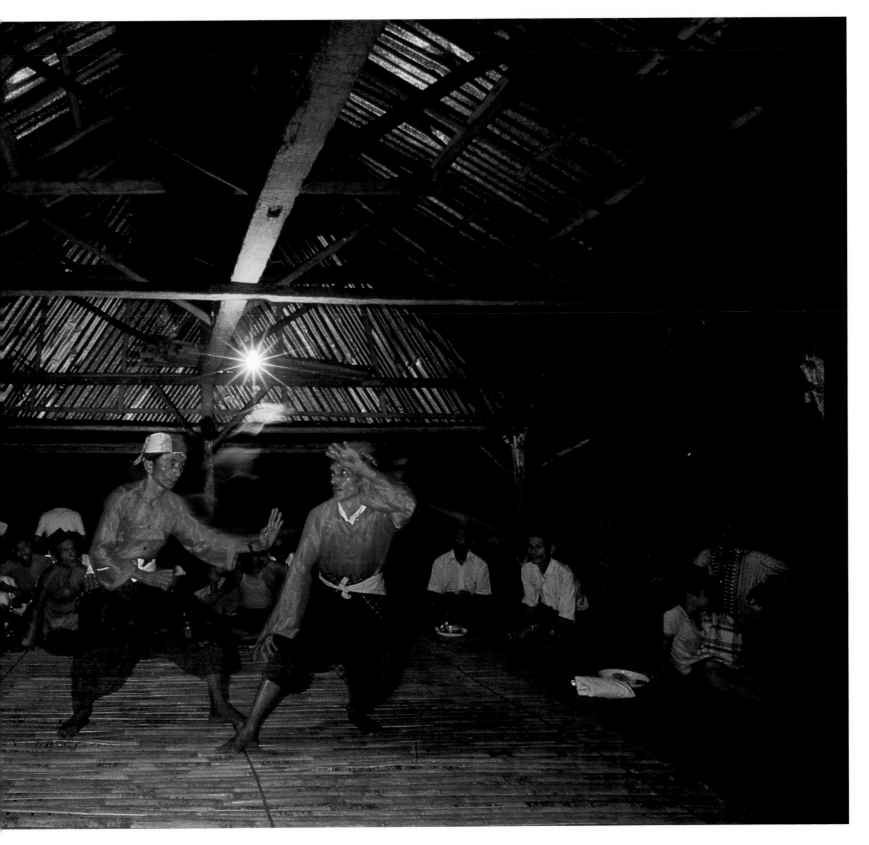

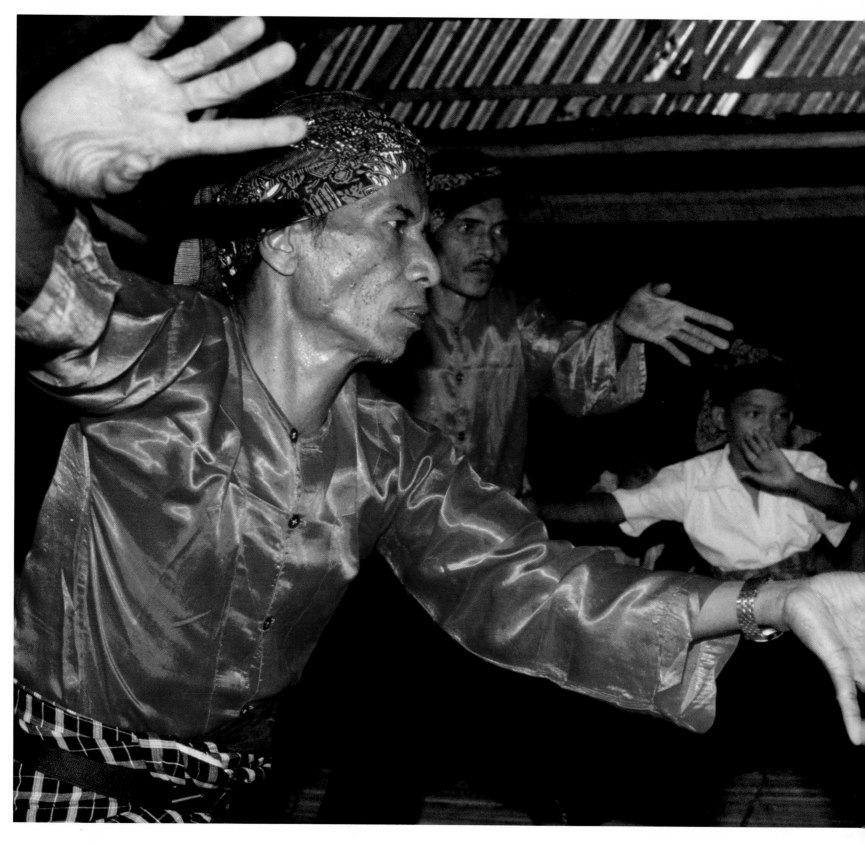

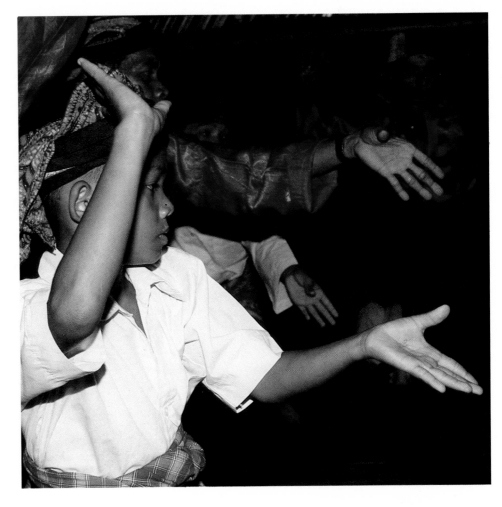

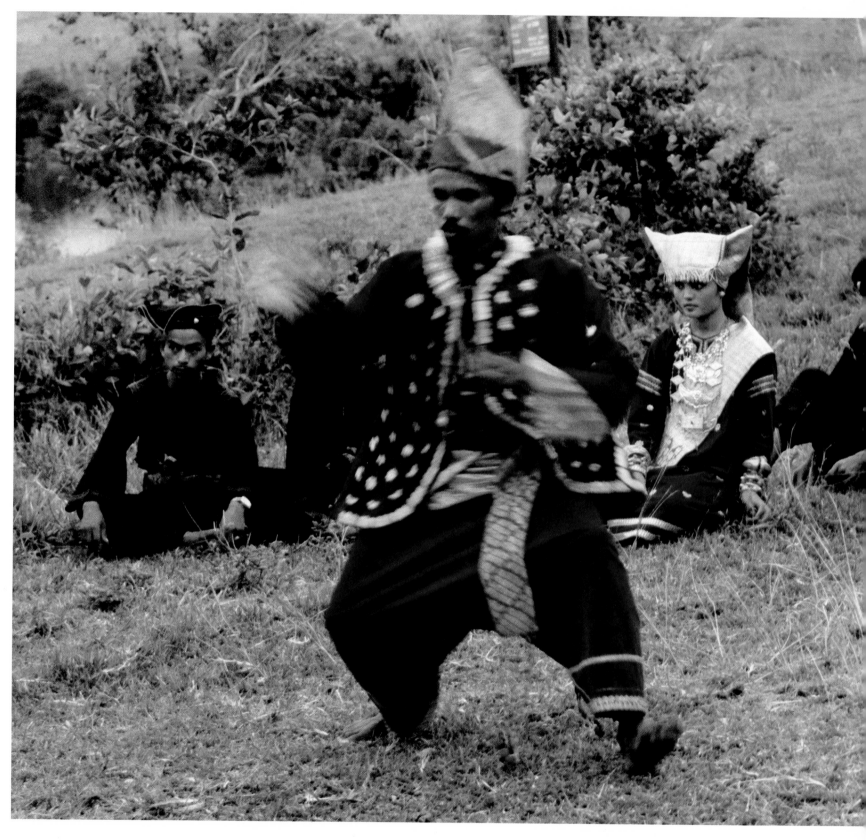

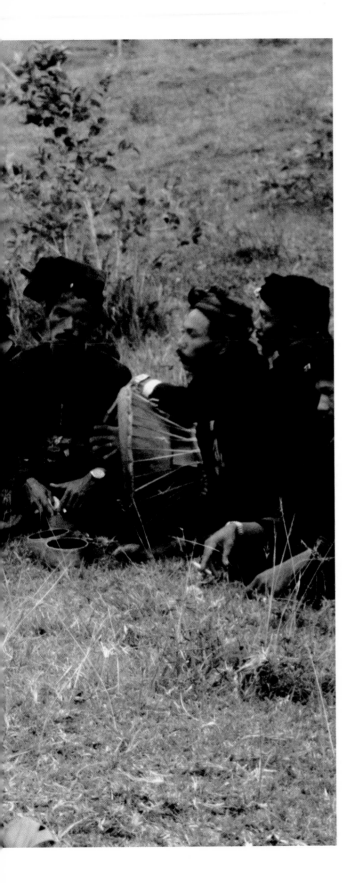

Ilau randai, *Saning Bakar, Singkarak, West Sumatra*

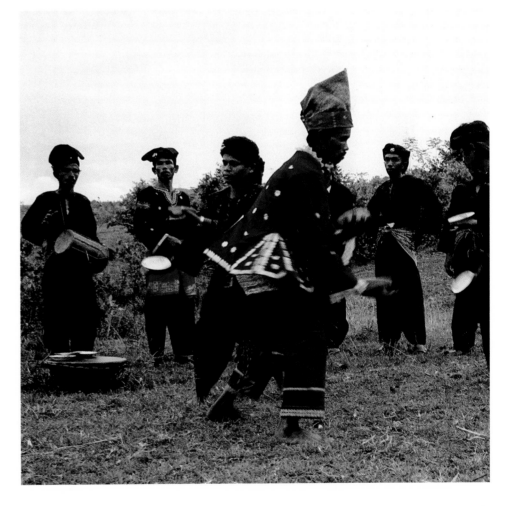

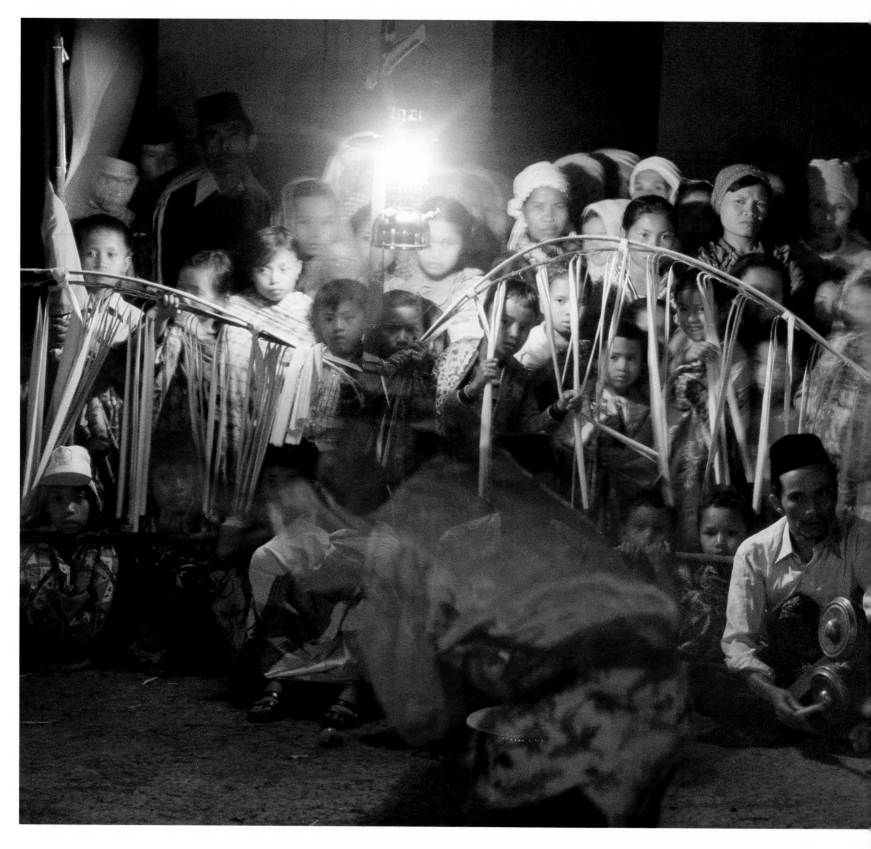

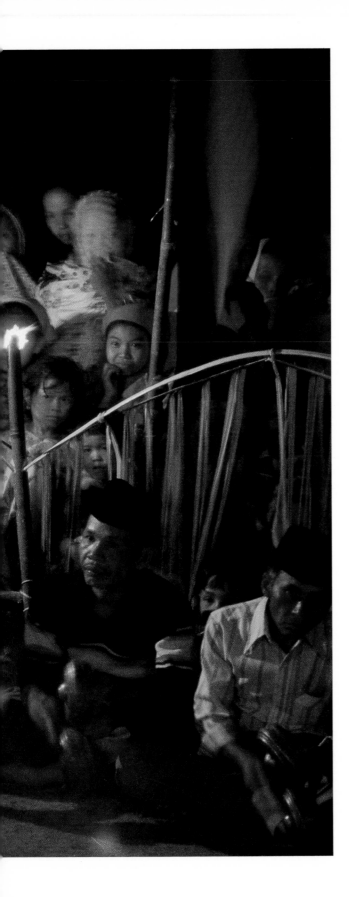

Si Malanca randai, *Sungai Janiah,*
West Sumatra

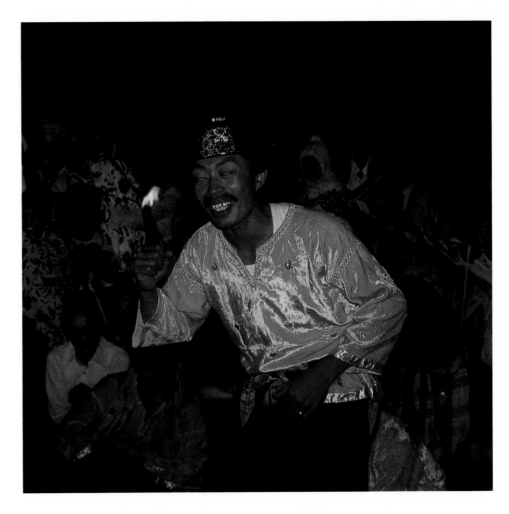

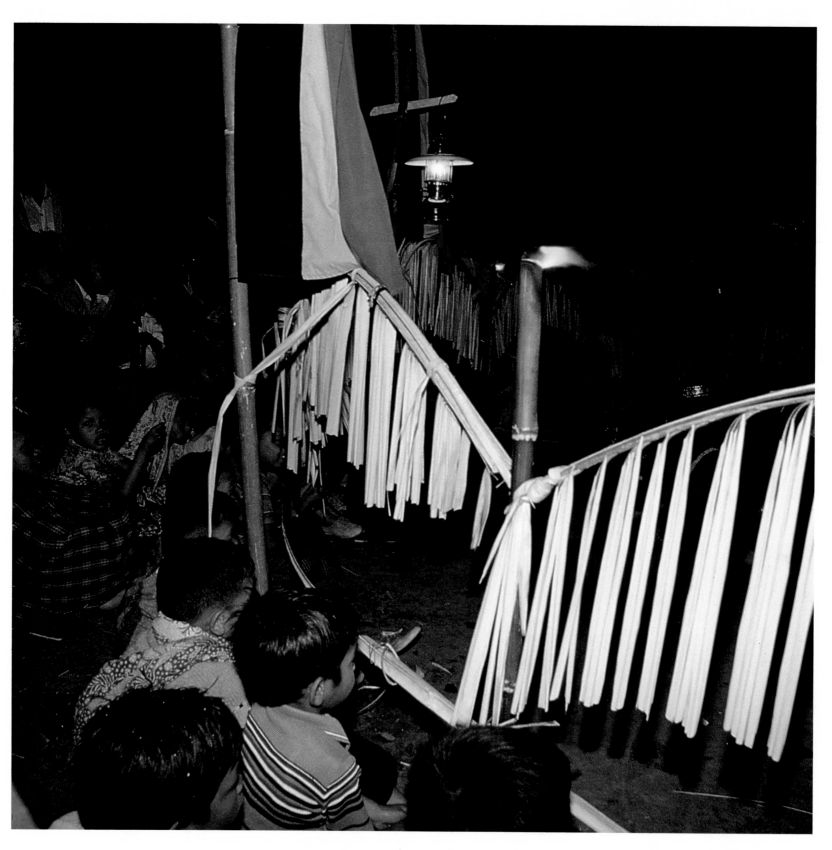

The 'Sacred Fish' Randai

In Sungai Janiah, a village near the town of Bukittinggi in the province of West Sumatra, dusk comes early. The mist slips quickly over the neighboring hills around 5.00 p.m. and soon blocks the sun, preventing its last hours of rays from penetrating the tranquil village.

In the village square, under the huge banyan tree, a crowd of people is busy putting up poles of petromax gas lamps, coconut oil lamps, and fences of coconut leaves. Soon a round arena has been formed. Mats and chairs are also brought in and children begin to gather around the arena. And when the musicians blow the paddy-reed trumpet and beat the drum, throngs of villagers and food vendors congregate around the square.

From the office of the village head a group of young men and women wearing the traditional dress of Minangkabau, the West Sumatran ethnic group, emerges and walks rhythmically into the arena. They then take seats on the mats. Again from the office emerges a group of men, village dignitaries and elders who also walk into the arena and take seats on the chairs. Meanwhile the musicians still blow the trumpets enthusiastically. Nearby, some men chat and sip their last evening coffee at the *lepau*, the coffee and snack house. After finishing their drinks, they pay the bill and hurry to the square under the banyan tree. From the distance they can see the young people on the mats being checked by the *Gurutuo Silek*, the *silat* or the martial arts dance coach, and the *Gurutuo Dandung*, the song and music coach. Then the two coaches approach the *Pangkatuo Randai*, the chairman of the *randai*, who sits next to the village dignitaries and signals to him that the group is ready to perform. *The Pangkatuo Randai* asks the village head for permission to start the show. The village head nods his assent.

Then the group of young men, three in red, four in yellow, and three in black, enters the arena, walking in a circle around the perimeter. Suddenly the *Gurutuo Silek* shouts "Heep" The performers make brisk but rhythmic movements with their bodies and stop as soon as they have formed the circle. They kneel, put

their hands on their heads as a gesture of greeting to the audience, then sing the *Dendang Dayang Daini*, the song of Dayang Daini. It is a *pasambahan*, or ode, to the audience. In the greeting song they beg the audience's forbearance if this *randai* they are about to show is not satisfactory to it, and they ask for tolerance because they are still inexperienced – their age is "not as old as the age of a corn." Again the leader shouts "Heep" The performers in the circle move and dance rhythmically with occasional shouting of "Heep . . . ba!" The movement of the circle follows patterns called the *gelombang* or wave. While the performers walk and dance the *gelombang*, the singer-narrator begins to relate the story. When the *gelombang* stops, one of the actresses who has been sitting on the mat stands and enters the arena. One of the dancers who has performed the *gelombang* also enters the arena. The story of *Si Malanca* begins with the dialogues between Malanca and his wife which are done in poetic form in the Minangkabau language. While the actors and actresses are speaking, the dancers sit crosslegged on the ground and follow the dialogues alertly since they must abruptly stand and dance the *gelombang* as soon as an episode of the dialogues is finished.

Again, the leader signals with his "Heep . . ." and again the circle moves. The actors and actresses who have just finished their performance then retire. The actors rejoin the *gelombang* while the ladies sit back on the mats. While the *gelombang* moves in different patterns, one of the dancers narrates in *gurindam* (rhyme) and sings the sequences which are not included in the acting. By the middle of the show, usually by midnight, they will stop for an intermission. During the intermission, dances or martial arts exercises will be shown.

* * *

The *randai Si Malanca*

Once upon a time there was a young man, Si Malanca, who married a young, beautiful, intelligent woman, Reno Nilam. After

they migrated to another country, they worked as cook and helper in a restaurant. Though they worked very hard, they could barely manage to live decently. Then one night Malanca told his wife that he was fed up with the routine which did not make them any richer and suggested that they return to their own country. At first Reno Nilam disagreed, fearing that they might meet an even worse fate there. But Malanca assured his wife that they would be successful since both of them were smart and experienced and his wife was a good cook. The wife was persuaded and soon both of them returned to their original village.

After a while, however, they discovered that the king was very cruel and despotic. He imposed heavy taxes on the people and kept most of the taxes for himself rather than for the betterment of the country. Since Malanca was determined to become wealthy himself, he decided to use his wits against the cruel king.

One day Malanca instructed his wife to prepare a sumptuous meal for the king in hope that the king would come to his house for lunch. He told her that the best and most delicious of the dishes must look as ugly as chicken droppings. The wife was amazed to hear her husband's instructions but carried them out after hearing his strategy.

The king and his entourage arrived on the day of the invitation. They ate heartily since the food was indeed good. They especially enjoyed the ugly-looking dish, and the king inquired about it while praising the wife's cooking. Malanca explained that the dish was the excrement from his sacred chicken, supplied at its owner's command. The king then ordered Malanca to hand the sacred chicken over to him. Malanca pretended to refuse until the king threatened to punish him. After he yielded, the king granted him 100 kilograms of rice.

The next day the king became ill after eating the foul-smelling excrement of the "sacred" chicken, and he decided to hang Malanca. But Malanca defended himself, explaining that the king shouldn't have put the chicken in an ordinary pen. In order to yield delicious meals, the sacred chicken should be treated and spoiled like a human. So the king forgave Malanca and sent him home.

Malanca tried the king's wit again. This time he invited the king and his entourage to have meals in two restaurants in town. To their amazement they saw that whenever they had finished a delicious and generous meal, Malanca did not take out his purse to pay but only shook his head and made the small bells on his hat ring cheerfully. The restaurant owner then gave a big smile and said, "It's all right, sir." The king wanted to own the sacred,

magical hat, which would free him from paying for meals at any restaurants in the world. This, at least, was Malanca's story. The king took the hat and granted Malanca hectares of rice fields.

Once again the king was cheated by Malanca, since the hat was not magical or sacred. Only by scheming with the restaurant owners had Malanca obtained free meals. When the king tried the hat in hope of getting free meals, its magic did not work. This time the king ordered his men to take Malanca and throw him into the deep river. Malanca and his wife heard of this plan and immediately developed their own plan to escape from the country. His wife quickly made an effigy of Malanca from a Dutch wife and pillow and wrapped it tightly into a blanket. Then she gave all her jewels to Malanca and asked him to leave the country immediately. Malanca managed to slip out just before the king's guards arrived at his house. His wife pretended to cry sadly and loudly over her husband's effigy. She told the guards that her husband was very ill, and they immediately took the "body" and threw it into the deep river.

Meanwhile Malanca arrived safely in a neighboring country. He sold all of his wife's jewels and used the money to purchase a ship which he loaded with goods. He disguised himself as a trader. This time he was determined to finish the cruel king once and for all. He visited the ruined complex of a former king's palace ground, chose a spot, dug, then put some remnants of beaten rice in it. In another spot he dug a second hole and buried some broken bowls and plates in it. He next went to the king's forbidden garden to find the sacred white heron which was the king's mythical ancestor. After Malanca killed the bird, he fished a shrimp from the river and put it into the mouth of the heron.

When Malanca arrived at the palace, the king was shocked to see him still alive. Malanca showed the king the dead heron and the dead shrimp, and told him and his audience that the ancestor of the king, the heron, had killed his ancestor, the shrimp. Malanca claimed that the shrimp was the original ancestor of the first ruler of the country. The king then challenged Malanca to prove that he was the descendant of the original ruler. They went to the ruined palace where Malanca challenged the king to show the original locations of the granary and kitchen. The king pointed to two spots. But when Malanca asked the people to dig for remnants, they could not find anything. Malanca then pointed, of course, to the two spots he had dug before, where the diggers found remnants of beaten rice and broken bowls and plates. The people cheered and the judge declared that Malanca was the real descendant of the original ruler who was deposed from the throne

by the father of the present king. Malanca forgave the king but asked him to leave the country. Then Malanca revealed his hoax and refused to become king. He asked the people and the elder statesmen to choose another king. But they unanimously chose Malanca.

After Malanca became king, he and his wife ruled the country justly and well.

* * *

The village of Sungai Janiah has 1150 inhabitants, most of whom are farmers. Since the soil is fertile, the village's economy is sustained by rice, vegetables, and fruits, as well as pottery. Furthermore the village is within easy reach of the town of Bukittinggi. The houses of the villagers look sturdy and clean and many still retain their *Rumah Adat*, the traditional family house, with its typical slanted long roof – the identity of Minangkabau architecture.

There is a small but beautiful lake located in the middle of the village. Though carp are abundant, the villagers seem to be afraid to fish them. They believe that the carp in the lake are sacred fish led by a huge carp as big as a cow. Because of this legend the *randai* group of the village takes the name of *Randai Ikan Sakti* – the sacred fish *randai*. The village is very proud of this *randai* group and supports it enthusiastically. The group holds regular exercises in which many young villagers participate. Older people serve as *Gurutuo Silek*, martial arts and dance coaches, as well as *Gurutuo Gurindam*, rhyme and song coaches. Because of this enthusiastic support and involvement, the group manages to maintain a high standard of quality in its performances.

It receives many invitations to play not only in the neighboring villages but also in other *kabupaten* (regions). And in the annual *randai* competition of the province the *Ikan Sakti* frequently wins prizes for its performances. As a *randai* the group is versatile in playing not only new repertoires such as *Si Malanca* but also classical themes such as *Cinduo Mato*, *Sabai Nan Aluih*, or *Anggun Nan Tongga*. They are also good in their *gelombang* variations and dances and songs. For their own village the group plays during harvest time, independence day, and several public holidays.

Sungai Janiah appears to be proud to possess the necessary attributes for a complete Minangkabau village: fertile soil, rich rice fields, a big mosque, a lake, and a good *randai* group.

* * *

Nobody seems certain about the origins of the word *randai*. Some say that the word is derived from *handai* which means an intimate situation, usually characterized by warm conversations. Another source says that the word *randai* is derived from the Arabic word *rayan-li-da'i* which is closely connected with the *da'i*, the propagators of the *na'sabandiyah* Sufi movement. The dances and the *gelombang* of the *randai*, according to this source, are closely linked with the calligraphic configuration in the ritualistic movements of the *na'sabandiyah*. The villagers from Sungai Janiah associate the word *randai* with the word *rindu* which means "to feel the absence of a situation."

Whatever the word originally meant, the *randai* has been developed from several sources – artistic and mystical forms. Those important sources are the *kaba* and the *silat* (or in Minangkabau: *silek*). The *kaba*, which originally meant news, was a traditional form of oral literature in Minangkabau. In old times, roving troubadours or storytellers walked or rode in a *pedat* (ox cart) from village to village telling or narrating in songs rhymes of traditional stories. The most popular *kabas* until now have been *Sabai Nan Aluih* (Sabai the Delicate One); *Cinduo Mato*, the story of Cinduo Mato; and *Anggun Nan Tongga*, the story of Anggun Nan Tongga. The three *kabas* are closely linked with the old myths of the Minangkabau kingdoms of Pagarruyung and Rantau. The themes deal with statecraft, and concepts on the judiciary, on ruling a country justly, and on involving the people in dealing with tradition and the value system. The *tukang kaba*, the storyteller, narrates and sings his *kaba* by special invitation. Usually the invitation is linked with special occasions such as a circumcision, a wedding, or the official construction of the *rumah gadang*, the big traditional Minangkabau family house. The *tukang kaba* may be very flexible in arranging his time. If the host demands a full and original narration of the *kaba* such as *Cinduo Mato*, the *tukang kaba* might narrate this for 17 evenings. But if the host wants him to narrate for only one night, then the *tukang kaba* would merely relate fragments of the complete *kaba*.

The *tukang kaba*, like the Javanese *dalang* (puppeteer), takes his work very seriously. He meditates and fasts prior to his work. And when he is invited to narrate for a special occasion he will demand offerings of white and black chickens. Then again, like the Javanese *dalang*, he also mumbles his prayers to the ancient ancestors of Minangkabau in Pagarruyung and on the Mount Merapi and Priangan – sites that are considered the sacred roots of the Minangkabau tribe and culture.

The *tukang kaba* is also very selective in choosing his pupils. Key

criteria for a pupil are the clearness of his voice, his memory, and his determination to be a real *tukang kaba*.

Kaba, then, plays an important role in Minangkabau rural life. It strengthens the community's sense of appreciation of its oral literature. To the Minangkabau, "beautiful art" is equated with the beauty of the language. *Kaba* is also very important as a medium for conveying the community's culture and value system.

The performing of *kaba* is occasionally linked with "magic." Jealous *kaba* narrators are capable of destroying other *kaba* narrators or singers by employing black magic. In traditional Minangkabau, pre-Islamic knowledge in this field seems to be thriving. Apparently all the serious effort of the *tukang kaba* prior to the performance has something to do with creating a kind of "deterrent" power to the *tukang kaba*.

The other source of the *randai* is *silek* or *silat*, the martial arts. In West Sumatra, martial arts are an important part of the way of life. A young man is not considered ready to enter manhood until he has learned to recite the Koran and mastered the martial arts. When an uncle decides it is the appropriate time for his young nephew to learn the *silat*, he takes the boy to a *Panokatup Silat*, the *silat* guru of a village. (The Minangkabau family system is matrilineal and matrilocal. Husbands live at the house of the wife's family but are responsible for their sister's children's education.) At the *perguruan*, the place for learning, the pupil must not only master the secrets of *silat* but also the technique of oratory. This demonstrates how the Minangkabau cherish language as a precious part of life. Oratory is important to the Minangkabau people, who love to argue at their mosques, *lepau*, *rumah gadang*, and formal village meeting places. In their community, decisions are made only after long arguments and deliberation. Speeches are also an important part of Minangkabau life. At parties and other occasions, speeches are obligatory and extensive, often lasting for hours.

The *silat* is meant for defending, not attacking. That is why its movements are concentrated on avoiding bodily attack, and discouraging possible hits from an opponent. Only in very rare circumstances does a Minangkabau *silat* attack, and then only to disarm the opponent. The *silat* must also be done elegantly, which is why it contains basic movements very close to dance and is rich with ornamental movement. There are at least 10 well-known *silat* styles in West Sumatra.

There is also a special kind of *silat* which is meant for "mystics" – older people who are versed in Sufi-oriented mysticism. Known as the *Ulua-ambek silat*, it stresses inner strength and therefore discourages assaults or other body contacts. Through slow, elegant, rhythmic movements the participant may hit the opponent from a distance.

As the *kaba* and the *silat* gradually became intertwined, they formed the eventual *randai*. The repertoire and the songs are obviously derived from the *kaba* tradition. The *kaba Sabai Nan Aluih*, *Cinduo Mato*, and *Anggun Nan Tongga*, for instance, are considered the most important *randai* repertoires. The songs, melodies, and rhyme are also derived from the *tukang kaba*'s narration, but the melody is better known as *dendang* and the rhyme as *gurindam*.

Not all *randai* are accompanied by musical instruments and carried out with dialogues and *gelombang* dancing in circles, though. One kind of *randai*, the *Randai Ilau* of the *Muaro Lembang* group from the vicinity of Lake Singkarak, does not involve dancing in circles and does not have any dialogues. The stress is on the choreography, which is very much influenced by straight *silat* movements. The dances are accompanied by traditional *randai* music. The repertoires are classical stories from the *kaba*.

Another kind of *randai* is the *Ulua ambek* from the Pesisir Pariaman region. Here again, some of the movements are *silat* which are closely linked with Sufi mysticism. The *Ulua ambek randai* is without music or dialogues. It stresses calculated rhythmic movements which are at times very slow, reminiscent of the Chinese *t'ai chi* movement, but at other times are also quick. But obviously the "inner strength" *silat* is still dominant here.

But in general what is popular among the population in West Sumatra is the well-known *randai* with the colorful costumes, rich dancing and songs, and captivating dialogues. It is so popular that there are now about 300 *randai* groups in the province.

* * *

The province of West Sumatra is blessed with beautiful panoramic scenery: mountains, lakes, gorges, and lush green forests. The prosperity of the villages is due to the rich soil of the rice fields and industrious people. They look relaxed, tranquil, filled with self-confidence.

Because of the West Sumatrans' pride in their own language and oral literature, *randai* has occupied a vital role as traditional folk theater supporting the infrastructure of the society. Furthermore, the Islamic religion, like Hinduism in Bali, is a living community religion. And the fusion of tradition, prosperity, and a strong belief system has created a balance of forces that encourage the *randai*.

Lenong: a shrinking culture

When the seaport of Jakarta was destroyed and conquered by the Dutch in the 17th century, Coen, the Dutch governor-general, rebuilt and renamed the port city, Batavia. The name was retained until 1942, when the occupying Japanese renamed it Jakarta. Even then, after three centuries of colonization, the Batavian identity remained. The inhabitants of Batavia pronounced the word "Betawi" and adopted it proudly and affectionately as their cultural trademark. Thus, they would say that their dialect, music, theater, dance, and even food were characteristically Betawi. That pride remains, even now, despite the major changes that have taken place in the now swollen metropolis of seven million.

But "typically or characteristically Betawi" is a unique phenomenon. It is not the development or evolution of a single dominant ethnic group in a particular cultural environment, but the result of centuries-long inculcation of many ethnic and racial groups in the region. Long before the Dutch conquest, Jayakarta (Jakarta) was a thriving port which had good commercial connections with Malacca, Banten, Mataram, and the eastern parts of the archipelago. The condition had made Jakarta a traditionally mixed ethnic and racial community. From the hinterland of West Java came the Sundanese; from Central and East Java, the Javanese; from the Malay peninsula and eastern coast of Sumatra, the Malay; and from the eastern part of the archipelago, such ethnic groups as the Bugis, the Makassarese, and the Ambonese migrated to Jakarta, followed by the Chinese, and later, from Europe, the Portuguese, the British, and the Dutch. The conglomeration of nationalities that populated Jakarta over the centuries through wars and spontaneous migrations gradually has developed into a homogeneous culture which we now recognize as Betawi culture.

For example, the Betawi folk music *gambang kromong* is a unique combination of Chinese, Malay, Sunda, and Javanese elements. The instruments consist of three kinds of Chinese violins – the *tehyan*, *kengahyan*, and the *shukong* – while the indigenous elements are the Sunda and Javanese *gamelan* instruments such as the *gambang* (a pentatonic wooden xylophone), the *kromong* (a pentatonic *gamelan* percussion instrument consisting of 10 small gongs), the *gendang* (the drum), the *kecrek* (thin metal sheets that provide a unique noise when struck), and the gong. The music is usually played to accompany the *cokek*, a community dance performed during wedding parties or other celebrations. *Gambang kromong* groups consist of Indonesian as well as Chinese musicians and members. But usually the instruments are owned by the Chinese group leader. Most of the songs are in the Betawi dialect, although occasionally one might hear a song in Hokkian Chinese.

If the *gambang kromong* music is influenced by the Chinese, the *tanjidor* music has been deeply influenced by the Dutch fanfare music. The instruments are those of a traditional fanfare orchestra and play the diatonic scale music. The repertoires are basically Dutch fanfare music, but played with the centuries-old Betawi touch and gusto. From time to time the musicians like to play the repertoires in pentatonic scale despite the diatonically tuned instruments. The instruments have been passed down from three to four generations back and in many cases are considered sacred heirlooms by the owners. *Tanjidor* is usually invited to accompany wedding and circumcision processions and, subsequently, to entertain the invited guests.

Like their music, the Betawi theaters are also configurations of various elements – namely Chinese, Javanese, Sundanese, Malay, and European. The most important Betawi theaters encompass the *wayang-kulit Betawi* (the Betawi leather puppet), the *topeng Betawi* (a variant of Betawi folk theater), and the *lenong* (another variant of Betawi folk theater). In the *wayang-kulit Betawi*, the flat leather puppets and *wayang* characters clearly show a central Javanese influence. But the repertoires, the music, and the language used by the puppeteer combine many cultural elements. The repertoires not only borrow from *Mahabharata* and *Ramayana*

stories, but also from local legends. The music, although heavily influenced by Sundanese pentatonic music, employs a Western trumpet in the orchestra. The language used by the puppeteer is a Betawi dialect mixed with Sundanese and, sporadically, old Javanese. The *aficionados* of this *wayang kulit* are not only Betawi Indonesians but also descendants of Chinese emigrants.

The *topeng Betawi* is the original folk theater *par excellence*. It is played under an open sky, on the ground, and in the midst of the spectators. There is no distance between public and players, since the spectators may participate and interrupt the dialogues of the players. The word *topeng* in Javanese means "mask" but in Betawi dialect it means "show." The Betawi dialect for "mask" is *kedok*, which is indeed used during the performance but only in the prelude and at the climax, neither of which has direct relevance to the main theme of the story. The prelude consists of an orchestral overture which functions more to attract spectators than to introduce the play. This, in turn, is followed by the *tari topeng kedok*, a solo or duet danced by one or more masked girls. It is followed by the *kembang topeng* and the *bodor*, which are danced by the prima donna and the clown.

The main portion of the play starts by midnight and features favorite themes – stories about local heroes and villains as well as stories from the Arabian Nights. The main part goes on until almost dawn. It closes with the story of *Bapa Jantuk* (Father Jantuk) who wears a black mask and quarrels with his wife because their dried fish has been stolen and eaten by a cat. The husband divorces his wife over this domestic disaster, but eventually the couple reconciles.

The music of the *topeng Betawi* is similar to the *gambang kromong* but lacks the strong Chinese influence. Instead of the Chinese instruments, pentatonic Sundanese *gamelan* instruments are used. The songs and dialogues are in the Betawi Sundanese dialect, which is also called mountain Sundanese (*Sunda Gunung*).

The *lenong* is another Betawi folk theater. Unlike the *topeng*, however, it is more tightly structured. It starts with an overture which again functions as a crowd gatherer. The play then runs through the night until dawn. The *lenong* is considered more urban than the *topeng* since the dialogues are in pure Betawi while the *topeng* blends the Betawi dialect and the *Sunda Gunung*; the orchestra that accompanies the play is *gambang kromong*, which is more cosmopolitan due to the Chinese elements in the music. The *lenong* is more popular in the city and enclaves while the *topeng* is more popular among the people at the outskirts bordering the province of West Java.

Like the *topeng*, the *lenong* was originally a pure folk theater. It was not played on a raised stage but on the ground among the spectators. In the past several decades, however, the *lenong* has been moved onto a stage, and developed into a "modern" theater with curtains, screens, stage properties – and costumed performers. As repertoires of historical stories, legends, and tales from the Arabian Nights began to demand more elaborate costumes, only *lenong* groups with strong financial backing from the Betawi Chinese could survive. The more elaborate *lenong* is called the *lenong dines* (the formal *lenong*), while the *lenong* which concentrate on the comparatively humdrum local heroes and villains and local romances are called the *lenong preman* (the casual *lenong*). Due to its expensive production costs, the *lenong dines* is rarely performed, while the more economical *lenong preman* flourishes among the population.

The *lenong* players, like those in the *topeng*, are "amateur professionals." This means that, although the players regularly perform on stage and receive minimum fees, they generally earn their living from other sources. Thus, washmaids, *becak* (rickshaw) drivers, office messengers, storekeepers, fruit growers, fruit vendors, and many others join the *lenong* as actors, actresses, musicians, and helpers. Few grow wealthy, but many have become popular stage personalities.

As folk theater, the *lenong* is very popular among the working class and lower middle class in the city and its outskirts. It has become not only a folk entertainment but also – as in many other kinds of folk arts – serves as a venue for bringing the community together. Weddings, circumcisions, anniversaries, and other celebrations would not be considered complete without a *lenong* performance. Repertoires about folk heroes and heroines have become Betawi favorites because of the people's strong attachment to the history of the shaping of Jakarta. Interestingly, repertoires with a 19th-century background are the most liked. During this period, the Dutch finally managed to contain the indigenous population into pockets of the city and its outskirts where many became small fruit growers. It was also the time when wealthy Dutch, Eurasian, Chinese, and Arabic landowners established themselves in the region. Local "Robin Hoods" such as *si Pitung* and *si Jampang* and many others emerged as folk heroes for the population. The tragedy of *Nyai Dasima*, the unfortunate mistress of an Englishman, is also a part of the folklore of the period.

* * *

The village of Kampung Baru is located about 25 kilometers from the center of Jakarta. Its population is only about 2000 and it relies mainly on the cultivation of tropical fruits for which Jakarta is famous. In former times when *delman*, dog carts, were still in use, many of the inhabitants earned their living by driving and renting them. When the village was still a "real" village with its brown dirt road, where *delman* and bicycles were the most important vehicles and more *durian* and *rambutan* trees grew among the yards, Kampung Baru represented the typically tranquil Betawi village. Now, of course, Kampung Baru has changed. A hard paved main road splits the village and for most of the day city buses, minicars, motorbikes, and trucks pass continually. The road connects Kampung Baru with other villages and makes it much more convenient to Jakarta. New houses have sprung up, replacing old Betawi-style houses. Prosperous fruit growers have rebuilt their houses according to the new taste, and color television, radio cassettes, and video cassette recorders now perform in their homes. The old tranquillity of the village seems gone. Yet Kampung Baru still manages to remain Betawi. People still converse in the local dialect and encourage newcomers to embrace it. And what is more important, the village still has one *lenong* group, one *tanjidor* (fanfare) music group, and one *wayang-kulit Betawi*. The tradition continues.

The name of the *lenong* group is Mustika Jaya, "the victorious jewel," and is owned by the couple, Samian and Nyami, who in daily life are fruit growers. They have about 21 full players and musicians, six of whom are women. The members, as usual, represent all sorts of professions. The group is the pride of the community and is regularly in demand among other villages; occasionally it also performs in the city. It competes rather strongly with the Pusaka Mayang Sari group of the neighboring Cijantung who also enjoy a good reputation among *lenong aficionados*. In the old times, competition between *lenong* groups could mean real "war" of black magic charms where prima donnas were the main targets. Nowadays, occasionally, one still can hear stories about the "black magic" practices among *lenong* players. However, on the whole, the competition, though strong, is done in a friendly and peaceful fashion.

The Mustika Jaya group also has a fine ensemble of *gambang kromong* musicians under the leadership of Samian. Nyami, Samian's wife, is the producer and stage director of the *lenong*. The orchestra does not have a Chinese musician—an old pattern which is still in use in other parts of the city. The *gambang kromong* of Mustika Jaya has also adapted itself to the new demands and tastes

of the younger audience. In addition to the traditional repertoires the musicians also play new *dangdut* (Indian-influenced Indonesian pop music).

Lately, to the dismay of the group, *wayang-kulit Betawi* and the *topeng Betawi* seem to be attracting more attention from the public. That was why the group grew excited when they received an offer from a rich office in the city to stage the classic, *Nyai Dasima*. They wanted to do their best to show the public that *lenong* is not only still around but still *the* Betawi folk theater. To give the best performance they also invited Anen, a celebrated *lenong* comic actor and *tanjidor* musician from Ciganjur, and Mpok Siti, another celebrated actress and singer.

* * *

The stage is set. Food vendors have lined the streets. Children have disregarded their school chores and crowd in front of the stage. Backstage, behind the screen, the performers get themselves ready by making up their own faces. Some help themselves to a supper of rice, *jengkol* (a rather malodorous fruit), and *sambal* (very hot sauce).

The *gambang kromong* has started the *angkat slamet* (welcome song) followed by Mpok Siti and Bu Nyami singing a duet. Soon the story will begin . . .

* * *

Nyai Dasima was a mistress of Edward Williams, a rich Englishman who lived in Pejambon, Batavia. The year was 1820. At that time Pejambon was not an important part of the city, as full of government buildings as it is now, but it was a fashionable section consisting of large European country houses with large gardens. Nyai Dasima, who originally came from the village of Kuripan, was a beautiful young woman when she became Williams' mistress. She was taken into the Pejambon house, lived luxuriously, and soon gave birth to a daughter, Nancy. Williams seemed to be a good and generous master and loved his mistress and daughter.

But after a while Dasima felt lonesome and caged in the big house. She also felt isolated from her master's companions who were Europeans, Christians, and educated. As a simple Muslim and village woman she felt patronized and, at times, ridiculed and insulted by her master and his companions.

Among the local people, there was little sympathy for a woman who became a mistress of a European infidel. Most of them

thought her place should be among her own kind, the indigenous Muslims in the village.

Not very far from Pejambon was Kwitang, a village at the outskirts of town where the indigenous Betawi lived. Samiun, who owned several *delmans* and was considered rich by Kwitang standards, was smitten with Nyai Dasima. But since her beauty was famous, he was not alone in wanting her. In addition, Samiun was unhappy with his wife, Hayati, who gambled too much and spent most of her time at card games.

Samiun asked Mak Buyung, an old woman who was a notorious matchmaker, to help him get Nyai Dasima. Mak Buyung agreed. Since Nyai Dasima could no longer stand the situation in the luxurious house, she began to long for a chat with her old friends in the village among its shady trees and tranquil atmosphere. She missed the sound of the horses' hoofbeats and the bell of the *delman* along the dirt road. She wanted to leave the Pejambon house.

Mak Buyung invited her to visit Kwitang and meet Samiun. Finally Dasima agreed to leave Williams and become Samiun's second wife. Williams was shocked by his mistress' decision, but he finally gave in.

Dasima moved to Kwitang but soon discovered it was not easy to lead the life of a second wife. Hayati, Samiun's first wife, was very cruel to her and wanted to pawn her jewels to support her gambling. And Samiun seemed too weak to protect Dasima. Now life in the village was hard for her since she was no longer used to conditions there. At Pejambon, Dasima had been a mistress, looked after by a loving, rich master and obedient servants. Dasima gradually became very unhappy and ill.

In the meantime Williams felt betrayed and deserted by his mistress and bore revenge in his heart. Finally he called upon Bang Puase, a notorious hired killer from the Kwitang area, who agreed to kill Dasima in return for a handsome fee.

One evening Samiun took Nyai Dasima to a *wayang* show in another village. By that time she was ill, and had lost weight and her wit, but she smiled happily, and dressed for the performance in her best *sarong* and *kebaya*. But as the couple was en route to the performance, Bang Puase awaited them in the dark, killed Dasima, and threw her body into the river. Samiun was too frightened to do anything and fled instead.

After the body of Dasima was discovered, the police also found Bang Puase and arrested Samiun as well.

Curtain.

* * *

So goes the present-day version of *Nyai Dasima*. In an older version said to be based on an 1896 novelette by G. Francis (a British Eurasian writer in Batavia), it was not Williams who hired Bang Puase to kill Nyai Dasima, but Samiun and Hayati who wanted to inherit all Dasima's jewelry.

The present *Nyai Dasima* is a version of S. M. Ardan (a contemporary Indonesian writer) who is apparently more sympathetic with Samiun. But *lenong* groups play both versions.

* * *

Meanwhile old Betawi has grown in the past 50 years into Jakarta, the nation's capital, and a metropolis of seven million people. It continues to attract various ethnic groups to come and settle, but at much faster rates and in greater numbers. As a result, layer after layer of cultural assimilation has taken place and seems to push the Betawi core into a more isolated position. Gone are the old Betawi pockets in the city with their typical architecture and *rambutan*, *durian*, and *kecapi* fruit trees growing in their yards.

They have been replaced by enclaves of contemporary stone houses with tiny yards and sporadic flower shrubs. More fashionable, luxurious enclaves of large, rich houses have emerged. And increasingly, high-rise buildings line the streets as well as ugly slums.

Ironically, the population of contemporary Jakarta is made up of roughly the same ethnic groups that in the past have comprised the Betawi character. These same people also claim to be settlers who want to take root and give up their old cultural loyalties. Have they become Betawi people? Not quite. It is true, though, that they – especially the children – speak the Betawi dialect, eat *gado-gado* (mixed salad in hot sauce) and *nasi uduk* (rice cooked with coconut milk), and occasionally watch the *lenong*. But they tend to do so on a superficial level, and the old homogeneous solidarity has been sacrificed. Perhaps their own ethnic ties are too strong to be shaken off in a brief time. Meanwhile, the demands of shaping a new life style for a new nation and a new metropolis exert their pull.

Nonetheless, the Arts Council of Jakarta has put *lenong* back in the center of the city again by producing *lenong* plays regularly at the Council's *Taman Ismail Marzuki* (The Ismail Marzuki Garden). The Jakarta Municipal Government has funded and developed systematic programs to keep *topeng Betawi*, *tanjidor*, *gambang kromong*, *lenong*, and other Betawi traditional arts alive. Though Betawi has shrunk to a smaller cultural island, these efforts represent positive signs.

Preparations behind the curtain, Jakarta

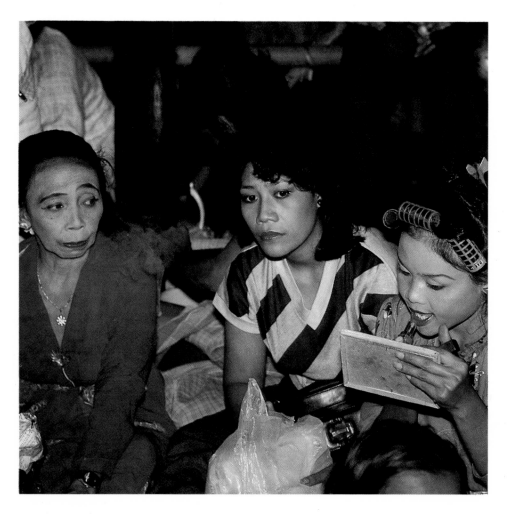

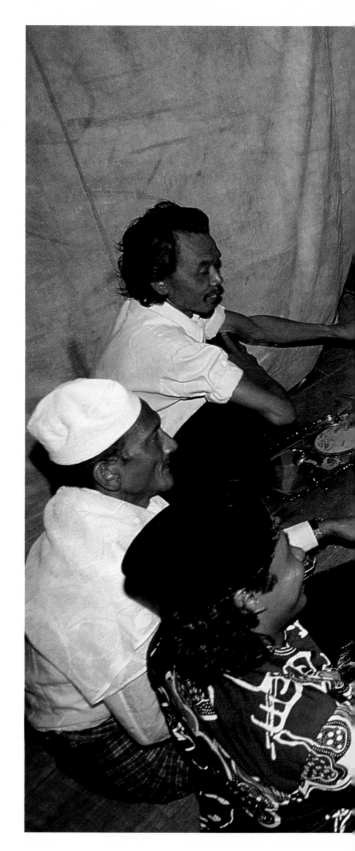

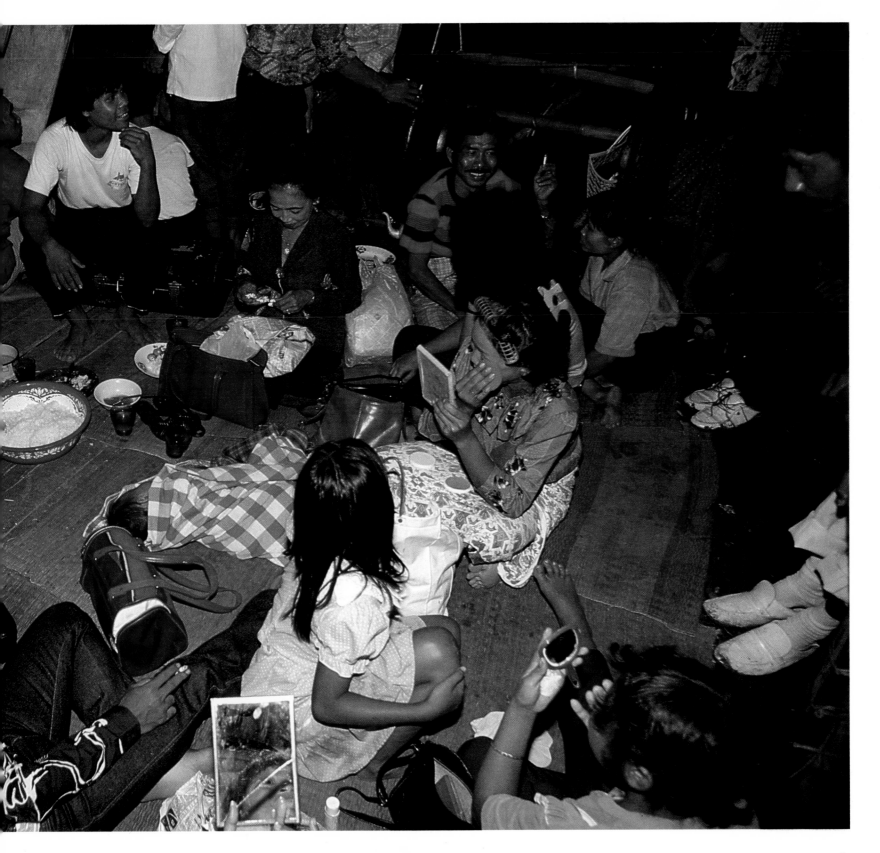

Miss Siti and Miss Nyami, the two leading ladies

The lenong *clown*

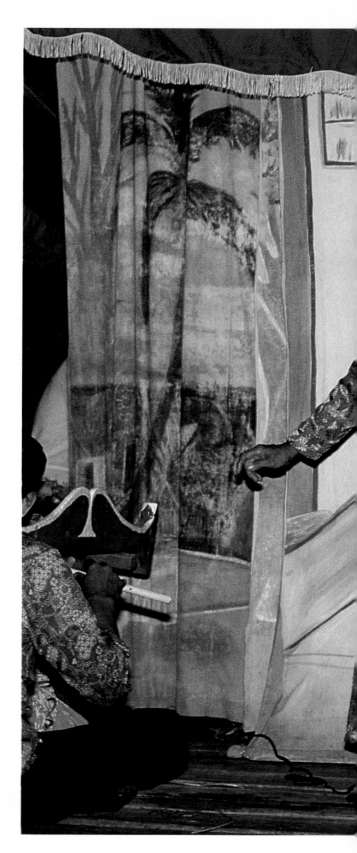

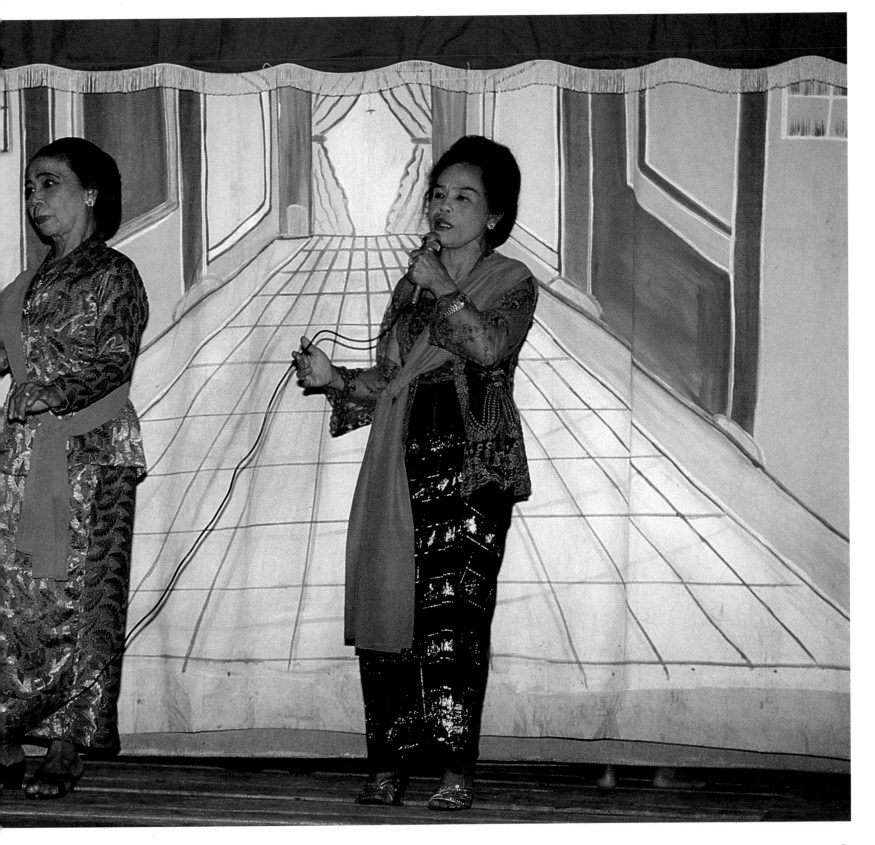

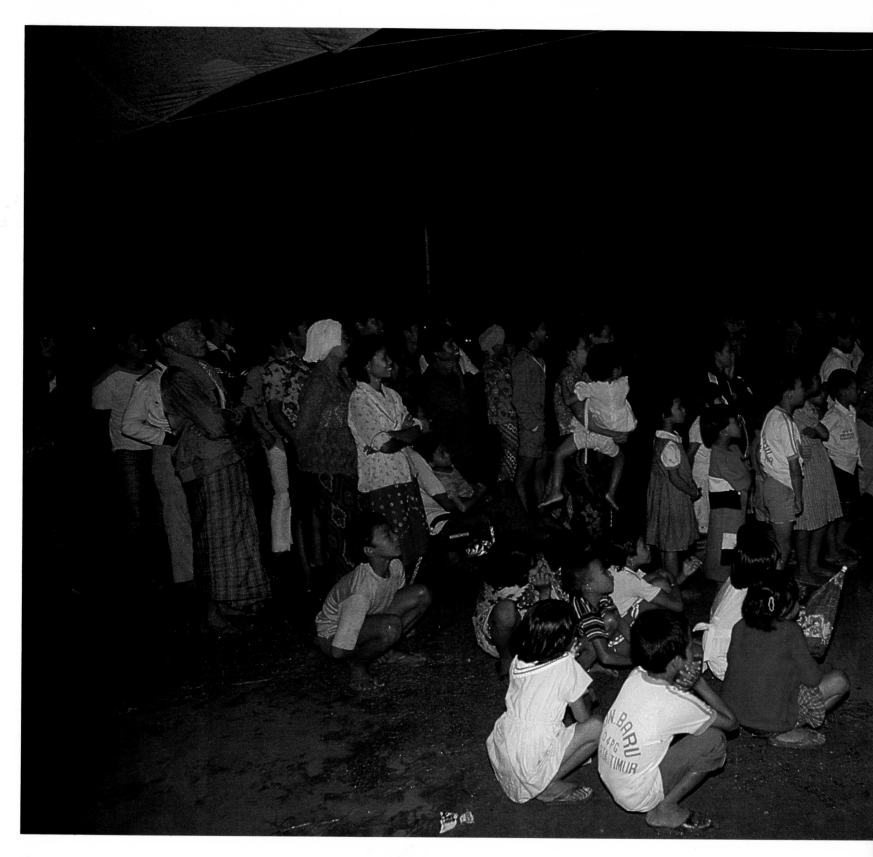

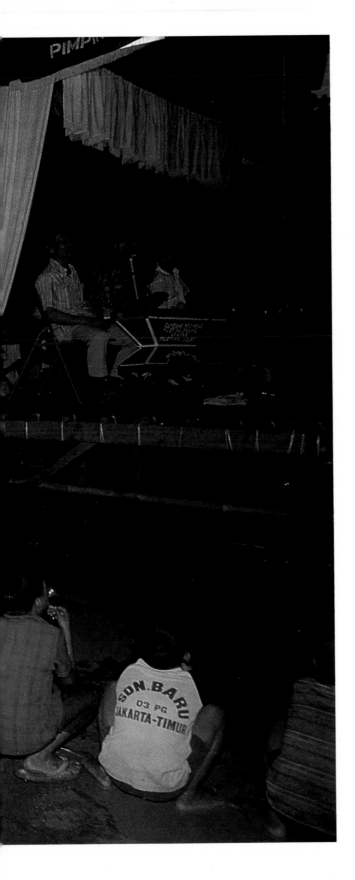

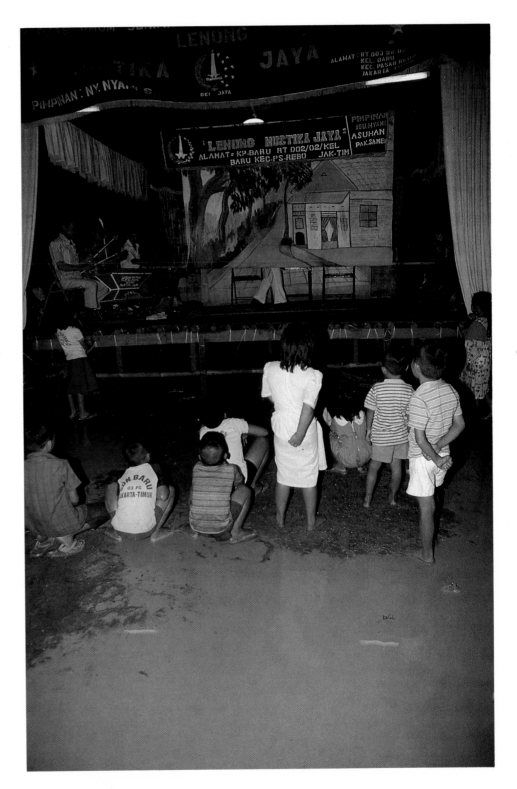

'The Awakening of Kresna'

Watching wayang, *Kadisobo*

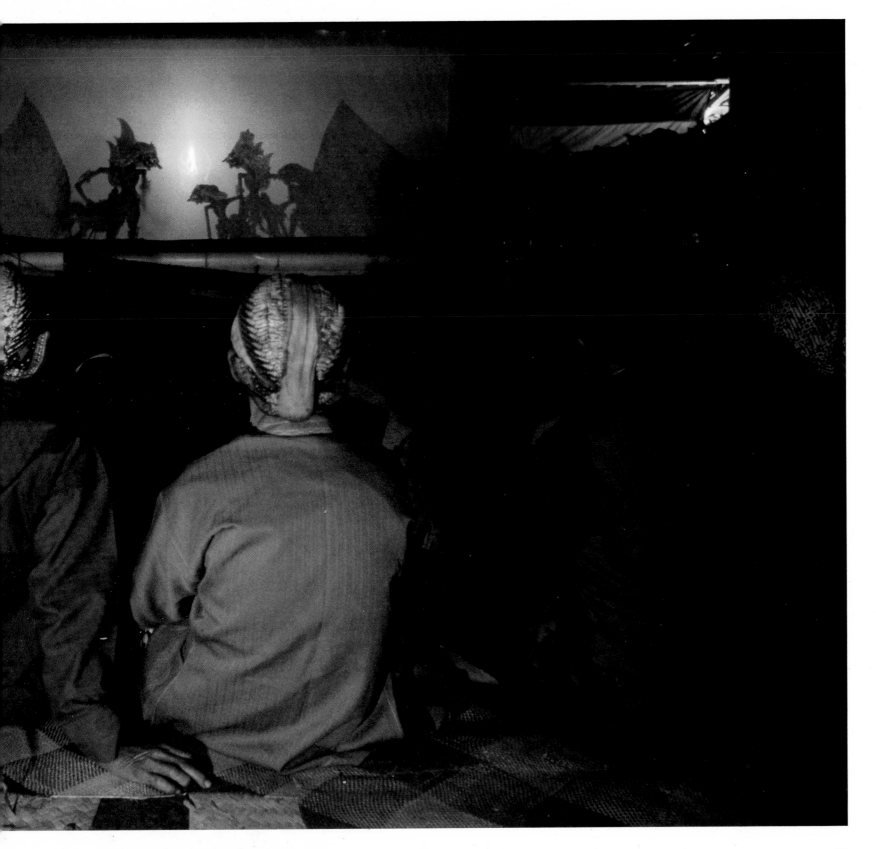

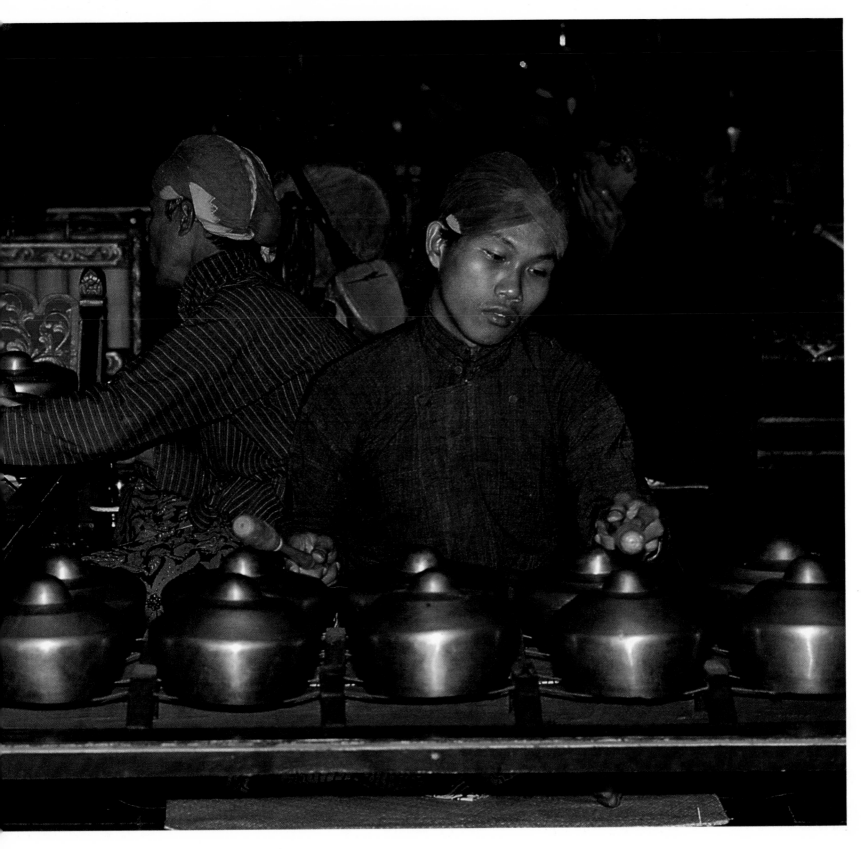

The wayang *musicians, Kadisobo*

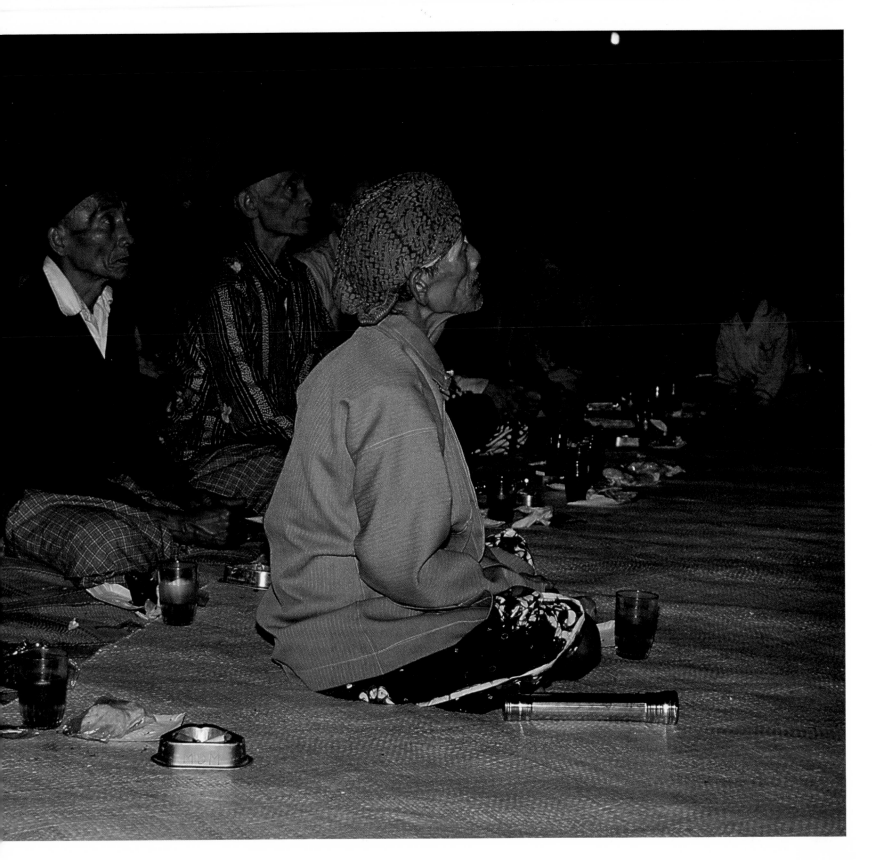

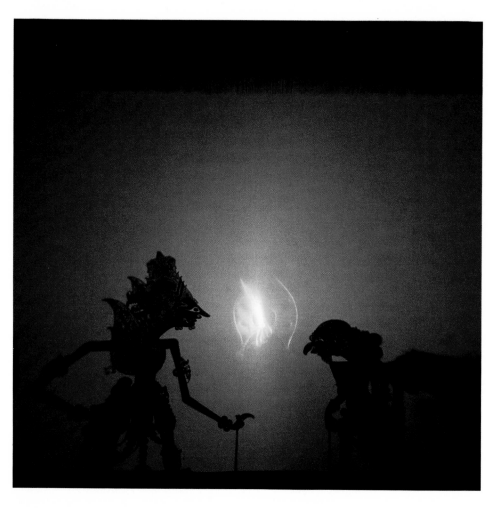

King Baladewa and Sangkuni, Kadisobo

Kadisobo: Hadisugito, the puppeteer

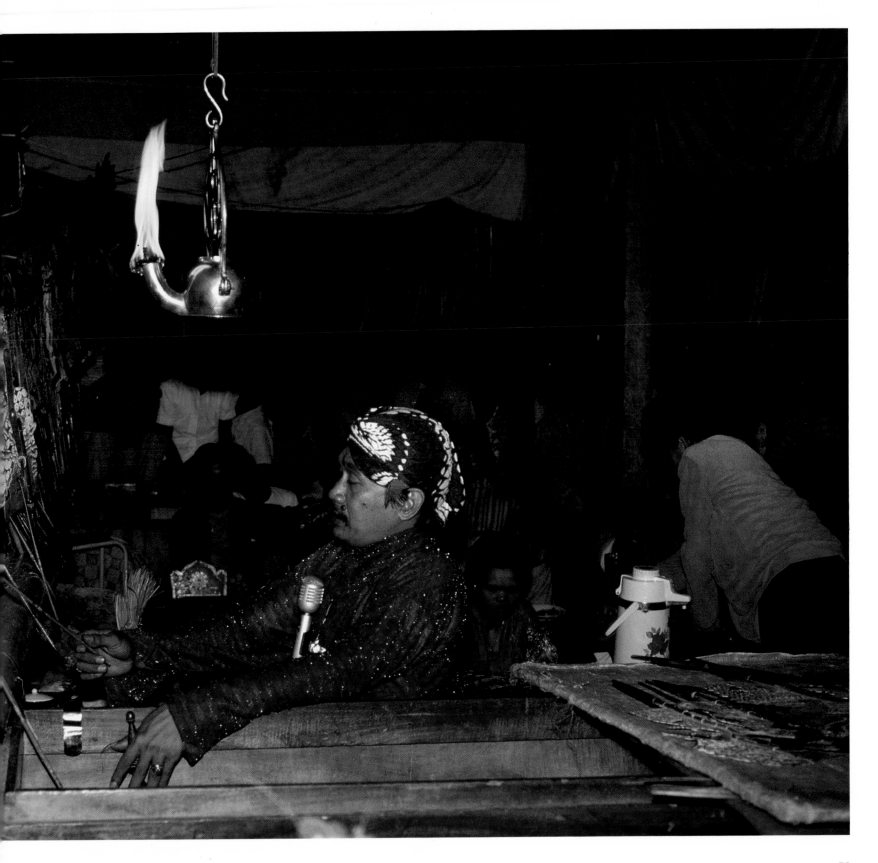

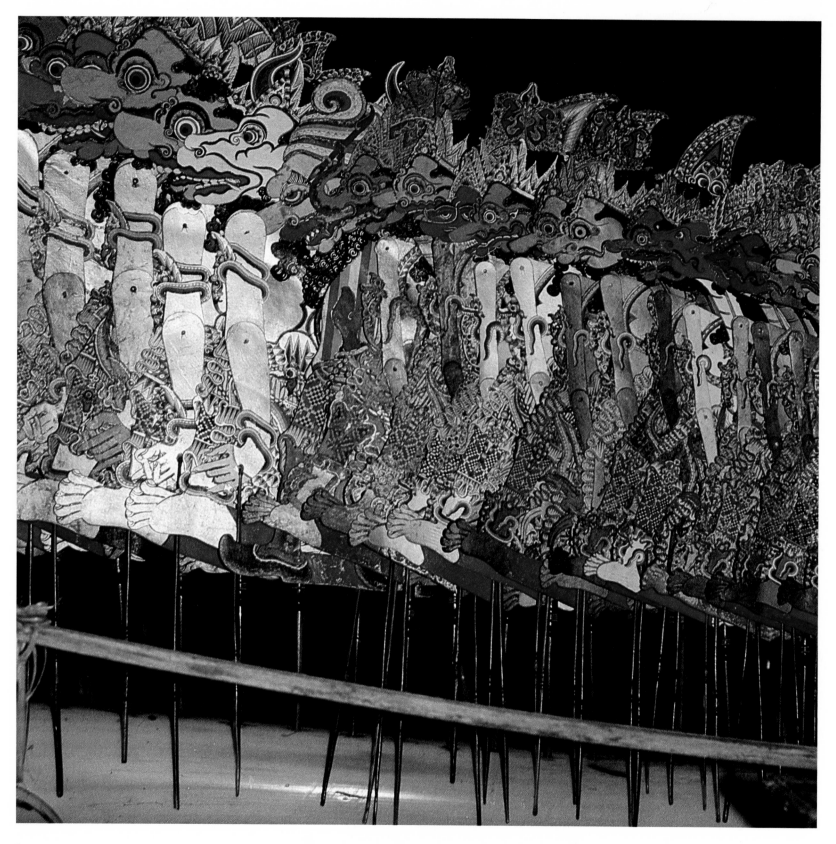

'The Awakening of Kresna'

Dusk has fallen upon the village. Soon evening will come, but so apparently will the rain. The gray cloud has been hanging menacingly since late afternoon and the village elders have hurriedly sent for the rain-chaser. Everybody in the house of the village head is anxious to see the *tulak udan*, the rain-chaser, do his job effectively. What will happen to our party if the rain can't be prevented from pouring down? mumbles one of the village elders.

The rain eventually does pour down, first in drizzles, then heavily, obviously disregarding the rain-chaser's intensive mumbling of his *japa-mantra*. The village elders' faces express despair and hopelessness. But, surprisingly, people come to the house in throngs, taking their places and standing patiently under their umbrellas at the front of the *pendopo*, the large open living room. And food vendors and toy sellers, wrapped in their plastic and rubber raincoats, stand just as patiently, shivering in rows under the line of lemon trees in the yard of the house, never giving up hope for eventual customers.

This night the tiny village of Kadisobo, located on the slope of Mount Merapi in the region of Yogyakarta, Central Java, will have the *bersih desa*, the village-cleansing ritual, and the *wayang-kulit*, shadow play, performance. The ritual has not taken place here in more than 10 years and has been anxiously awaited by many villagers. They feel it is especially important since new postponements of the long overdue ritual might result in disastrous consequences for the village such as drought, epidemic diseases, poor harvest, or flooding. The *wayang-kulit* performance is also eagerly awaited since the *dalang*, the puppeteer, for the night will be Ki Hadisugito, considered to be the most gifted and witty *dalang* of the region. And moreover, the *lakon*, the story, will be *Kresna Gugah*, *The Awakening of Kresna*, which has rarely been performed since it is considered to be a very demanding and sacred play. Nothing therefore seems more appropriate than having the *bersih desa* intertwined with the performance of *The Awakening of Kresna*.

* * *

Evil characters of wayang

THE BERSIH DESA

The Javanese consider each of their villages to be a complete cosmos where men, animals, vegetation, rivers, mountains, rice fields, and spirits are inseparable elements in sustaining the harmony of the cosmos. The village head, his assistants, and the village elders, of course, look after the welfare of the village, but the harmony of the elements of the cosmos requires a complete collective effort of the community, reflected in the prevailing value system as well as in the daily behavior of the villagers. The role of the extended family or the family network is therefore very important. Through this network social and cultural values cherished by the community are guaranteed to be implemented among the network's members. Birth, marriage, and death rituals are not only closely connected with the welfare and safety of the involved persons or family but with the whole village – the cosmos. The Javanese believe that failure in observing the cosmos' scenario will lead to disharmony in the village and disharmony eventually will expose the community to various kinds of disasters. Flood, poor harvest, volcanic eruptions, or epidemic disease among plants, men, or cattle are usually interpreted within the context of the community's obedience or disobedience to the prescribed value system of the cosmos.

The central source of worship, however, is sited in Dewi Sri, the rice goddess. It is she who guards and controls the whole cycles of rice planting throughout the season. Dewi Sri is believed in the traditional Javanese myth *Sri Sadana* to be the first person to plant rice, coconut, corn, chili, and eggplant in Java. Although the Javanese also believe in the *danyang*, the village guardian spirit, as another protector of the village, it is Sri whom the Javanese villagers respect most.

In the past, in every traditional Javanese home one could always find a small space in the rear of the living room with an offering consisting of a bunch of tied paddy, sugar cane, and coconut as a tribute to Dewi Sri and as a symbol of ever-present abundance. And when a farmer is about to participate in planting or harvesting, a small *slametan* (eating ritual) would be held in his home for Dewi Sri.

The *bersih desa*, the village-cleansing ritual, is also a tribute to the rice goddess. The ritual was customarily held every year since the Javanese considers it as a symbol of rebirth. On that day the village should make a fresh start by cleaning the whole village. Houses, ditches, and rice fields would be cleaned and repaired. Household *slametan* would be held. And a big village *bersih-desa slametan* ritual would be organized at the village meeting hall, usually followed and closed by a *wayang-kulit* performance with a special *lakon*, *Sri Sadana*, the myth of Sri. During this occasion Dewi Sri would dominate the scene as the main person to whom villagers begged forgiveness for past mistakes and blessing for future prosperity. The *danyang* as village guardian also got his due homage but his place wouldn't be as important as Dewi Sri's.

The *bersih-desa slametan*, whether big or small, consisted of the same kind of ingredients or elements. There would be cooked rice, spiced vegetables, dried fish, and hard-boiled eggs. All of these parts of the *slametan* would be neatly arranged on a big, round, woven bamboo plate. The plate, or plates, would then be placed in the middle of the room where the *slametan* would be held. Side dishes with more vegetables, bean cakes, meat, and fruits would also be placed near the big round plates. In the homes the *slametan* would be observed by the head of the family, his adult sons, and invited male guests. At the village hall *slametan* the number of invited guests would be larger with the village head acting as host. The ritual would be presided over by the village priest who would lead the audience in prayer. The prayer is a curious combination of phrases from the Koran and from Javanese sources, and homage is expressed to Allah, the prophet Muhammad, Sri the rice goddess, and the village *danyang*. After the prayers the guests would be invited to share the meal. The guests would then be given food from the *slametan* to take to their respective homes. Later in the evening people usually would come to the village hall to see the *wayang-kulit* performance, which lasted until dawn.

The *bersih-desa* ritual originated in ancient Javanese villages but obviously has been penetrated by foreign influences. Though Dewi Sri is a Hindu name, Dewi Sri in the Javanese rice cult is not a Hindu goddess. The legend *Sri Sadana* has always been considered as an autochthonous myth of ancient Java. But the prayers in Arabic and Javanese show how Islam was absorbed smoothly by the Javanese villagers into their traditional rituals. Islam, which entered Java in the 12th century, penetrated the island and gradually influenced the Hindu-Javanese culture synthesis that had dominated the island for centuries.

In villages where rice is the main staple and the major driving

force of the village economy, apparently the rice goddess became recognized as the source of protection to the small cosmos.

* * *

THE WAYANG KULIT

This is a unique kind of puppet show. The words *wayang* and *kulit* literally mean "shadow" and "leather," and appropriately it is a puppet show in which the puppets are made of leather. The unique aspect of the show is that the leather puppet is flat, not three-dimensional, and it is played in the evening against a wide screen where audiences at both sides of the screen can watch the puppets manipulated by the puppeteer in two fashions – on the bright and colorful side which is lighted directly from the oil lamp, and on the dark side at the other side of the screen. *Wayang kulit*, termed as shadow play, apparently is derived from the way *wayang kulit* is performed. Traditionally men watched the show at the bright side of the screen by the *dalang*, while women watched from the rear part of the *pendopo* at the other side of the screen, thus enjoying the original fashion of the play. The children – being children – frequently preferred to wander around between the men's and women's sides, and of course, among the food vendors in the yard of the house.

It has been speculated that long before the Hindu religion came to the archipelago at the turn of the 1st century, *wayang* was already known as a medium for ancestor worship among the Javanese. In addition to worshipping Sri the rice goddess, they also worshipped the village *danyang* and their ancestors' spirits. According to speculation, the ancestor worship originally took the form of listening to a storyteller relate the virtues and braveries of their ancestors to the family gathering. As it developed later, the storyteller would use pictures to add dramatic effects to his stories. And finally the worship was developed into a shadow play accompanied by a *gamelan* orchestra.

The *wayang kulit*, as it is known today, is said to have been given its latest development by the 18th-century artists during the reign of the Mataram kingdom of Central Java. It was also said that the richly carved buffalo leather got its elaborate ornamental touches from Islamic influences as a consequence of the religion's practice of transforming human and animal features into stylistic florid ornaments. The Hindu influence in the *wayang kulit* was obviously seen at repertoires or the *lakon* of the play. The *lakons* of the *wayang* are based on the great Hindu epics, the *Mahabharata* and the *Ramayana*. The influence and popularity of the two epics through the shadow play were said to have penetrated the life of the Javanese even deeper than that of the Indian. To the average Javanese villager's mind the two epics did not even take place nor have their actual setting in India but in Java. It would be no exaggeration to say that through *wayang* the *Mahabharata* and the *Ramayana* had become the basic Javanese world view. One scholar, Benedict Anderson of Cornell University, even talks about "*wayang* religion." The two epics, of course, had been thoroughly Javanized through much interpretation and reinterpretation. Many of the episodes would no longer be recognized as Indian stories. The most important protagonists of the epics, such as Arjuna, Kresna, and Sembadra from the *Mahabharata* or Rama, Sita, and Hanuman from the *Ramayana*, for instance, were transformed into Javanese cultural heroes whose character and behavior had become models or references in the Javanese daily life. Thus, Sembadra's behavior and her role as Arjuna's wife had become a model of loyalty and love for the Javanese husband.

In short, the *wayang* developed through the ages, over many generations and religious influences, from a medium for ancestor worship into an interpreter of Javanese culture. And while *wayang* developed from its status as family ritual into a community entertainment, it still retains its important function as linkage to the past. To the Javanese villagers, who see their village not just as a mere habitat but more as *jagad*, the cosmos, where everything in it is harmoniously linked and sustained, the *wayang kulit* has become an appropriate medium to bind the community together. A *wayang-kulit* performance in the village is, then, also an occasion for social gathering and an opportunity for the villagers to express their solidarity to the cosmos. In addition, the *wayang kulit* has grown from its function as an educational medium for the family into an educational medium in the community. When a particular family has a *wayang-kulit* performance, it also serves as a venue for reiterating the community's accepted values to the villagers. Thus when a wedding party in the village has chosen *Partakrama* (*The Wedding of Arjuna*) as a *lakon* for the performance, it also means that on that special night the host has given the community the privilege to reiterate, reconsider, and reflect on the virtue of Sembadra's unselfish loyalty and love of her husband, Arjuna. In an overpopulated world where people are crammed together into small patches of rice fields, what is more important than unselfish loyalty and love? And in many other repertoires of the *wayang kulit*, while enjoying the dialogue, the humor, and the music,

the community could also see, listen, and reflect on many important concepts and perceptions of power, state, war, love, hate, solidarity, and even practical hints for newly married couples on the arts of love and the tricks of organizing a household.

The *dalang's* role and status in the community are definitely very high and very important. In ancient times it was common belief that the puppeteer was a kind of priest who knew all kinds of *mantras*, prayers, and life stories of the ancestors. But contemporary *dalangs* enjoy high status due to their competency, artistry, and skill not only in manipulating the puppets but also in narrating and interpreting the whole *lakon*, sophisticatedly and humorously, from nine o'clock in the evening until half past five the following morning. To reach the virtuoso level of a *dalang* one must have had years of preparation. In old times the candidate had to be enlisted as an apprentice to an accomplished *dalang*. During his apprenticeship he had to do everything his *dalang*-teacher told him. The preparation didn't merely consist of formal training in manipulating a puppet, reciting the poems, singing the songs, and studying the dialogues, but also in "physical" training such as filling the bathroom with buckets of water from distant wells, washing the clothes of the *dalang*-teacher's whole household, and other very demanding and strange errands. Apparently all of these were meant as a kind of "total approach" in mental and spiritual training in the *dalang* world. Nowadays the government has established schools for prospective *dalangs* with complete curriculum and syllabus. And those who have passed the final exams at this school also receive diplomas. But this does not mean that all contemporary *dalangs* have gone to the *dalang* schools and have had formal training there. Many of the most popular and sought-after *dalangs* are those who had their training through old-style apprenticeship. And actually these *dalangs* are still the most highly esteemed due to their recognized style in manipulating the puppets and in narrating the story. This does not necessarily mean that the younger, modern *dalangs* would have less chance to develop some day into "super-*dalangs*." The superiority of the old-fashioned *dalangs* probably lies in the fact that they have been "in business" longer, travel more extensively, have met more people, absorbed more ideas, and evolved a recognizable style through many hours of experimentation. Some observers also have said that the superiority of the old *dalangs* lies in the way they perceive their role within the community and the way they perceive the *lakons* and the puppets; accordingly they are considered to be more serious and diligent than the younger ones in paying attention to and studying the classical Javanese literature. Their narrative

style is regarded as being "clean," "uncluttered," and "literarily sophisticated." The old *dalangs* also tend to see *lakons* more as educational, rather than mere entertainment material. They would be inclined to take on the "heavy" *lakons*, which are considered as being sacred and difficult to execute due to the esoteric content of the dialogues. In accepting such assignments the *dalang* might need extra days prior to the performance to fast, to refrain from sexual intercourse, and to isolate himself in his room to meditate or reflect about the *lakon*. The highly philosophical *lakons* such as *Dewaruci (Bima's Self-Discovery)*, *Makuta Rama (The Crown of Rama)*, *Dewa Amral*, *Kresna Gugah (The Awakening of Kresna)*, *Sri Sadana*, and many episodes of the last battles between the Kaurawas and the Pandawas, the *Bharatayudha*, would fit the "heavy" category. Many *dalangs* and villagers believe that careless treatment of the more sacred *lakons* would result in unforeseen calamities such as the sudden death of the *dalang*, food poisoning, possession of the audience by spirits, and so on. While the *dalang* is preparing and cleansing himself, the host who has chosen the particular "heavy" *lakon* must also make a special offering to the spirits of the *wayang* protagonists, to the spirit of the *danyang* and, of course, to Dewi Sri who is ever present in protecting the village and the rice fields. But "non-heavy" *lakons* are in abundance. Delightful, romantic, satirical, and humorous *lakons* such as *Rosotali-Taliroso*, *Partakrama (The Wedding of Arjuna)*, *Petruk Dadi Ratu (Petruk, the Clown Coronated as King)*, *Sembodro Larung (The Abduction of Sembadra)* and many others. Usually people would prefer to see these "non-heavy" *lakons* rather than the "heavy" ones. Accordingly, Javanese *dalangs* and audiences have over the years managed to develop appropriate *lakons* for appropriate occasions.

* * *

THE GAMELAN

Another decisive factor in the *wayang kulit* is, of course, the *gamelan* music. The Javanese word *gamel* means a special kind of tool which functions as a hammer, which indicates the percussive character of the *gamelan* musical instruments. According to the Javanese traditional belief, the first *gamelan* orchestra, the Lokananta, was built by Batara Guru, Lord Shiva, who according to the Javanese did not reside in Himalaya but at the summit of Mount Lawu at the border of Central and East Java. The first *gamelan* orchestra consisted of only five types of instruments, the big gong, the

kemanak, the *ketuk*, the *kenong*, and the drum. The modern Javanese *gamelan* orchestra consists of two sets of 25 types of *gamelan* instruments. With the exception of the rebab violin, all of the *gamelan* instruments are percussions and are made out of bronze. Each set of the *gamelan* represents a tuning system, namely the *slendro* and the *pelog*. The *slendro* has five scales of tones while the *pelog* has seven tones. Both *slendro* and *pelog* are used in accompanying *wayang-kulit* performances although certain regions have their own preferences in using the tone scales. The coastal areas, for instance, prefer the *pelog* scale over the *slendro*, while the interior regions of the court cities of Yogyakarta and Surakarta prefer the *slendro* scale. Of course during a night performance in either region both scales are played with different emphases. Here again the role of the *dalang* dominates over the other members of the group. It is up to him to decide which scale, which song, which singer is to be put forward during a particular stage of the *wayang-kulit* performance. Nartosabdo, one of the most popular wizard *dalangs* in Java today, will hire seven prima donnas and order them and the musicians to work very hard singing and changing the scale from *slendro* to *pelog* and back again.

* * *

But Javanese villagers have changed. The urban life style has penetrated the village and the village is no longer a culturally "isolated identity." The Javanese cosmos is no longer homogeneous. The nation's economy has embraced the villages into its dynamism and Java and her villages are now very much involved in the process of shaping the new Indonesian culture. As a consequence of this new impetus the *wayang kulit* also has experienced changes. First, it is growing increasingly entertaining and "kitschy" rather than educative although one would find it difficult to draw a sharp line between the two aspects of *wayang kulit*. The audiences, especially the younger ones, prefer lighter *lakons* rather than the heavy ones. Moreover, the younger generation is becoming more and more attracted to modern pop and rock music, and, of course, also to films. Second, a *wayang-kulit* performance is getting very expensive to perform due to the increased exposure of the villages to the integrative national (money) economy. In the old times a *wayang-kulit* performance could be done through mutual help, *gotong royong*, of the villagers and only partly had to be paid in cash. Today everything must be paid in cash. The consequence of this change is that the *dalang*, in many cases, has also turned into producer of his own show. Many

of the first-rate *dalangs* now have their own *gamelan* orchestra and full-time singers, their own set of puppets, and even their own sound system, truck, and minibus. One or two *dalangs*, supers like Nartosabdo or Anom Suroto, come in their own deluxe private cars. Nowadays a super-*dalang* charges the host two to three million rupiah for the complete "package." This phenomenon has already had its impact on *wayang-kulit* performances in the village. Since only the very rich can afford the fees of a superior *dalang*, fewer and fewer villagers can enjoy good *wayang-kulit* performances. Instead, since most of the wealthy Javanese now live in cities, they have access to the best *wayang-kulit* performances. As a result, there is a tendency now for villages to become estranged from *wayang-kulit* performances and to turn to radio cassettes for their wedding parties, circumcision parties, and other occasions. Eventually, people may no longer be able to see the *wayang* but only listen to and imagine their cultural heroes through the radio.

With this "identity crisis," there is a question of whether the traditional *wayang* protagonists still function as cultural heroes for the villagers.

* * *

Kadisobo is more a hamlet than a village. It has only a population of about 800. Though the land is fertile, the tiny pockets of rice fields barely sustain and feed its 800 inhabitants. This may explain why the hamlet has not held a *bersih desa* for about 10 years. *Bersih desa* is, after all, expensive to organize. The *slametan* alone costs about Rp. 500,000 and another Rp. 1,000,000 is required for the *wayang-kulit* performance. Moreover the villagers are not as fanatical about the ritual (the hamlet is now practically within reach from the highway and the city of Yogyakarta, has a high percentage of school children up to high-school level, and a large number of commuters who work in the city – in short, the hamlet is not a "culturally isolated" place). Yet the village wanted to have a *bersih desa*, especially in view of its high percentage of jobless youth and other features of the economic slump. Thus, a *bersih desa*, a moment of total village cleansing and reflection at the *slametan*, and an appropriate choice of one of those serious and sophisticated *lakons*, has become relevant and meaningful to its people. By revitalizing the ritual, they hope to create a new atmosphere of optimism and hope in the hamlet. For the older, more traditional generation, the decision to have a *bersih desa* is a source of relief.

* * *

The *talu*, the overture of the *wayang-kulit* performance, has started. The *dalang* has taken his seat right below the flickering *blencong*, the ingenious oil lamp that gives the shadowy effect to the puppets on the other side of the screen. He nods his head to his musicians and singers, gesturing that the performance is about to start. Slowly and majestically he pulls off the *gunungan*, the tree of life, from the horizontally laid banana tree trunk that holds all the puppets for the show. And thus starts the story of the *Awakening of Kresna* . . .

A floating rumor had been widespread for quite some time among the Kaurawas and the Pandawas: Lord Kresna had disappeared! He had not been seen sitting on the golden throne receiving his routine audience; he had not been seen reviewing the troops at the palace square; he had not been seen entertaining himself in his wives' quarters; he had not been seen leading a hunting party in the forest, and finally he had not for quite some time visited his beloved cousins, the Pandawas, at Indraprastha. These phenomena were considered odd, and people began to speculate. If Lord Kresna, who was none other than the God Wishnu himself, the God of nature's harmony, began to disappear from sight, there must be serious reasons. Would that be a bad omen or good sign? Would there be a natural calamity? Bad seasons, bad harvest, volcanic eruptions, epidemic? And where did he go?

Apparently Kresna didn't go anywhere. He slept, or at least appeared to sleep, in his private garden, accompanied or guarded by his brother-in-law Setyaki and son Samba. When the Kaurawas and Pandawas found out about the actual situation, they rushed to the scene. But Kresna's soul had secretly gone to heaven for a special meeting at which the gods would decide on the fate of the forthcoming war between the Kaurawas and Pandawas. Kresna wanted to know about the gods' death and survival lists, so he turned himself into a very small flea, and entered the conference room.

In the meantime the Kaurawas and the Pandawas gathered in his garden and sat by the feet of the sleeping Kresna. They believed that those who could wake up Kresna would appear victorious in the Bharatayudha, the forthcoming war between the Bharata kin. The Kaurawas started first. All the 100 brothers tried with all their might to wake up Kresna. But Kresna just looked as sound and serene in his sleep as before. None of the Kaurawas knew, of course, that Kresna's soul had gone to heaven. Only Arjuna of the Pandawas, brother-in-law of Kresna, knew what was really going on. He meditated and then flew to heaven to fetch his brother-in-law.

The gods meanwhile were in the middle of the conference and had begun to verify the death and survival lists of both parties who were going to wage the war. Kresna diligently kept his notes until the gods finally discovered that he had disguised himself as a flea. Though the gods were very angry, it was too late, for the list had already been made up. And Kresna had kept his notes. He was the only mortal on earth who knew the full scenario of the coming war. But the gods then ruled that Kresna would be forced to abandon his kingdom and troops if he decided to side with the Pandawas. He would also have to return to the gods his two most precious belongings, the eternal flower Wijayakusuma which had the power of bringing dead people back to life and the almighty Cakra weapon against which no mortal on earth could stand.

Kresna reluctantly had to give in. After all, it was the gods who asked it of him, and also he had to admit that he had committed a serious crime. But Kresna, who was Wishnu, the God of harmony and equilibrium, must know about the details of the coming war between the evil Kaurawas and the good Pandawas. Which, for instance, would be the evil ones among the good Pandawas who should die and which would be the good ones among the evil Kaurawas who should be spared? Kresna the mortal being was aware that it was not his jurisdiction to know all about it. But Kresna as reincarnation of God Wishnu had a duty to know it. Otherwise who would keep the cosmos' equilibrium?

Finally Arjuna met Kresna in heaven and persuaded him to return to earth.

* * *

It is dawn. The rain has been over since about 3.00 a.m., and the first soft sun rays can be felt penetrating through the lemon trees in the yard where the food and toy vendors are sound asleep. The children too are asleep among the *gamelan* instruments. The rest of the audience, mostly old people, sip their morning coffee and try to digest the last words of the *dalang*. When finally the *dalang*, slowly but still majestically, puts the *gunungan*, the tree of life, back in the middle of the screen, everybody knows it is the end of the *bersih-desa* ritual. People yawn, stand up, and start to walk back to their respective homes. One or two hours later they will have to work in their rice fields again. But the village has been cleansed . . .

'The celebration of Arjuna'

In southern Bali, a region of lush vegetation, terraced rice fields, winding roads, and the sounds of *gamelan* music, the appearance of Banjar Sangging at Kamasan, Klungkung, couldn't be more misleading. The hamlet, which consists of 87 households, looks more brown than green, with its few garden plots inadequate for planting rice. The village is flat and quiet, except for the occasional crowing of a fighting cock or a silversmith's hammering. It is not an ugly village but it comes as an anticlimax after the breathtaking view of the rice-terraced villages in the Bukit Jambul area about 15 kilometers away.

The name Banjar Sangging means a hamlet of painters, and the village is indeed one of artisans and artists. Of the 445 inhabitants, 50 are gold and silversmiths while 142 are painters. The village has been a habitat of artisans since the 17th century, when the kingdom of Gelgel had its heyday. At that time, Banjar Sangging served as a kind of artisans' guild, consisting of homes and workshops where the inhabitants lived, worked, served, and died. The king was seen as *dewa-raja* (god-king), whose duty was to ensure that the cosmos was kept in balance and harmony. Since the arts were considered an important element in maintaining this harmony, it was the role of the ruling class to protect and nurture the arts.

When Gelgel's site of power moved to Klungkung, about five kilometers away, the village of Kamasan and the Banjar Sangging retained their artistic status. Today, however, with Klungkung reduced to a regency or county capital of the province of Bali, and the descendants of the king and other nobles serving as officials of the republic of Indonesia, Banjar Sangging is no longer the village of the "king's artisans." *Maecenas*, traditional patrons of the arts, have gone from the Klungkung area. And yet the artisans of Sangging still produce the very things that made the *banjar* famous – the beautiful, traditional *wayang*-style paintings and delicate, ornamented silver and gold bowls. Furthermore, the existence of 192 full-time artisans in a village of 445 suggests that there are still enough customers, though they are no longer called *maecenas*.

Since the abolition of the aristocratic system, members of the new ruling elite have become the patrons of the arts. High-ranking officials at the provincial and county levels now commission Kamasan painters to do works for their offices and homes. With the increase in tourism, art and souvenir shops have also come to recognize the lucrative potential of Kamasan paintings, and are buying and commissioning paintings from Sangging.

* * *

Though the Hindu caste system is not as rigid in Bali as in India, society here is divided into *brahmana* (the priest), *ksatria* (the warrior), *waisya* (the trader), and *sudra* (the laborer). Upward mobility between the castes through marriage is possible only after long and delicate negotiations between the family networks. A special, sacred ritual must be observed when the future wife is being elevated from a lower to a higher caste. However, if the husband comes from a lower caste than the wife, she must be lowered to his caste – and is even declared an outcast. Otherwise, most Balinese remain confined to their own castes. Despite the division in the castes, however, individual members are free to pursue any profession or formal training other than the priesthood, which is limited to *brahmanas*.

Sangging is predominantly *sudra*, the caste of artisans who have inherited their craft from their forefathers in an uninterrupted succession since the founding of the hamlet. Just as Sangging has been a *sudra* hamlet, so its arts have been practiced communally.

Kamasan painting – like the growing of rice – has traditionally been a collective family enterprise. Since the paintings were always commissioned by a higher caste, they were considered a prestigious task for the lower, *sudra* caste, and one worth the entire family's reputation. Just as any diligent farmer would use every available hand for the farm's management and cultivation, so the Kamasan painters organized their whole families to meet the demand for a new work. Grandmothers would wash and straighten the canvas; mothers would do the composition and coloring, including the meticulous detailing of leaves, trees, hairdos, and clouds; fathers would do the sketching, give the essentials of the story through the detailed facial expressions of the characters, and add the finishing touches; and children performed the chores as part of their apprenticeship before becoming specialists themselves. Grandfathers were usually exempted from

the painting, since they either worked as silversmiths or looked after their fighting cocks. When members of the family were ill or lacked the expertise in a particular job (usually sketching or detailing), it would be given to a close relative – almost never to an outsider. After the painting was finished, the entire family would act as salesmen for it. Today, if the family chooses to peddle its work at the marketplace or to tourist spots in Klungkung, the children or women will do the job. But if customers come directly to Sangging, the father conducts the business.

* * *

Nyoman Mandra, 38, is now perhaps the most famous and sought-after Kamasan-style painter. His paintings have been bought by international collectors and exhibited in European museums and galleries. His style is considered as most *halus*, refined and sophisticated, uncluttered with unnecessary details, and very clear and straightforward in expressing the message in his paintings. The traditional Kamasan style is also called the *Wong-Wongan Kamasan* or *Wayang Kamasan* style, which means that the paintings imitate figures from the *wayang*, the shadow play. Mandra's paintings could be considered both traditional and modern. He is traditional in his faithfulness to the classical *wayang* themes and style of depicting the figures decoratively in his paintings, and in still using local raw materials such as stones and leaves for his paints. The only imported materials he uses are the canvas and Chinese ink for his black colors. At the same time he is modern in that he is the only traditional painter in Sangging who does his paintings completely alone and not collectively.

In view of Sangging's historic tradition, Mandra's insistence on working alone is extraordinarily modern. A true individualist, perfectionist, and master of detail, he almost invariably refuses any interference in his work. Only on very rare occasions, for instance, when one of his relatives is out of work and needs financial help, will he let him do a small part of one of his paintings. Otherwise Mandra is the solitary painter of Sangging. This attitude doesn't necessarily mean that Mandra is an asocial person who stands aloof, distant from his immediate environment, or indifferent to village affairs. Nothing could be more misleading. Mandra is still an active member of the community, helping other painters finish their paintings, and participating in all compulsory village rituals, such as the *odalan*, the anniversary of a temple; the *nyepi*, the Hindu New Year when practically all activities in Bali come to a standstill; the joyful and festive *galungan*, a day to commemorate a victorious battle; and of course the *ngaben*, the day of cremation. On all those days he acts as a regular member of the *banjar*, the hamlet, the homogeneous cosmos. He puts aside his homemade brush, pen, and paints, and lets himself be absorbed in the series of activities. When the village temple, the *pura*, has needed a new painting, he has readily given it as a present.

Obviously Mandra's attitude as an individualistic painter does not reflect his attitude as a member of the village. Even his effort to establish a painting workshop for children where he "indoctrinates" his pupils to paint and work individually still reflects his strong community solidarity. Every morning, in his house, one can find him sitting patiently by a pupil's chair helping the child to do a sketch. In the meantime, if another artist interrupts and asks Mandra to help with a detail or a finishing touch for his painting, he will usually smile and put aside some time to satisfy the request. To everyone in the hamlet he gives his time and willingness to help. But for his own work he is a self-demanding and disciplined painter. To understand this rather contradictory attitude one should examine further the place and role of Kamasan paintings in the community and the present condition of the community itself.

* * *

A customer once asked Mandra to paint an ordinary landscape – the "flora and fauna" of his village – if necessary, in *wayang* style. After several months of frowning, pondering, and sweating, Mandra gave up, and returned his advance payment to the customer. According to Mandra, the assignment was impossible to execute. No matter how hard he had concentrated on a "contemporary concrete object" such as a Balinese cow or pig, the *wayang* figure or other traditional imagery were all he could see on the blank canvas.

The themes and episodes of the Kamasan-style paintings are usually taken from the *Ramayana* and the *Mahabharata* epics, the *Suthasoma* tales, the *Brayut* local tales, and the Javanese *Malat* stories. Favored themes from the *Ramayana* include the fight between Jatayu and Rahwana, the fall of Rahwana, the fight between Hanuman and Indrajit, the purity test of Sita, and the Negasari garden scene where Hanuman acts as Rama's messenger to Sita. From the *Mahabharata* there is the *Adiparwa* series that depicts the creation of the world and the emergence of the important kingdoms of the Bharata family; *Arjuna Wiwaha*, the celebration of Arjuna; *Bima Swarga*, in which the gods show Bima

heaven and hell; *Bisma Gugur*, the death of Bisma; *Abimanyu Gugur*, the death of Abimanyu; *Swarga Rohana Parwa*, the ascension of the Pandawa to heaven; and *Suthasoma*, in which Suthasoma is sacrificed to a tiger.

Unlike Muslim Java, in which *wayang* stories are no longer closely intertwined with formal religious life, Hinduism is a living community religion in Bali, and *wayang* stories are incorporated and absorbed within the religion's practice and ritual. The *wayang* stories are similar to those in the Javanese *wayang kulit*. As depicted in paintings and on temple reliefs, they are venues for the strengthening of the community's religious and social values. As with other community arts, the *wayang* stories do not function as an individual expression but as an expression of the community's values. The throngs of people who watch the show or listen to the poems being recited are there to be among the community and to demonstrate the strength of the community spirit.

Thus when throngs of people crowd around a newly finished painting by Mandra, Mudalara, or Pan Seken and exclaim their typical "*beh, beh, beh . . .*" it should be understood within this context. They have come to ascertain whether their understanding of the accepted values in the society still corresponds with the interpretations of the community artists. They do not come to "see" a painting as modern city-dwellers do when they attend exhibits. They come for a few minutes to "check," and after "*beh, beh, beh . . .*" they go away. They stay longer by a painting if they spot new and strange things in it which are considered alien to the familiar values or the system. Then they might not say "*beh, beh, beh . . .*" again. They might linger on for a while, demanding an explanation from the painter and making a fuss with their fellow villagers, because something new and alien (and probably ugly-looking too) has arrived in their midst, among their familiar belongings and properties. This might happen to a famous and respected painter such as Mandra or Pan Seken if he paints an entirely new version of a theme — even if the theme is taken from the *Mahabharata* or the *Ramayana*. Since the chosen themes from the two epics correspond with the cherished values of the community, any new approach which does not correspond with the accepted values risks severe criticism from the community.

From this perspective, it is understandable why Mandra failed when he attempted to paint a subject unrelated to the *wayang* stories and local tales and legends.

* * *

But Sangging is not untouched by change. Despite its relatively isolated position off the main tourist road and its lack of attractive, lush vegetation, green rice fields, rivers, gorges, and temples, the hamlet cannot escape the tentacles of tourism. Even its long commitment to the traditional community art of *wayang*-style painting has not been strong enough to keep Sangging free from change.

We experienced the impact of tourism in the way traditional Sangging painters have accommodated themselves to the demands of peddlers from the art and souvenir shops — the so-called new *maecenas*. Formerly, commissioned paintings had to meet a rigid standard of quality. The paints, except black, had to be produced from local materials to give the right shades of colors to the delicate *wayang* composition. The sketching and blocking of the *wayang* characters had to be done in a delicate, refined way. Consequently, the paintings took months to finish because the painter's prestige and the family's name were at stake. But the new *maecenas* are an entirely different breed. They are in a hurry to sell, and they want their painters to work to a much faster tempo and delivery schedule. The new *maecenas* are not interested in difficult themes embodied in the *Adiparwa* series or the *Bima Swarga* — themes that deal with complex and esoteric concepts involving gods, heaven, and hell. The new patrons are more interested in lighter themes with which they hope to attract and delight the tourist. They feel that subjects such as *Arjuna Wiwaha*, the celebration of Arjuna, attract more buyers due to the bright colors and vivid scenery and the beauty of the seven angels who try to tempt Arjuna during his meditation in the forest. At first the painters hesitate and probably even shudder at the thought that they must switch to an entirely different tempo and different techniques, and will not be using their customary paints. But then traditional painters, like peasants in the contemporary Indonesian economy, need extra income. They not only need income to pay for their participation in traditional social rituals (even though these have become fewer and less elaborate) but also for their participation in contemporary living and education. The children are growing up and they demand more education in the cities. So, the painters are ready to accommodate the wishes of the new patrons. They even agree to receive advance payments for their commissions. But Nyoman Mandra and Pan Seken are exceptions. They refuse to accommodate the demands of these new patrons. They prefer to stick to their old way of painting and their old tempo. They still use traditional paints and they refuse to have anyone dictate the delivery time to them. This attitude has made them bonafide painters for serious collectors and patrons but not very popular among the art shop peddlers. Even Mandra and Seken, however, now make concessions when the customer asks for a given theme.

The second impact involves Mandra's workshop for young schoolchildren. From Mandra's point of view the workshop he is organizing is his contribution to the community. He is aware that the community's main income is from the Kamasan paintings. At the same time he is also aware that too many youngsters in the village drop out of elementary school for financial reasons. Mandra, who considers himself lucky because he has finished junior high school (and therefore is regarded as a leading local intellectual), wants to help by providing the youngsters with skill in painting according to the traditional style. He also hopes that by acquiring the skill the children can continue their schooling and pay for their own education through their paintings. And should the parents want their children to stop their education they would have at least mastered a minimum degree of painting skill. To finance this workshop he receives some help from the government and pays the rest from his own pocket. The impact of Mandra's noble enterprise is obviously very positive. Parents send their children after school to Mandra's house to join the workshop where he and his assistants patiently and diligently teach the children.

And yet there is a question of whether, in the long run, the workshop will have a positive impact on the community's economic structure. Since Mandra's workshop has created a new breed of skillful — probably much more technically skillful — artisans, what will happen to the old specialists whose work has been like a quilt to which all contributed? Will the new breed of painters tolerate them? Will the new breed also contribute to the community's artistic endeavors? Or will they follow their guru's philosophy to work solitarily and independently? It is rather hard to predict. Though they might still be respected by their direct kin, once these older generations are gone it is hard to imagine the paintings occupying the same traditional position as community art. Henceforth, it is easier to imagine a community of skillful artisans working competitively on traditional themes that have evolved over the generations. But by then won't they dare to change the themes of the paintings? This again depends on many factors: on the tourism industry and its dynamic and aggressive infrastructure; on how the younger generation of Balinese view social change; and on their perception of the community rituals.

* * *

Mandra has just completed a large canvas for a customer. It shows an episode from the *Ramayana* in which Rama refuses his half brother's appeal to return from banishment and rule the kingdom. Rama refuses because the banishment was his father's vow to Rama's stepmother when he asked his stepmother to marry him. And a vow from a king should not be revoked because it would only degrade the aura of the king. Instead of returning home, Rama asks his stepmother Bharata to rule the kingdom until he has completed his banishment in the forest. Rama then teaches Bharata the eight rules to become a good and successful ruler. These rules represent the character of the eight gods. According to the teaching, a ruler should at one time behave like Baruna, the god of the sea, who is broad-minded and full of forgiveness. Another time he should behave like Agni, the god of fire, who can mercilessly burn out a whole forest. At another time he may behave like Kartika, the god of stars, who prefers to be distant and beautiful.

According to Mandra, the customer does not know *wayang* stories since he is not a Balinese nor a Javanese but a Sumatran. Mandra has chosen the theme because he likes it and hopes that the customer eventually will grasp the wisdom of Rama's teaching. Mandra has also completed another large canvas, this time for a high-ranking provincial official of Bali. Here again, the customer let Mandra decide the theme of the painting. This time Mandra has chosen the last episode of the *Mahabharata*, the *Swarga Rohana Parwa*, which depicts the last journey of the five brothers Pandawa on their ascent to heaven. Only the oldest of the five brothers, Yudishtira, reaches the gate of heaven, bearing his white dog. When the gatekeeper denies entry to the dog, Yudishtira refuses to enter heaven. He insists that he and his brothers, his wife, *and* the white dog be admitted together; otherwise he would prefer to stay with his brothers in hell. Finally the gods grant Yudishtira's wish.

Mandra's strategy in choosing the theme is obvious: he wishes the high official to remain loyal and to keep his solidarity with his low-ranking colleagues and the common people.

From these instances we can see how basically traditional Mandra is in perceiving his paintings. He is still a true believer in their function as an important venue for communicating social values. Though he might be "modern" in his technical execution of the painting, he is still the traditional *sudra* from Sangging in the way he perceives the emotional and spiritual aspects of the painting.

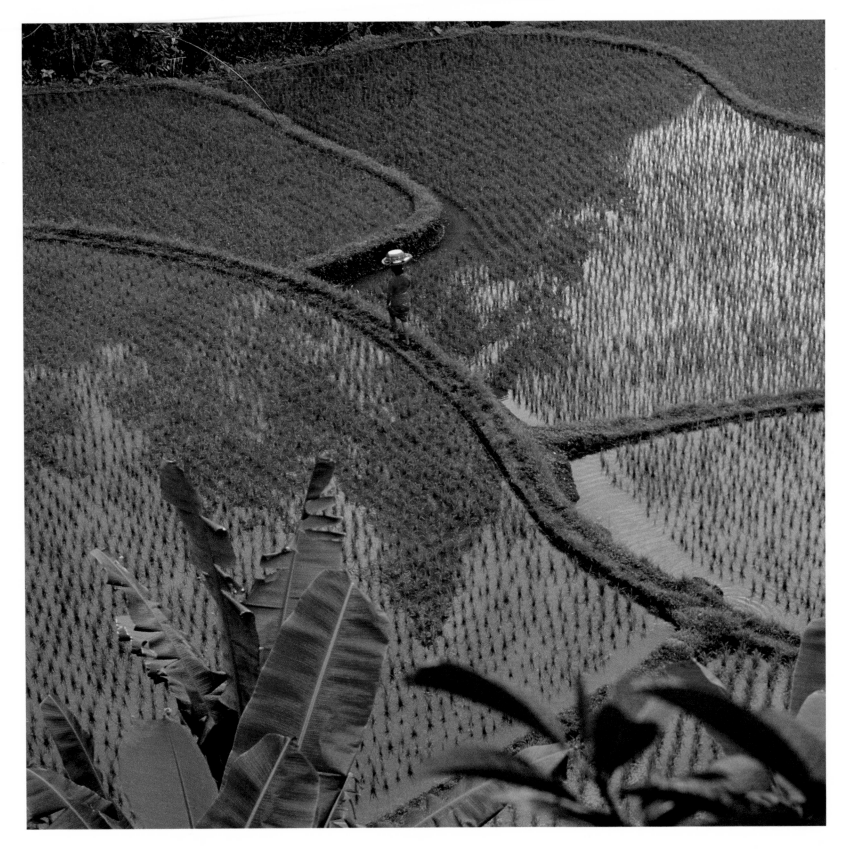

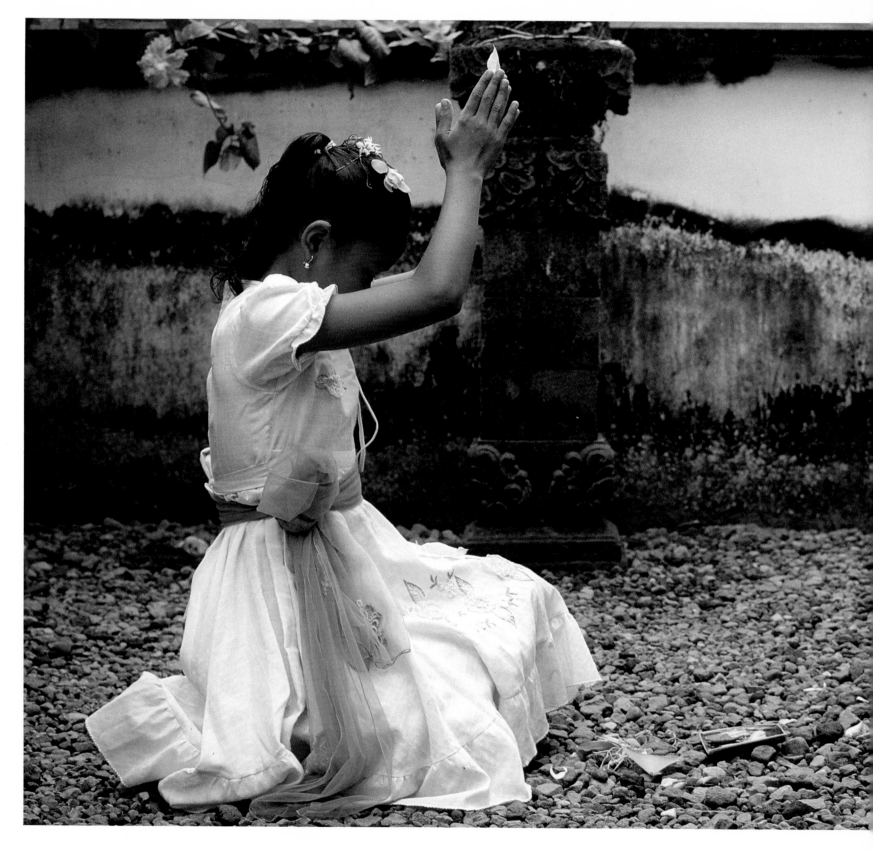

Praying in front of a house shrine, Kamasan

Temple gate, Klungkung

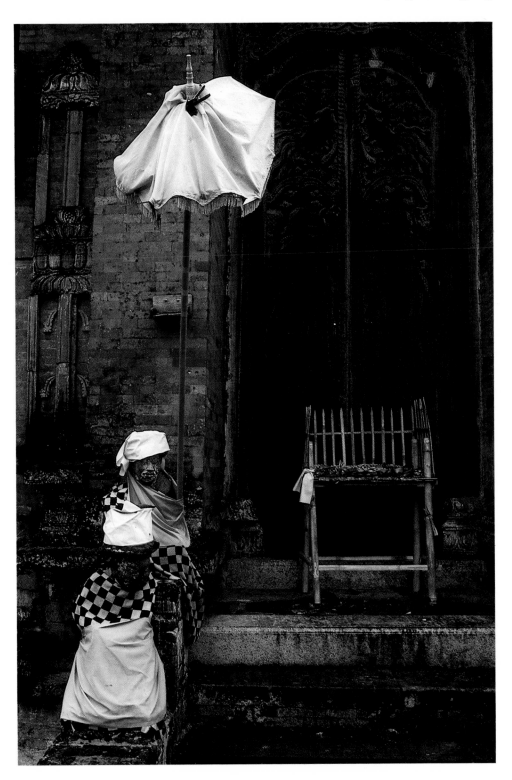

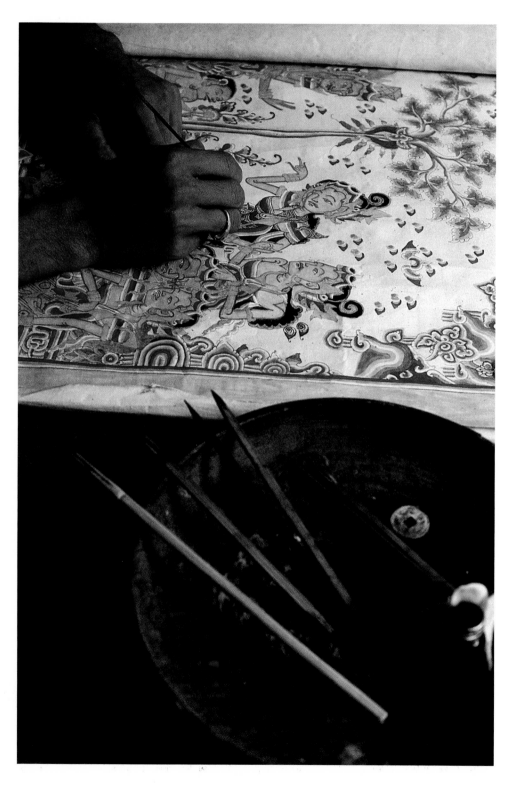

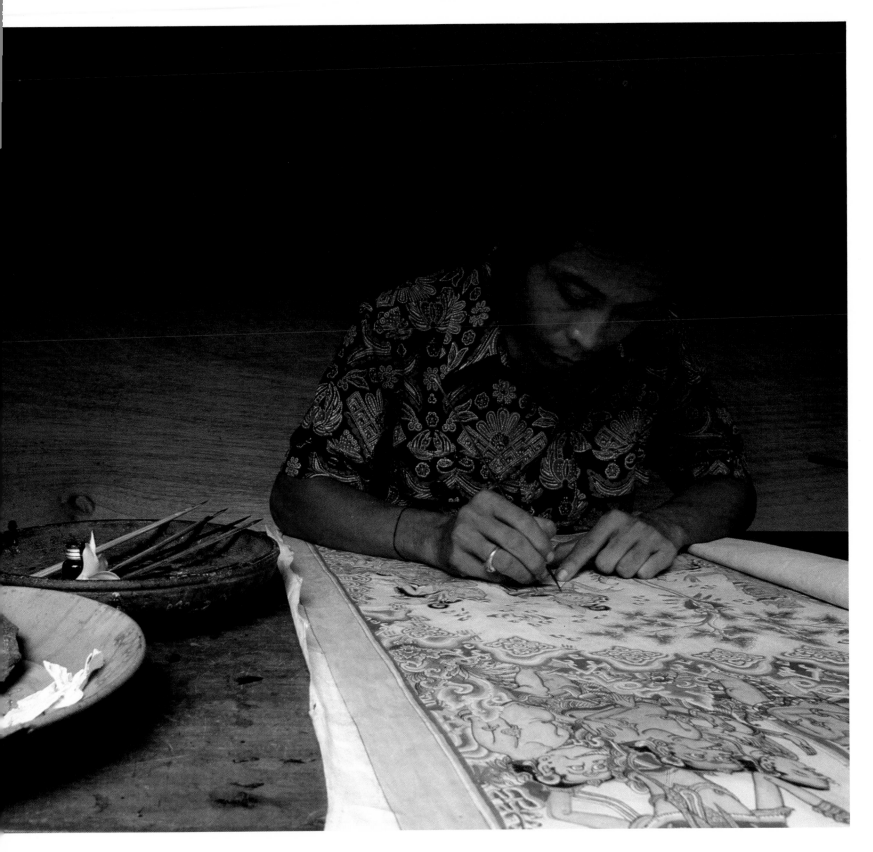

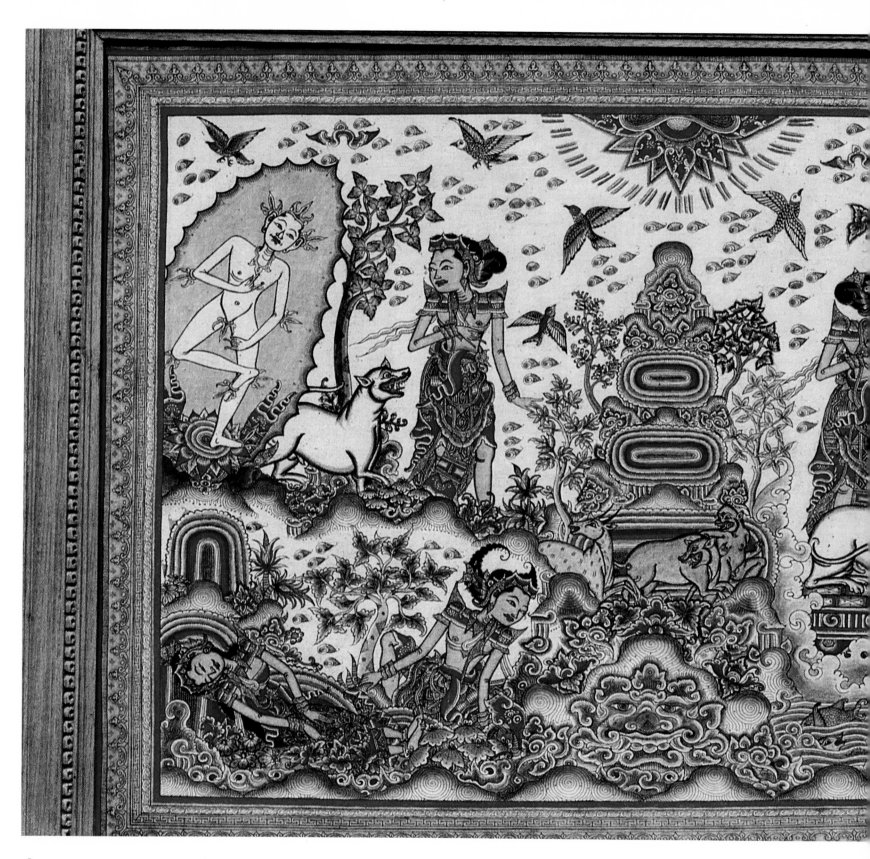

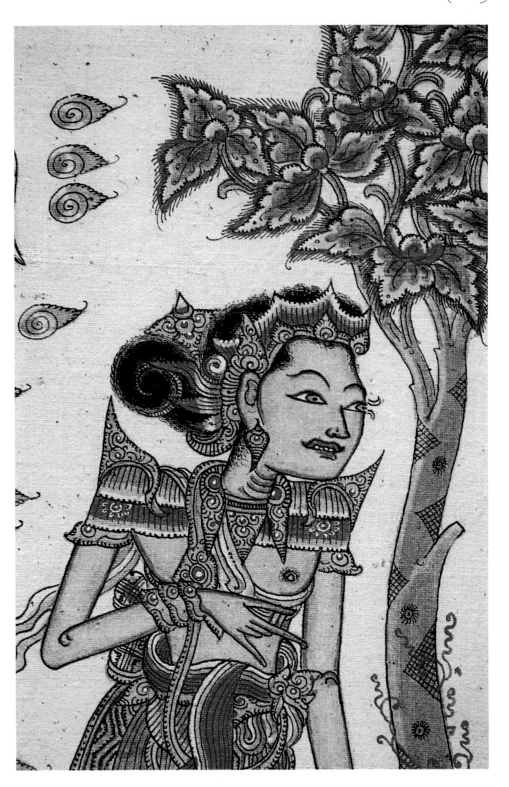

Yudishtira with a white dog at The Gate of Heaven
Painting by Nyoman Mandra

Yudishtira (detail)

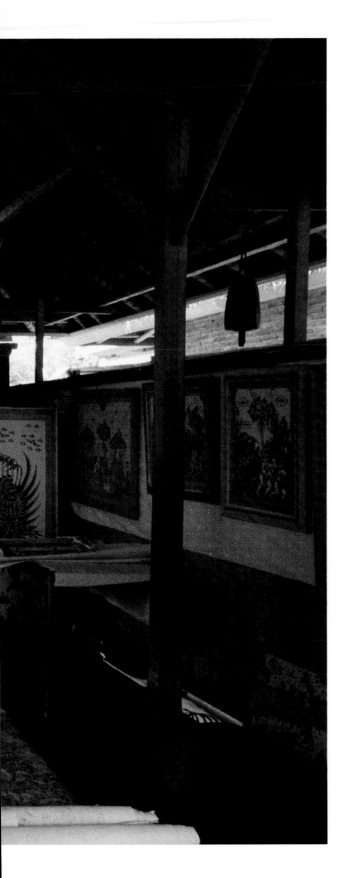

Nyoman Mandra's workshop

Ceiling of Kertaghosa Courthouse, Klungkung

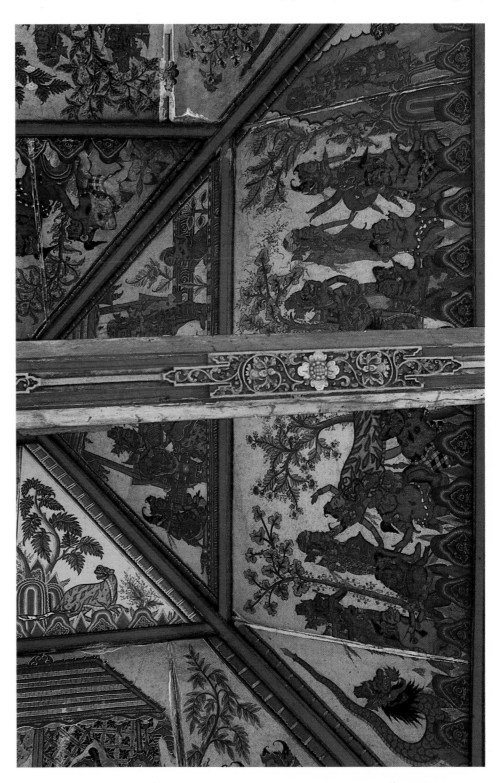

The home of the Bakung Dayaks

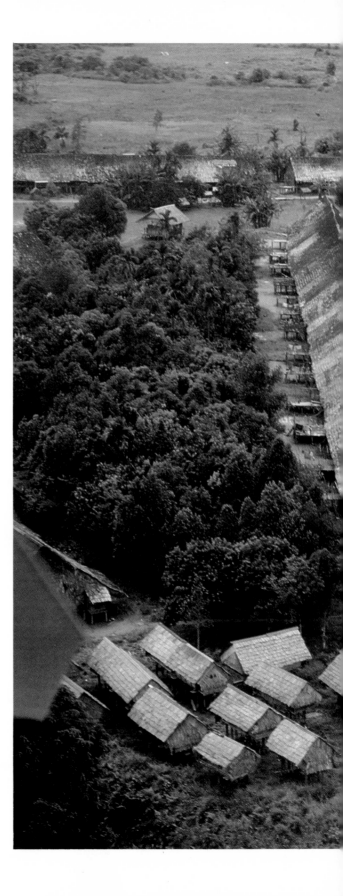

Mahak-Dumuk village, East Kalimantan

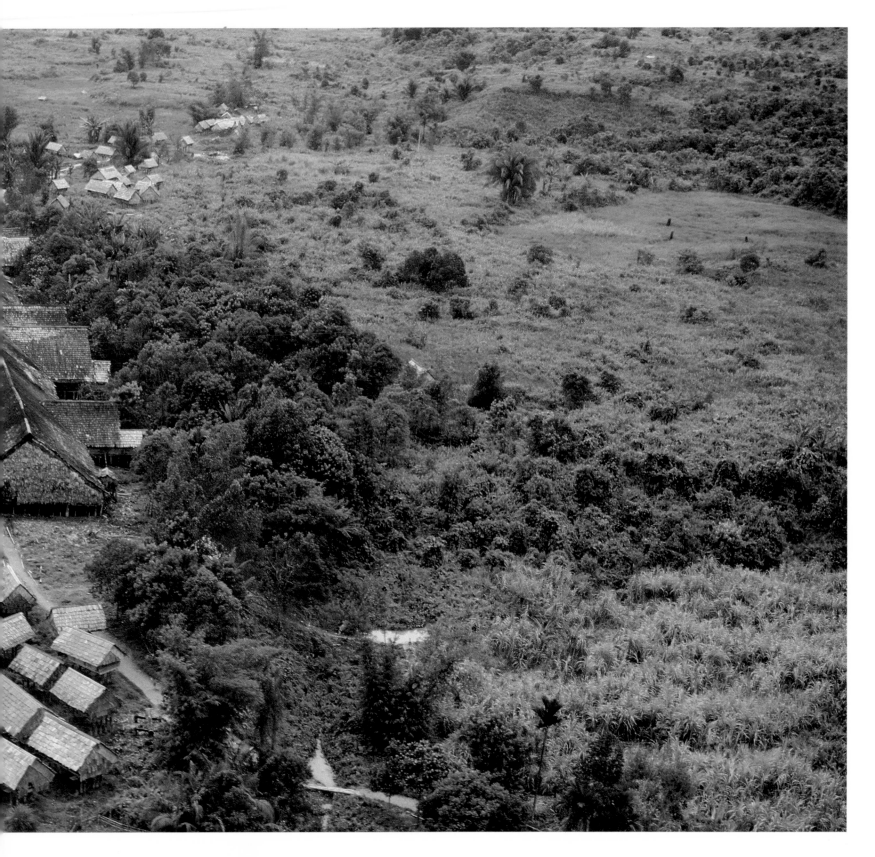

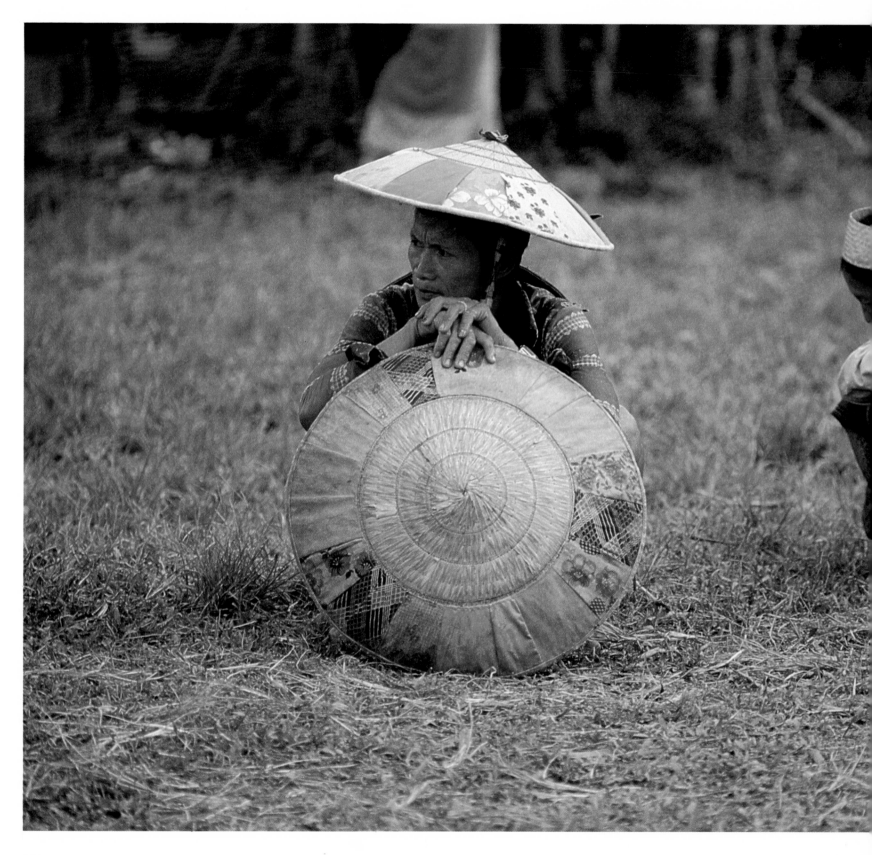

Dancing the Kancet Datun Julut

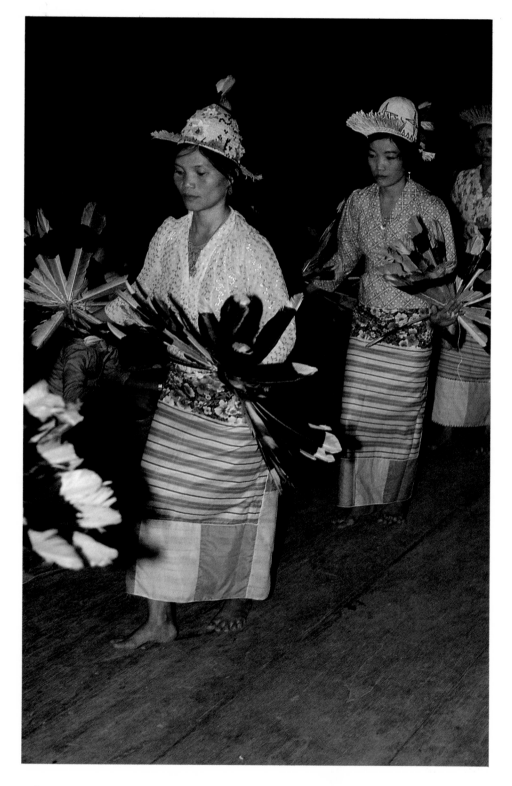

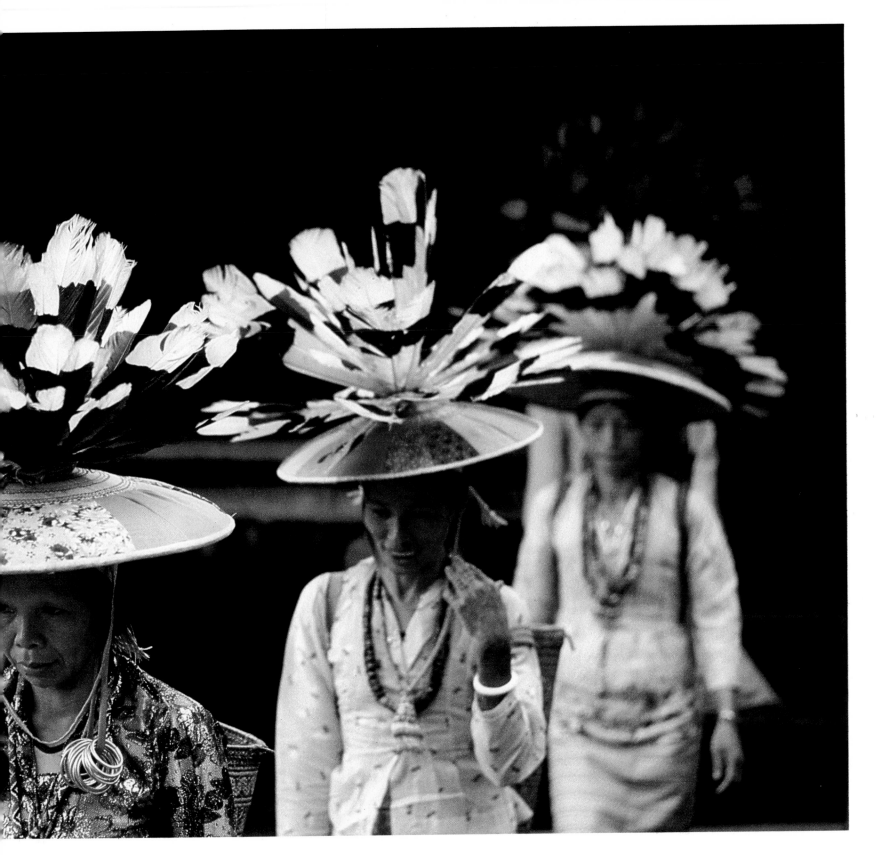

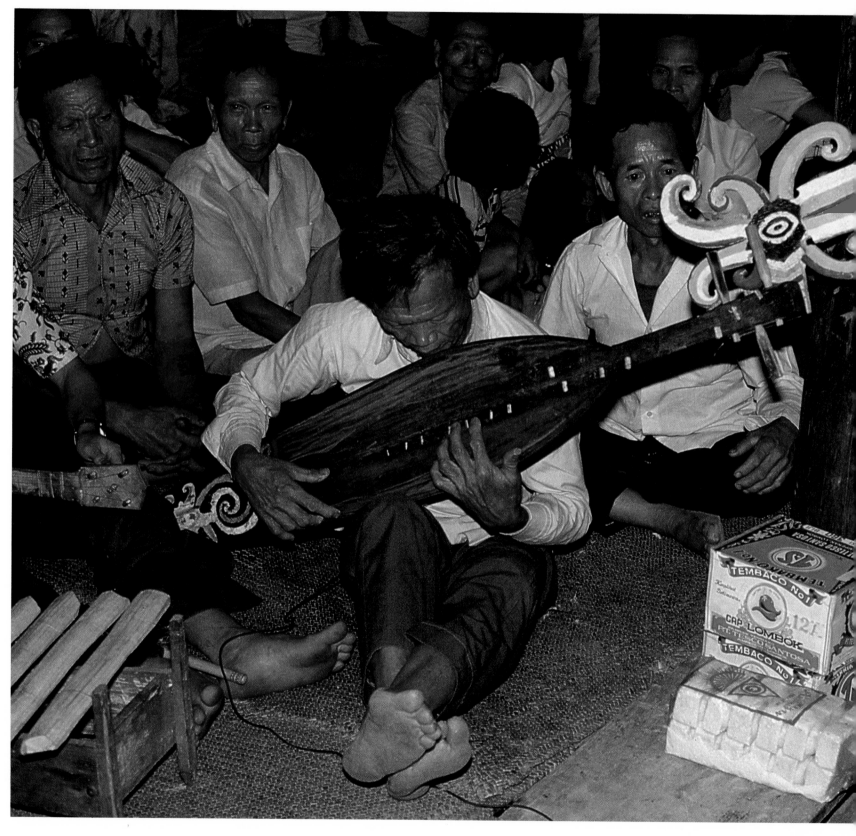

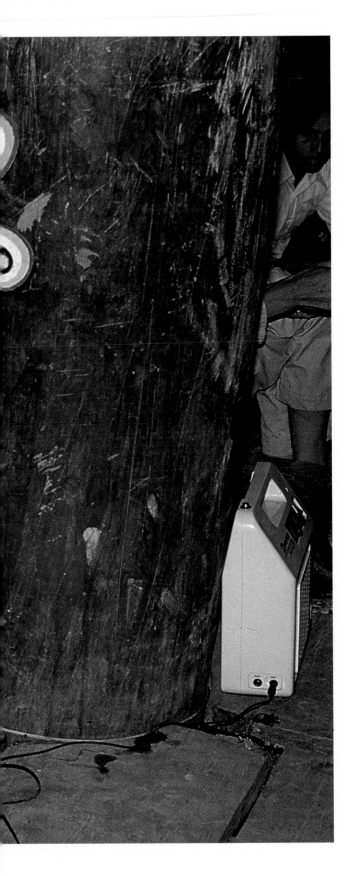

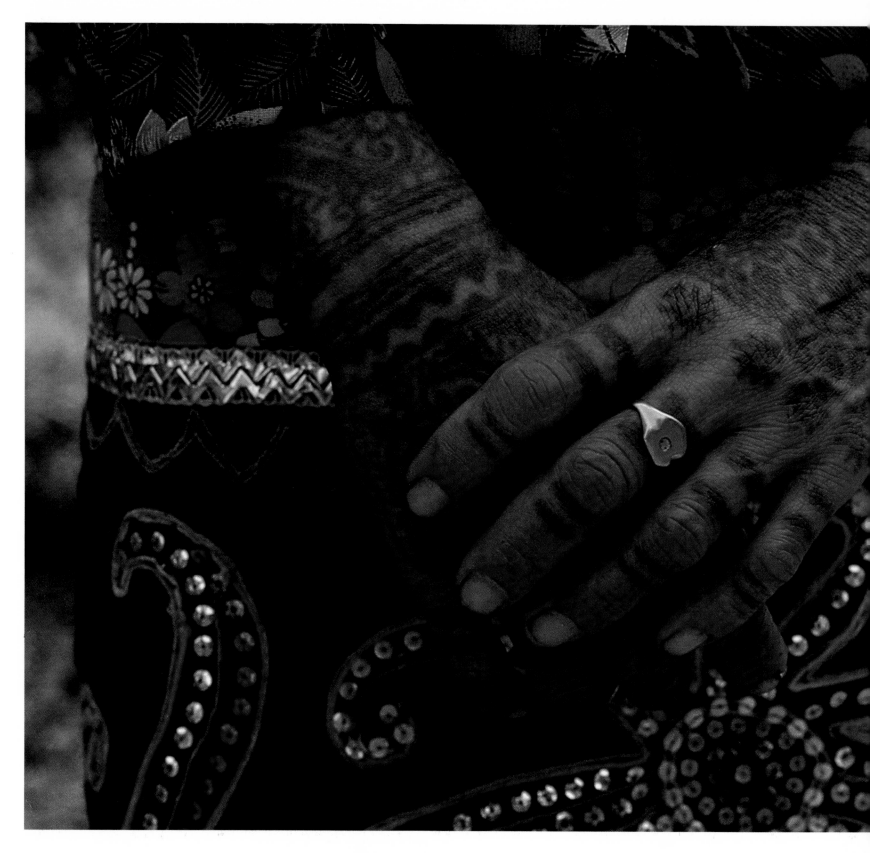

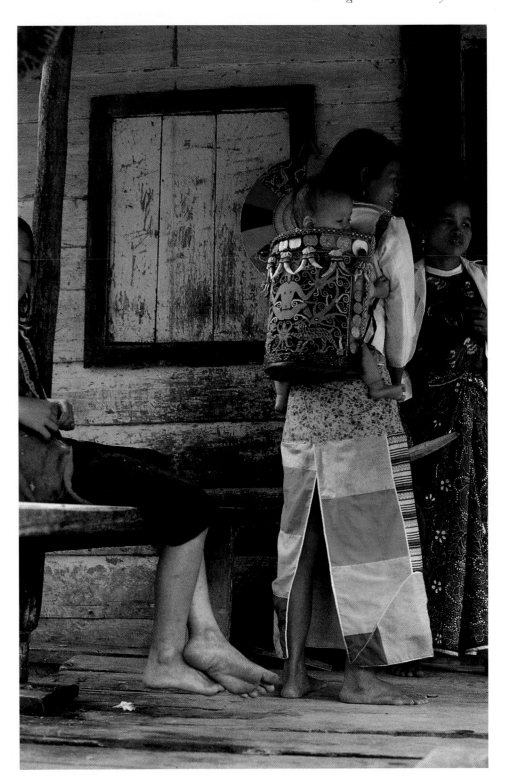

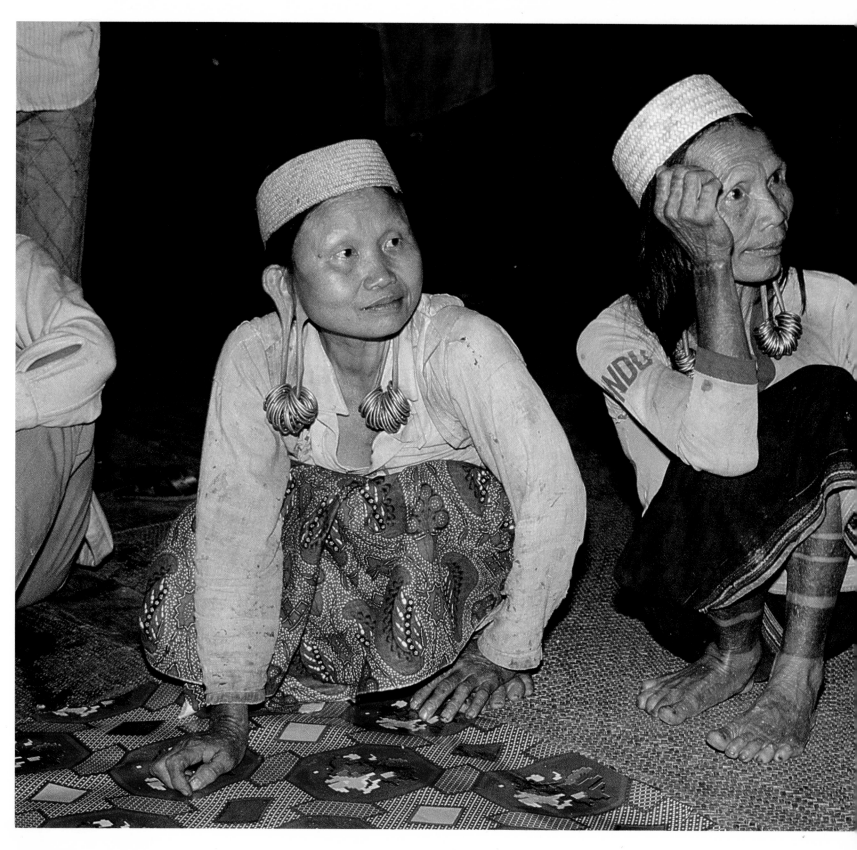

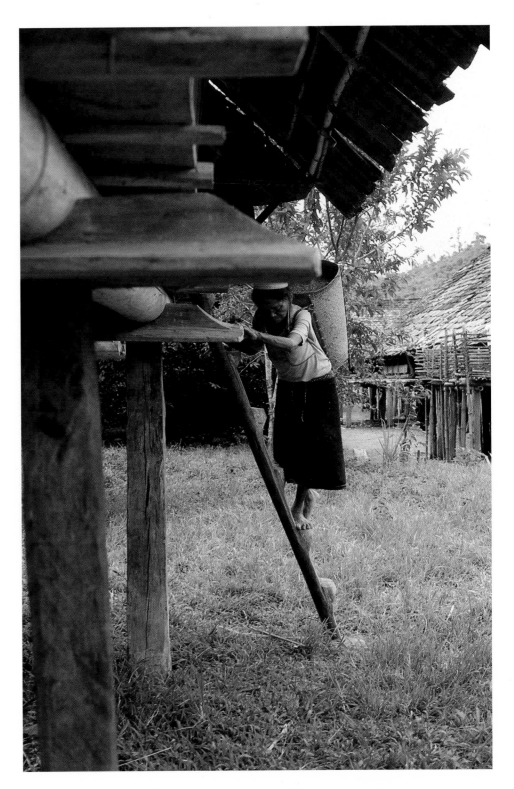

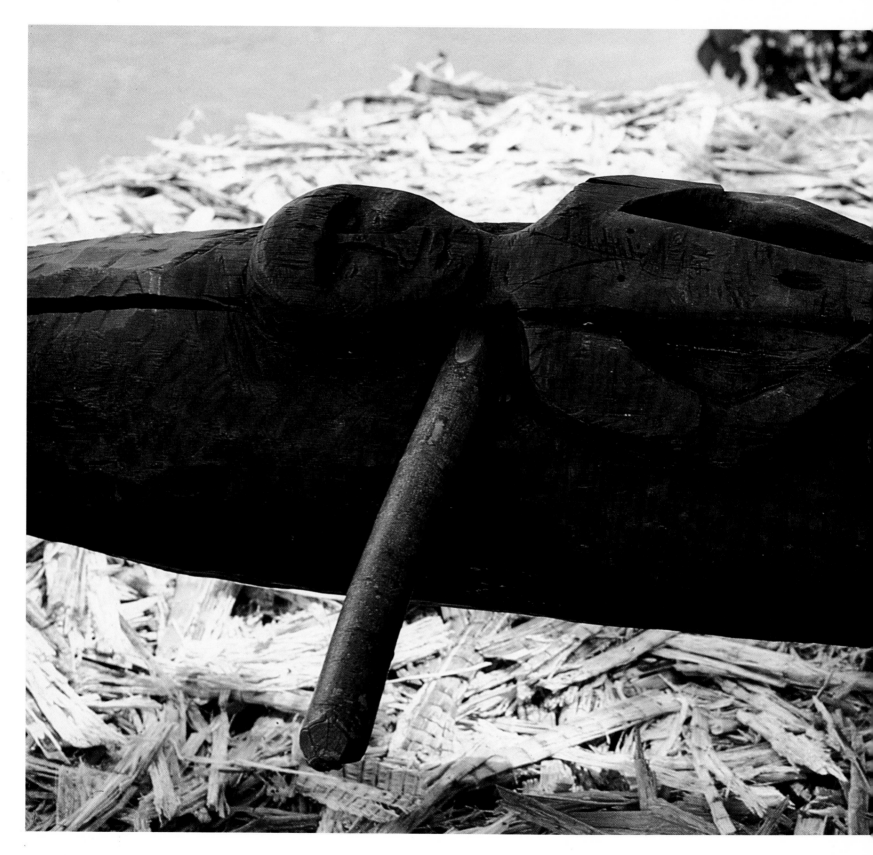

Remnants of wood-carving tradition

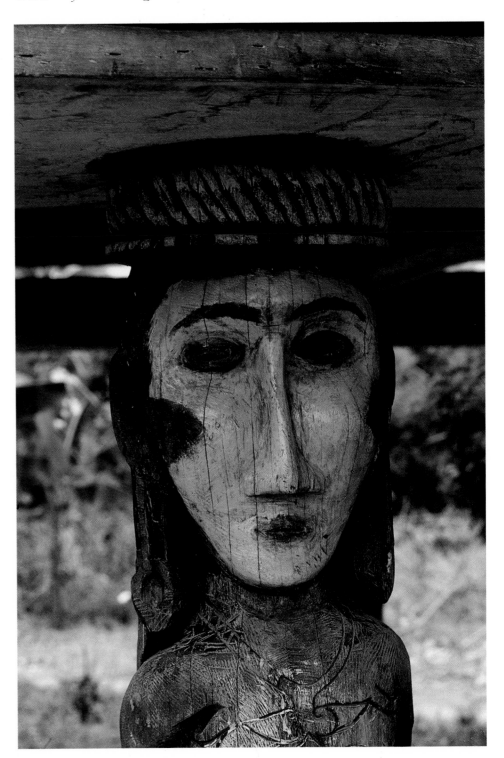

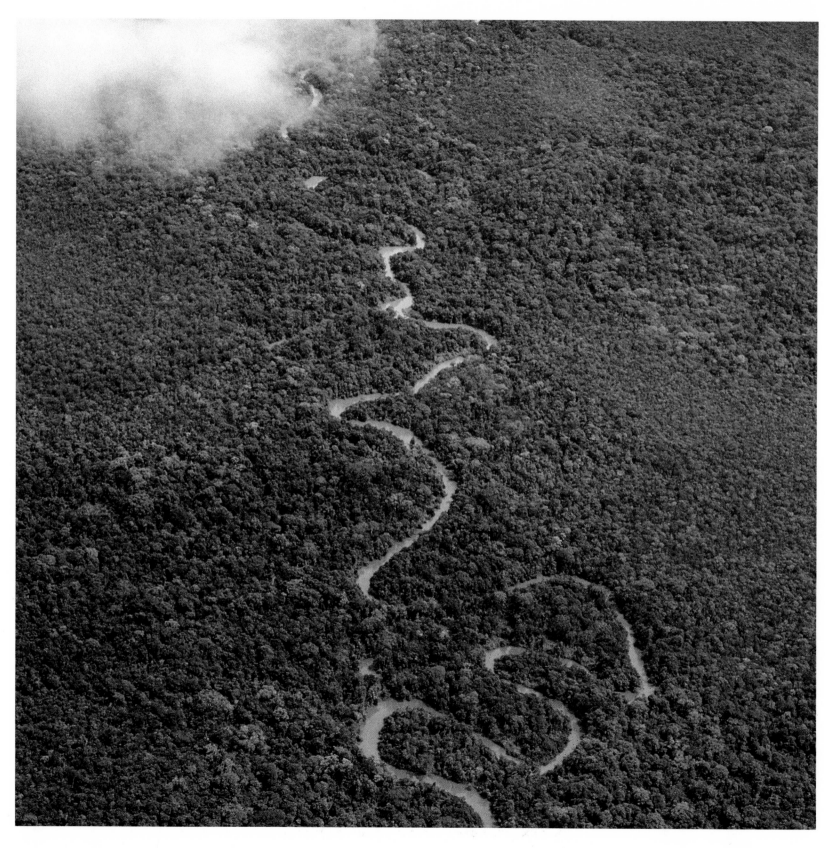

The home of the Bakung Dayaks

From the small Cessna the thick, lush, green jungle below held no promise of an opening. Occasional thick clouds and high mountain ranges did not help to raise our hopes of locating the village after two hours in the air. Suddenly the pilot informed us that we were about to land because "somewhere down there must be the village of Mahak-Dumuk." All of us looked down, anxious to catch a glimpse of the village, but nothing was to be seen except thin clouds over another stretch of thick, green jungle. Then the pilot suddenly made a sharp turn and gradually lowered the altitude. As we kept searching, a river emerged from nowhere and a green opening with rows of Dayak longhouses welcomed us. After two hours of anxious flight, the sudden "discovery" of Mahak-Dumuk seemed a bit like finding Shangri-La.

The fertility and prosperity of the village could be detected almost upon arrival at the airstrip: green, lush, thick paddies at the *ladang*, "swidden" rice field (a product of their slash-and-burn agriculture); abundant ripe pineapples among the rows of bushes that lined the road to the village; pigs, dogs, and fowl along the road; and the beautiful fresh river that bordered the outskirts of the village. At the village gate we were welcomed by schoolchildren who stood in long rows on both sides of the village road. To our surprise they sang "*Sorak-sorak Bergembira, Indonesia Merdeka* . . ." ("Let's Cheer Happily, Indonesia is Free . . ."). Nothing was stranger than to hear a patriotic Indonesian song in the middle of a deep, tranquil jungle isolated in the northwestern part of the province of East Kalimantan. Yet, there it was, the song loudly and confidently sung by the cheerful Dayak children.

The village of Mahak-Dumuk can only be reached by air, through jungle paths, or over wild rivers. In fact, only those who are really adventurous in spirit and in good physical condition, like the Dayaks, would dare to challenge the rivers against the current and then walk arduously through thick jungles and over mountains. Therefore, the only practical means of transportation is the aviation service of the Protestant mission.

Mahak-Dumuk is inhabited by the Kenyah-Bakung Dayak. This means that the village is inhabited by the Bakung sub-tribe of the Kenyah Dayak tribal group. There are dozens of tribal groups among the Dayaks on the island of Kalimantan, which is also called Borneo. (The huge island of Borneo is divided into the Malaysian territory, the Sultanate of Brunei, and the Indonesian territory.)

The tribal groups are divided into many more sub-tribal groups. The Dayaks, the original inhabitants of the island, occupy most of the hinterlands of the island. Towns and cities located closer to the coastal areas are inhabited by other ethnic groups such as the Javanese, the Bugis, the Banjar, and the Indonesian Chinese in Kalimantan, while towns and cities in the Malaysian and Brunei parts are inhabited by Malays. The best-known Dayak tribal groups in the province of East Kalimantan are the Kenyah, the Modang, the Bahau, the Apo-Kayam, and the Punan. The Bakung, a small sub-tribe which apparently parted from the Kenyah not long ago, lives mostly in the two villages of Mahak-Dumuk and Lebusan. About 1200 Bakungs live in the two villages and about 1500 more live in Serawak, Malaysia. According to their story, the Bakungs came originally from Pujungan in Serawak and before that from the coastal areas of Serawak. Previously they were Kenyahs and only became Bakungs after they came to Pujungan. They also claim that they were related to the Kayan tribe which lives in Serawak. The Bakungs settled down in Mahak about 15 years ago and were later joined by another family group of Bakungs who settled down in neighboring Dumuk. Later the two settlements were united into one village, Mahak-Dumuk. Before they came to Mahak-Dumuk they were in Long Payau, a big Bakung settlement about six days' journey away over narrow jungle paths and wild rivers. According to them, they lived in Long Payau for about 40 years before they decided to disperse. Many of the present inhabitants of Mahak-Dumuk were born in Long Payau and some even in Tegeh – still another earlier settlement.

The Bakung, like most Dayak tribal groups, is a nomadic community. They settle down in one place just long enough to practice their swidden – slash-and-burn – agriculture. When the soil and other resources are nearly exhausted, they will look for another fertile forest, cut down the trees to make clearings for their *ladang* and clusters of longhouses, and settle down there until they decide the resources there are being exhausted. As long as the Dayak apply the slash-and-burn system of agriculture, they will follow the same nomadic pattern in contrast with the sedentary *sawah*, rice field, system of the Javanese, the Balinese, the Bugis, and many other Indonesian ethnic groups. Because of its migratory pattern, the tribe has periodically split and dispersed, leading to the formation of sub-tribes.

* * *

There were only five longhouses – each about 100 meters in length – in Mahak-Dumuk. Each longhouse, *umak*, had around 30 compartments, *lamin* or *amin*, where nuclear families lived. In each *amin* lived an average of two to three nuclear families. In front of the compartments was the long corridor which ran the length of the house and served many functions: as veranda; as sitting place, where members of the families would gather and gossip; as resting place for the dogs; as gathering place for parties and dancing; and as location for fireplaces. Architecturally, the longhouse was a "jungle marvel." Located in the middle of a jungle, the house, or cluster of longhouses, did not appear incongruous to the lush, thick trees surrounding it. On the contrary, it looked as if the longhouses had always been a natural part of the jungle environment. The buildings, supported by huge wooden pillars and sturdy planks of hardwood for the corridors, looked solid but in harmony with the environment. The high ceiling and open ventilation allowed enough air to circulate, making the longhouse a comfortable dwelling place for the Dayaks.

We were quartered in one *amin* which apparently was meant as a kind of guest compartment. Both of the village heads of Mahak and Dumuk were present in our *amin* most of the time, and other village elders, men as well as women, would come and go. When we first arrived they gathered in front of us, stared at us, and smiled occasionally. They waited for us to start conversation and to open our packages. (The missionary discouraged visitors from bringing along alcoholic drinks, but people did so nonetheless, from time to time, and the Bakungs kept their secret distillery of wine made in their fields.) When we had opened our packages and invited them to share the tobacco, cigarettes, cakes, cookies, and drinks (Coca-Cola and Bintang beer) they waited until the two village heads had taken the things and distributed them to all who were present. Apparently the village heads had their own system for distributing the *oleh-oleh* (presents) among the villagers. They would give them first to the old women, then to the men, the younger women, and children. Then the conversation started.

Pelugan, 77, the head of the Dumuk side, was born when the sub-tribe was still in Tegeh. Although he and his people later joined them in Mahak he was obviously considered the most respected man in both parts of the village. Merang Apue, 40, the head of the Mahak part, was born in Long Payau, the settlement before they moved to Mahak-Dumuk. He was the more intelligent and articulate village head, perhaps because he mastered the Indonesian language better than Pelugan. Nevertheless, he

listened respectfully to what Pelugan had to tell him. The two heads told about the history of their villages and their migrating experiences. When it came to organizing a migration, they would send surveyors to look for the prospective site. The team could be away for months, finding potential places for their new settlement before returning to make their reports to the village head and the village elders. When the council of village elders agreed about the spot, they would start with the necessary preparations. They would form a team of settlement pioneers, mostly young men, who would open the long trail and jungle path to the prospective destination. But since the destination might be tens, or even hundreds, of kilometers away, requiring months for the journey and village migration, it would have to be done in stages. They would stop after they had covered a certain distance, and make a temporary settlement in order to rest, and to prepare logistically for the forthcoming migration. During their temporary settlement they would open a *ladang* and plant rice, corn, sweet potatoes, and vegetables. They would also hunt for game and make dried meat, and where there were rivers they would also fish and make dried fish. They would then move again, slowly but surely according to the meticulously planned migration strategy. When they reached the final destination – months or years later – the tribe or sub-tribe might have grown slightly larger due to new-born babies or even shrunk because of family groups which might have stayed in the "temporary" settlement.

The two village heads then indicated that they were in the midst of a new migration. Yet Mahak-Dumuk looked very prosperous and seemed capable of sustaining its own needs. Rice was abundant, as were vegetables, fruits, game, and fish. There was a regular flight service from the missionary who would bring other community needs from the city. Why should they need to move again? Were the resources again getting thinner? They had only been there for 15 years – a short time in the age of a village. Pelugan and Merang Apue explained that the forthcoming migration was not due to the depletion of village resources but, ironically, to education. Many of the children had finished the elementary school, the only school in Mahak-Dumuk, and wanted to continue their education in junior-high schools that were located in the cities. This was a problem for their parents. Studying in cities meant money. Where would the money come from? With their village located so far away from towns and cities it would be impossible to sell their goods. The missionary plane which came regularly could only take on limited cargo, at high cost. To sell their goods by plane was also out of the question, thus

they came to the conclusion that they must move their village to locations close to the markets. They would then hope to be in a much better position to sell their agricultural goods and earn cash to pay for their children's education. Eventually they would move to Mekar and Pampang which were located not so far from the *kecamaten* district, or capital.

They told the plan matter-of-factly without any tremor in their voices that would reflect emotional entanglement over being uprooted from their present habitat. It was an important decision and one would have thought that there would be, at least, a somewhat melodramatic air in the way they presented the case. But they did it seriously and matter-of-factly. Perhaps they saw the move as part of a traditional pattern, although the motivation now was different. Whereas the traditional motive was leaving exhausted resources and looking for a virgin environment, they were now preparing to leave abundant resources in favor of resources with potential economic flexibility. In fact, the Bakungs, when they decide to move, will take a fundamental leap to an entirely different concept of migration. Maybe they realized, intuitively, that through the demands of their children the times were changing.

Another guest in our *amin* was the elementary school teacher in the village. He told us that to collect his monthly salary he must come to Tanjungselor, the *kabupaten*, the regional capital, since the regional office which administered his salary was located there. To reach it he would normally walk for six days to Long Nawan, then go by boat through the Kayan river for six months before reaching Tanjungselor. Since it was impossible to collect his monthly salary this way (or otherwise he would have had no time to teach) he would go once a year by the mission's plane to collect his salary. He regards this annual trip to Tanjungselor as his vacation, when he usually spends all his meager annual salary for a good meal and presents for home (after putting aside some money for the airfare).

* * *

In the village square, surrounded by longhouses, the church, and the school, people gathered to see the re-enactment of several traditional dances. These dances, which were part of the ritual of the Dayaks' native religion, have been discouraged since the Dayaks were converted to Christianity.

The dances were related to the rice-planting cycle of the

Bakungs. The *Nugan* dance depicted the ritual of the first day of rice planting when the medicine man would conduct prayers in the hope that the rice would have a good, healthy growth and a good harvest. The *Tantagah* was a ritual prayer to chase away any plant diseases that might upset the whole cycle of rice growth. In the *Bang*, male and female dancers danced with bamboo sticks depicting the chasing of insects from the plants. The final rice-planting dance was the *Uman Undat*, which demonstrated the joy at the end of harvest time.

The re-enactment of the ritual dances continued with demonstrations of the *Hudo* dance, the war dance, and finally a solo female dance. Unlike the others, which are still danced occasionally at the appropriate time of the year, the *Hudo*, a ritual for chasing away evil spirits, is only danced during re-enactments.

The musical instruments usually used in accompanying the dances were gongs and *sampe*, a kind of two- or three-stringed guitar.

On the eve of our departure we were given a big party by the Bakungs, who came not only from Mahak-Dumuk but also from the neighboring village of Lebusan, about one day's trip by foot. The party was held in the corridor of a long veranda of a Mahak longhouse. The highlight of the evening was the *Kancet Datun Julut*, a collective female dance performed by 30 Bakung girls from Mahak-Dumuk and Lebusan. The girls, clad in their most beautiful party dresses, colorful Dayak skirts and *kebayas*, women's jackets, with *tapung kirip*, female hats, on their heads, also wore beads, necklaces, and bracelets. Lined up in two rows, they moved forward majestically, suddenly stamped their feet, turned around, then moved forward again, in the opposite direction, but just as majestically. The dance and the basic movements reminded me of the classical *kapang-kapang* movements of the *srimpi* dance at the court of the Sultan of Yogyakarta in Java. Perhaps it was merely coincidental. Perhaps it indicated a remote connection between the Dayak and Javanese dances.

The mood of the dances on that evening was very different from the previous day's re-enactment of a discouraged ritual. The re-enactment had been danced mechanically, routinely, and even clumsily at times. But when the *Kancet Datun Julut* was danced that final evening, it was done with joy and gusto. And the audience cheered and applauded the dancers happily.

Nevertheless, an old Bakung lady from Lebusan who still had very long ear lobes with bunches of earrings on both sides, and had both of her hands tattooed, complained that Bakung girls today are too lazy to practice the *Kancet*. She said the girls were more attracted to new Indonesian pop music than their own traditional dances and songs. As a result, the *Kancet* they showed at the party was not as good as it used to be.

Wah! Did I really hear this complaint in the middle of a jungle in Kalimantan and not in a Javanese or Balinese court?

* * *

The Bakungs, who originally came from the Kenyah tribe and therefore culturally belonged to the great Kayan-Kenyah complex, were surprisingly lacking in wood carvings — a tradition that has made the great tribal group famous. In the longhouses in Mahak-Dumuk we could not find any carved doors, even at the compartments of the village heads. The *aso* (dog) design which was so prevalent in most Kayan-Kenyah wood carving could only be traced in the painted shields, hats, and baby carriers of the Bakungs. Nor did we see the richly carved masks that appear in museum collections or in old Kenyah or Kayan tribal longhouses. Even the beautiful rattan woven bags of the Bakungs were imported from the Pumans, a nomadic hunting tribe which did not know agriculture and mostly lived from fruits and game. I wondered if the loss of the Kenyah wood-carving traditions among the Bakungs was due to the strong influence of the Protestant church with its concept of simplicity and frugality and its discouragement of ostentation.

* * *

On the afternoon of our departure, at the airstrip, Pelugan and Merang Apue, the two village heads, gave me as parting presents pineapples, corn, vegetables, and hats, and even a baby pig. I took only the hat, which I immediately wore.

Pelugan patted my shoulder.

"You have found our place now. But if you come again next time, I would not know whether Mahak-Dumuk would still exist. But who knows whether some of us would still stay behind. By that time I might have reached Pampang, or who knows if I would still be in the middle of the long journey somewhere"

I could only say *terima kasih*, thank you, to the two village heads. I wish I could say some longer sentences. Sentences such as : Please retain Mahak-Dumuk at all costs; or, don't go too near to the towns or cities — you will lose your Bakung identity as you have already lost your Kenyah identity. But then I saw at the airstrip the same group of Bakung children who sang *Sorak-sorak Bergembira* at my arrival. Suddenly I knew why it was difficult for me to blurt out those longer sentences. Those children were different Bakungs

Pinissi: vanishing ships

The crowd had gathered on the beach of Tana Lemo since seven o'clock in the morning. Two hundred of them congregated specially around the *bantilang*, the coastal shipyard, waiting to push the *pinissi* ship to sea and launch its maiden voyage. The rest were there to watch and later to participate in the delicious meal of *tedong* (water buffalo), which was part of the ship-launching ritual.

Suddenly, the *penghulu*, a spiritual leader of the village, shouted *laaaiilambaaateee*, announcing the beginning of the launching ritual of the *pinissi*. The 200 men answered the *penghulu's* call with a deafening counter shout – *taratajooo* – indicating their readiness to start the push. After the 200 men were divided into groups at the front, middle, and rear of the ship, once again the *penghulu* shouted *laaaiilambaaateee* followed by a higher-pitched shout *oooorilailahaa*, which meant to start the pushing. The whole group then pushed, shouting *beembaaa*. Slowly the 200-ton *pinissi* left the *bantilang* and moved down to the sea. Carefully the 200 men pushed and balanced the movement of the ship.

Meanwhile, the group leaders sang funny and bawdy rhymes which the spectators applauded. Next, the wife of the shipowner, assisted by several ladies from the village, sprinkled and spread rice and water on the ship. When the ship touched the water the *punggawa*, the master shipbuilder, recited the sacred verses to protect the ship and to appease the sea. The *pinissi* was safe now and ready for the long journey. The *tedong* party started on the beach. The villagers, the shipowner's family, the *punggawa's* family, the shipwrights, and the prospective shipmates ate the long-awaited meal together.

By sunset the *pinissi* was sailing eastward to the neighboring village of Tanjung Bira, where it would fetch the remaining shipmates, then proceed to Ujung Pandang, the capital city of the province of South Sulawesi. There, it would pick up the cargo for Surabaya and Gresik in East Java. The east wind was fair, everybody on the ship was looking forward to a smooth and prosperous voyage which would bring them back safely by the time of the west wind around November.

The *pinissi*, sleek and handsome, proudly hailed its seven sails, and moved with stately elegance through the Java Sea.

* * *

That scene took place about 10 years ago. Today, although Tana Lemo is still one of the most important *bantilang* of locally made

ships in South Sulawesi, *pinissi* are no longer being built under its thatched roofs. What the builders are making today are *Perahu Layar Mesin* (abbreviated PLM) which literally means "motorized sailing ship." The front of the motorized ship still retains the shape of the old *pinissi* but the rear is shaped differently since it has to make room for the engine. Gone is the sleek and elegant shape of the old *pinissi* and with that also has gradually gone the traditional image of indigenous shipmaking that has been in existence for centuries.

The *pinissi* has been known in historical annals as a means of transport for trade and for military expeditions since the 16th century, when the Goa kingdom of South Sulawesi was at its height of power. The *pinissi* enabled Makassar and Bugis traders (the two most important ethnic groups in South Sulawesi) to roam the seas of the Indonesian archipelago, and to visit Malaya's most important ports, Sri Lanka, the southern part of the Philippines, the western coasts of Irian, and the northern parts of Australia. The Bugis people also used the *pinissi* for transportation when they migrated to East Kalimantan, East Sumatra, South Malaya, and other parts of the archipelago. Even after foreign powers – the Portuguese, the British, and finally the Dutch – controlled the Indonesian waters and its traders, Bugis *pinissi* still managed to roam the seas on shorter trade routes.

Pinissi building has been closely linked with the three villages of Ara, Tanjung Bira, and Tana Lemo in the county of Bulukumba at the southernmost part of the province of South Sulawesi. According to myth, when the ship of Sulawesi's most important culture hero, Sawerigading, was wrecked in the vicinity of the three villages, the masts were found in the village of Tanjung Bira, the deck boards in Tana Lemo, and the remainder of the ship in Ara. Consequently the three villages had to restore the mythical ship, and have inherited the three most important elements of expertise in shipbuilding. The skilled artisans who build the body and give shape to the ship are from Ara; the experts in the finishing touches and details of the ship are from Tana Lemo; and the sailors are from the village of Tanjung Bira. Even to this day, the people of Ara and Tana Lemo have remained shipwrights rather than shipmates. And Tanjung Bira is still known as a village of sailors.

The fact that the *pinissi* was linked with Sawerigading, one of the mythical founders of the ancient kingdom of Luwu, indicates how the people from the three villages have viewed the shipbuilding process. This can be seen in the series of rituals that is related to the building of a *pinissi*. Although the Ara people

have embraced Islam as their religion, remnants of their ancient animistic beliefs are apparent in the ritual of finding the right timber. The *punggawa*, the master shipbuilder, would lead his *sawi* (shipwrights) into the forest to look for *bitti* wood. This kind of timber has always been considered as the most suitable material for the ship, although some parts of the ship might also be made from teak or iron wood.

As they entered the forest, the *punggawa* would shout to the spirits of the forest informing them that they wanted to look for *bitti* wood. In selecting the wood, the *punggawa* always put aside the first *bitti* to be used as *bengo*, the piece for the front of the keel. This part was considered necessary since its function was to confuse any forest spirits who might want to upset the whole plan. The *punggawa* then told the spirit of the tree that he wanted to cut it in order to build a ship for Mr. so-and-so. After having said this, the *punggawa* made his first cut in an upward direction, symbolizing his wish for the ship's fortune to be continually ascending. The second ritual was connected with the actual building of the ship on the *bantilang* on the beach. The ritual concentrated on the assembling of the keel and was considered very important since the keel symbolizes the basic essence of the ship's operation. That is why the ritual was also attended by the shipowner, the *sombalu*, and his wife, the *punggawa*, as well as the master shipbuilder, his shipwrights and his apprentices, the prospective captain of the ship, and a pregnant woman.

The ritual symbolized the solemn agreement between all parties involved: between the shipowner and the *punggawa* with his shipwrights and captain; between the *punggawa* and his shipwrights and captain. The symbol was expressed through putting valuable things (such as gold or copper) into two holes that were specially made on the keel to symbolize a vagina and a penis. Thus, it was hoped that the agreement would be as sacred as the union between a man and a woman. The third ritual was connected with the launching of the ship, as described earlier.

* * *

Traditionally, there was a strict division between the roles of owner and shipbuilder. However, after the withdrawal of the Dutch-owned K(oninklijke) P(aketvaart) M(aatschappij) shipping company from Indonesia, in 1957, there was an acceleration in trade among the Bugis *pinissi*. As more *pinissi* were built in various parts of the country, more *punggawa* tried their luck as shipowners. Sea transportation by *pinissi* thrived and the

archipelago waters were crowded with these sailing ships moving to and fro loaded with inter-insular cargo. Eventually, however, modern inter-insular shipping companies were established, using modern vessels with powerful engines. The state's inter-insular shipping company *PELNI (Pelayaran Nasional Indonesia)* filled in the gap created by the Dutch KPM and the *pinissi* sea trade began to face serious competition. Once again, their business shrank back to their old small routes between islands not effectively covered by the big ships. Even there, the *pinissi* were faced with competition because of the speed and reliability of cargo deliveries by the motorized ships. Too often, the traditional *pinissi* failed to reach ports on schedule, resulting in unexpected expenses – even losses – to the customers. The pragmatic Chinese businessmen who were now investing capital in the inter-insular trade solved the problem pragmatically: Put engines to the *pinissi*. The *punggawa* and his *sawi* frowned upon the monstrous idea. But the *pinissi* had to enter a new era of competition.

* * *

Traditionally, the building of *pinissi* was a family business. When a *punggawa* got an order from a *sombalu* to build a ship, he would recruit workers from his family network. And since Ara was traditionally, even mythically, the village of shipbuilding artisans, a code of honor dictated that only artisans from this village could be included in the shipbuilding process. Though the workers' hierarchy was based on expertise and technical skills, there was always an intimate element in the relationship. The *punggawa* saw each shipbuilding assignment as an opportunity to improve the expertise and income of his family network. Because shipbuilding provided the Ara people with continual training, their formal education was limited to elementary school.

The families of sailors from the neighboring village of Tanjung Bira also defined their community by the people who sailed the *pinissi*. Here again, the recruitment of the *sawi* (in this context, shipmates) was done through the family network. Since the most important occupation was seafaring, the village had no provision for any occupation other than sailing. Every year the two most important occasions for the village occurred during the season of the east wind around April and the season of the west wind around November and December. During the first period, women of the village would prepare their husbands' needs for the long voyage, while on the beach, rows of 200- to 300-ton *pinissi* waited to set sail. Finally, one by one the *pinissi* moved out to sea with their seven sails unfurled. Those who were left behind knew that for several months Tanjung Bira would be a village of wives and children, quiet and tranquil, the beach empty and deserted.

During the season of the west wind the beach would again be crowded with women and children facing the sea, trying to locate the *pinissi* of their husbands and fathers. As soon as they did so, they would shout and wave in anticipation of their reunion. Invariably, the sailors would bring them presents, including the latest goods available in the cities. For the next few months Tanjung Bira would regain its normal status as a village of men and women, husbands and wives, children and parents. Idle sailors could be seen strolling with their children through the narrow village streets, or gamboling on the beach. Meanwhile, the *pinissi* would be cleaned and repaired.

Tana Lemo was a habitat of varied occupations – among them, farmers, fishermen, ship artisans, and shipowners. The presence of many *bantilangs* gave Tano Lemo the appearance of a maritime village, as artisans worked on the half-finished frames of *pinissi*, fishermen tended their boats, and children played and looked for shells and small fish. From time to time *sombalus* would visit the *bantilang* to inspect the work and to chat with the *punggawa*.

Since one-half of the people of Tana Lemo were farmers, it was less homogeneous than the neighboring villages of Ara and Tanjung Bira, and did not strictly follow the Sawerigading myth. Nonetheless, the maritime ways of life strongly influenced the ethos of the whole population, and the traditional shipbuilding rituals were certainly part of the village life style.

The *sombalu's* relationship with the *punggawa*, although businesslike and guided by traditional shipbuilding norms, was by no means rigid or cold. Both parties applied mutual trust to their discussions of the shape and tonnage of the *pinissi*, the wages of the whole crew, or the stock of food and cigarettes. Above all, they were guided by the belief that shipbuilding was a sacred activity, and that any disharmony between them might directly influence the safety of the ship. Occasionally there were discrepancies. When a *sombalu* did not honor his commitments after the delivery of the *pinissi*, the *punggawa* traditionally would not refer his claim to the court but would resort to magic. He would ask his *sawi* to read a *mantra*, a sacred verse, cursing the *sombalu* and the ship. According to common belief, this curse would be disastrous to the *pinissi*. Either it could not find cargo in its visit to the harbors or it might even be drowned at sea.

* * *

The PLM, the motorized sailing ship, still retains the basic features of a *pinisi*, but since the rear part must be adjusted to allow for the engine it no longer has the sleekness and elegance of the traditional *pinisi*. Even the *punggawa* and his *sawi* find the PLM ugly and awkward-looking. As one *punggawa* said: "It has not gotten the proper shape yet." The average PLM is 300 tons with an engine of 150 horsepower. In addition to being faster than the traditional *pinisi*, the PLM is steadier and more reliable. Yet the *pinisi* may, in fact, outdistance the PLM when heading into the east wind. When sailing into the west wind, the *pinisi* has to make a zigzag movement — or to use the sailor's jargon, a "saw" movement — in order to avoid big waves. Because of this kind of movement a *pinisi* could never keep to a fixed schedule. With a powerful engine at the rear of the PLM the problem of facing the harsh west wind has been solved. The PLM is also more economical, in terms of manpower, than the *pinisi*, operating with a crew of 12 to 15 in comparison to the traditional *pinisi* crew of 20 to 30.

The PLM also has a competitive advantage since it can operate all year round while the traditional *pinisi* could only sail between April and November. In addition, since many of the new PLM owners are Chinese, they do not share the traditional beliefs of the *pinisi* owners. They can draw up new contracts with a captain and his *sawi* on a more businesslike basis, without concern for disharmony or magic. The PLM is just an ordinary ship that sails for trade while the *pinisi* is a continuation of a tradition.

The same condition holds for the relationship between the PLM owner and the *punggawa*. The owner would make a financial contract with the *punggawa* and leave him with the responsibility of dealing with his own *sawi*. (Usually, in fact, the owner is willing to be flexible by providing financial advances for the *punggawa* and the *sawi*.)

* * *

The consequences of the competitive position of the PLM *vis-à-vis* the traditional *pinisi* are socially vast. *Sombalus* are now compelled to build PLM instead of traditional *pinisi*. Some *sombalus* who want to keep their *pinisi* find it increasingly difficult to be competitive since traders simply want to have their cargo sailed more quickly and to arrive on schedule. Although remnants of the traditional ritual still remain, the rituals are nowadays simpler and less complicated than they used to be. Partly this is due to the difficulty of getting timber (*bitti*). In the old days *bitti* was still

abundant in the Ara and Tanjung Bira region. Now the scarcity of timber has forced builders to search for it as far away as the Salayar and Kalotoa islands. This search has compelled builders to simplify the tree-cutting ritual. Also, since the building of the PLM has no legendary connection with Sawerigading, old rituals are unrelated to the myth.

Though there is almost no call for traditional *pinisi*, artisans are still recruited from Ara since they are considered to be experts in shipbuilding. Nowadays, however, they have become roving artisans who work under contract for the PLM shipowners. As a result, they may conceivably turn into businesslike specialists who gradually will lose their emotional relationship with their profession and with their two mythical partners, the villages of Tana Lemo and Tanjung Bira.

The same could also be said about the sailors, who spend most of the year at sea on fast-moving, cargo-hungry, motorized sailing ships. Gone are the regular months between November and April when they could spend time idly in the village with their families. They now come to their village on two-week furloughs from the shipping company, flying to Ujung Pandang from Java or Sumatra or Kalimantan, switching into a bus or rented car straight to Tanjung Bira. Then off they go again by bus and plane to the scheduled port.

* * *

Where are the remaining traditional *pinisi* now? There must be some that still seek to compete with the PLM by chasing for cargoes among the smaller islands.

And the village of Tanjung Bira? It no longer knows the season of the east wind as the time of departure and the season of the west wind as the time of arrival and reunion. Now it knows only the long, dry, and rainy seasons, and the sporadic, brief family reunions.

Once, and presumably still, the *pinisi* was closely identified with the seafaring spirit and courage of the Makassar-Bugis. But with only occasional *pinisi* roaming remote and quiet seas like cursed ghost ships in ancient legends, how will the identification fare? One can only hope the contemporary generation of artisans and sailors is transitional and that there will someday be a cultural breakthrough — a more appropriate modern edition of *pinisi* with a Makassar-Bugis identity.

Right: Tana Beru beach with ships under construction, South Sulawesi

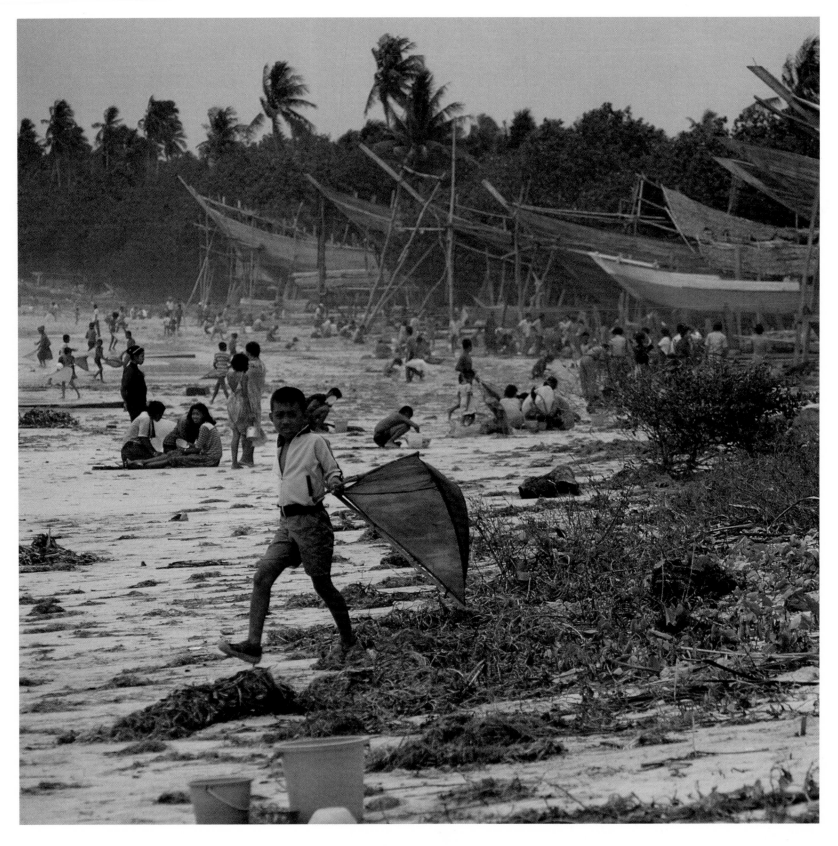

Small bantilang, *Tana Beru, South Sulawesi*

Punggawa *house,* Ara, *South Sulawesi*

Ship bantilangs, *Tana Beru, South Sulawesi*

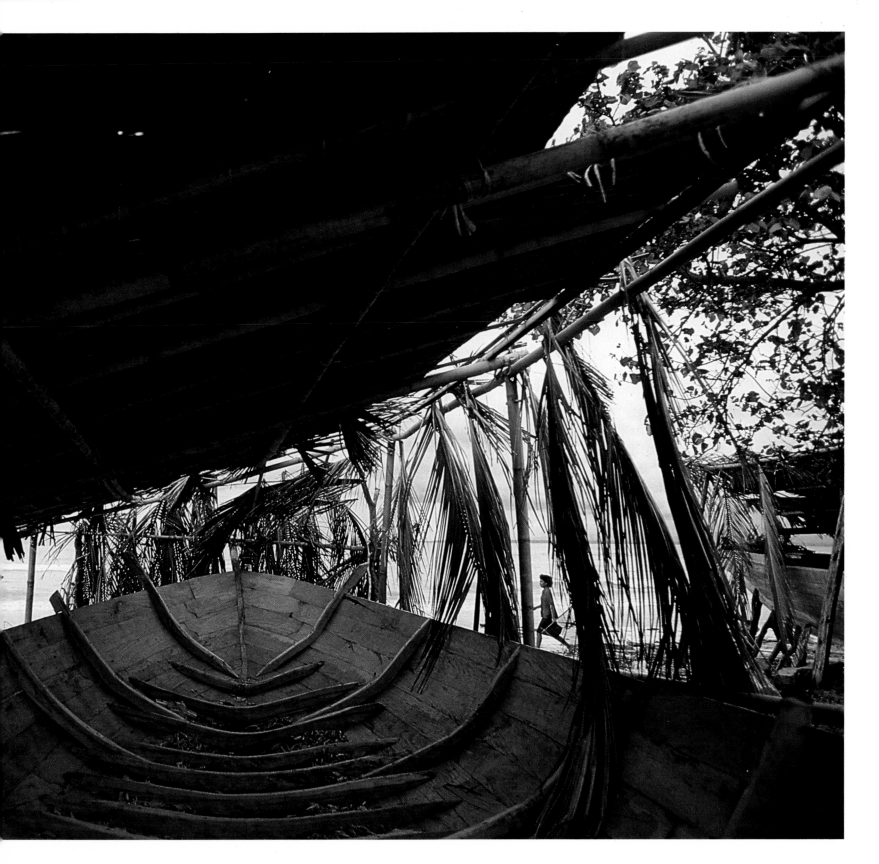

Punggawa *house, Ara*

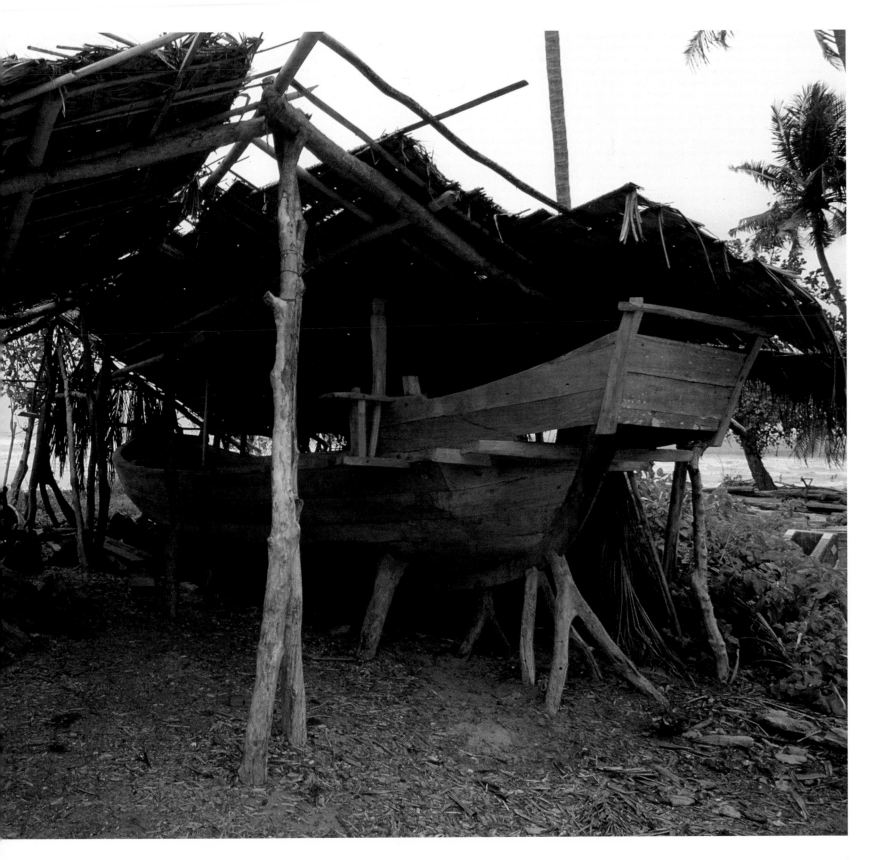

The wood-carving warriors

Carrying the mbis

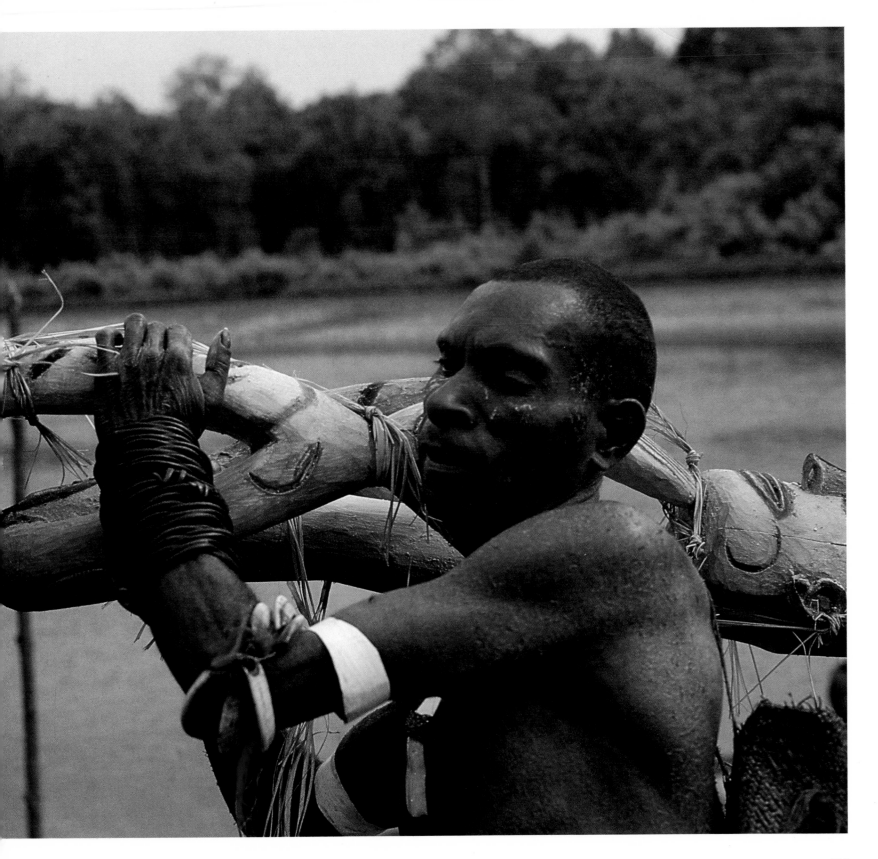

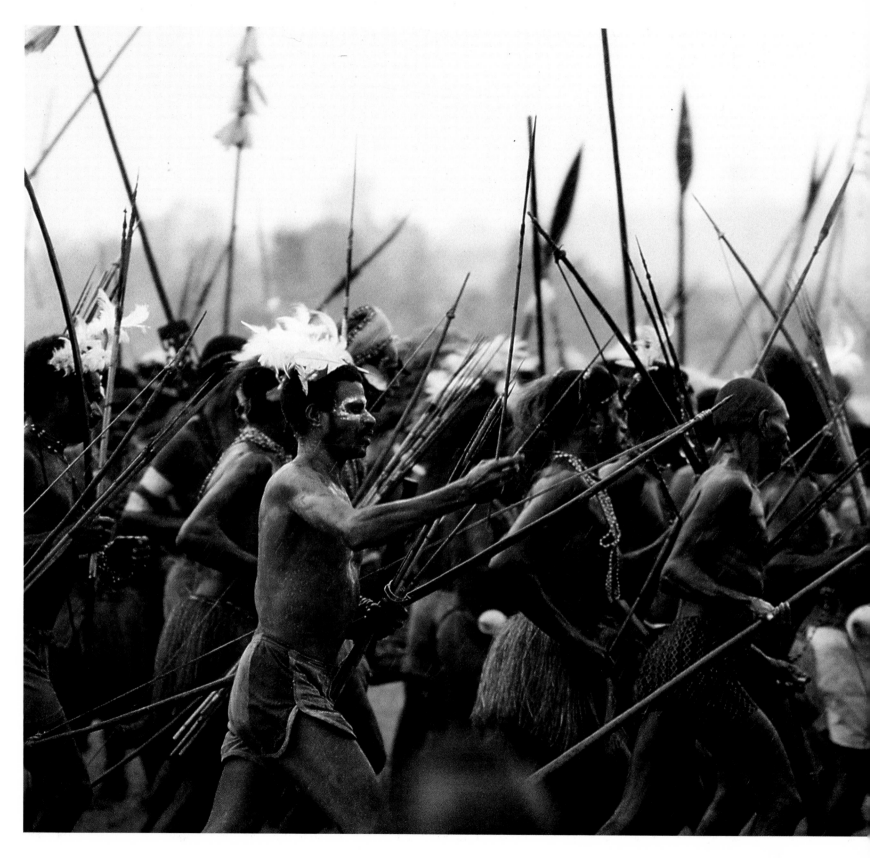

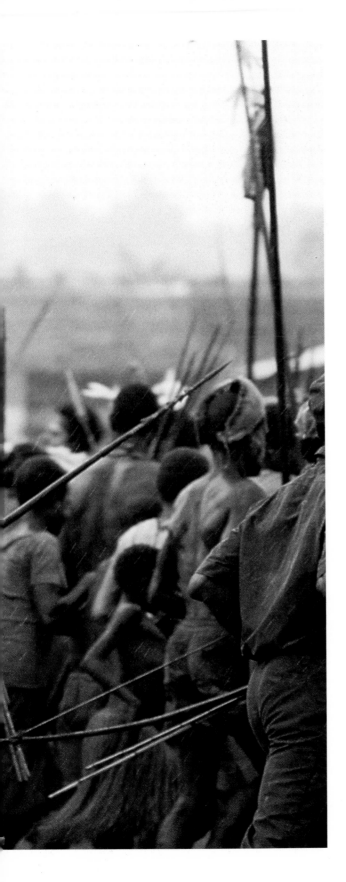

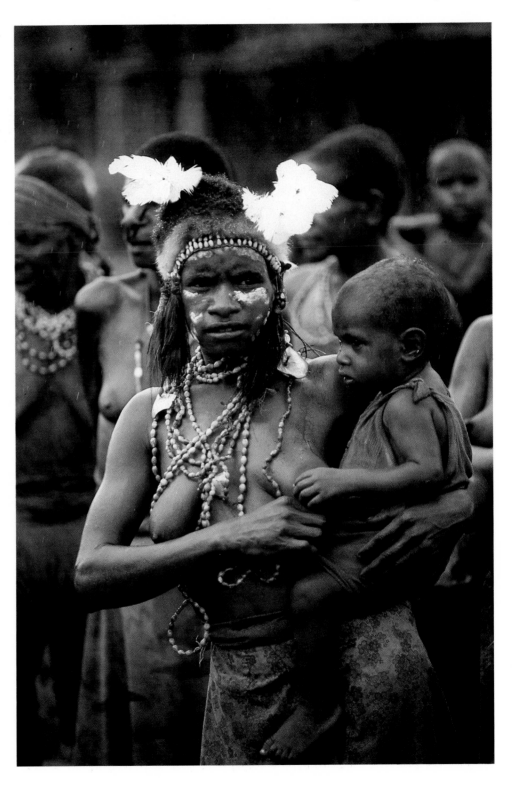

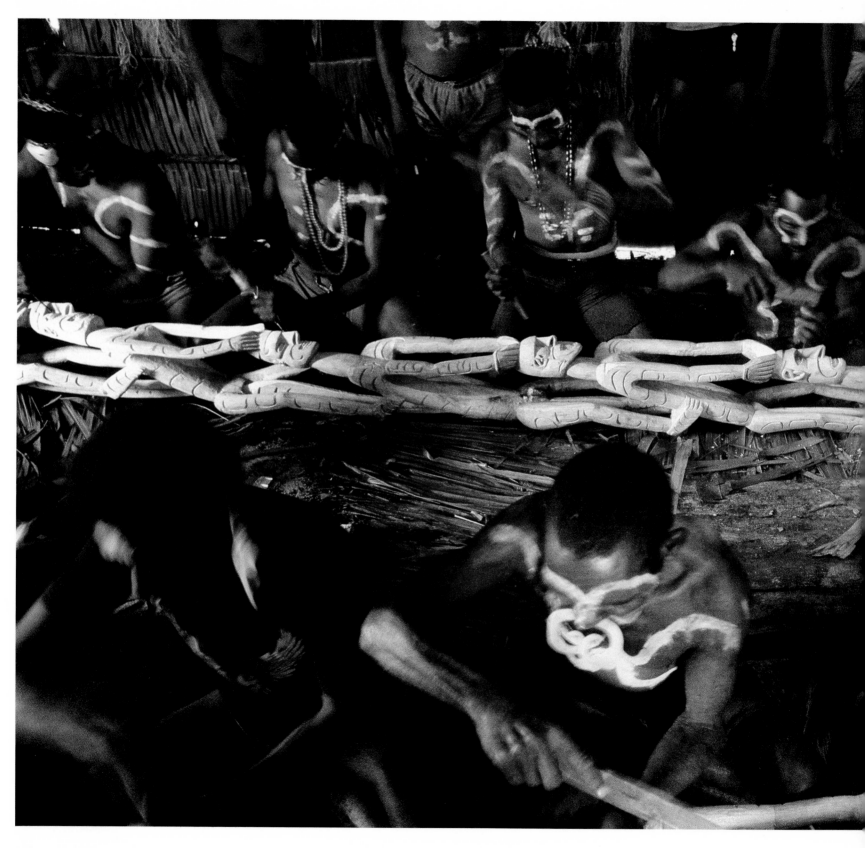

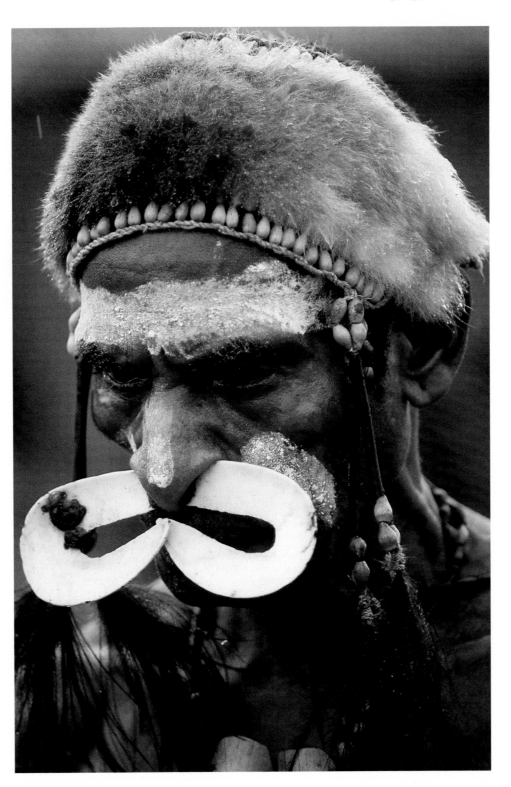

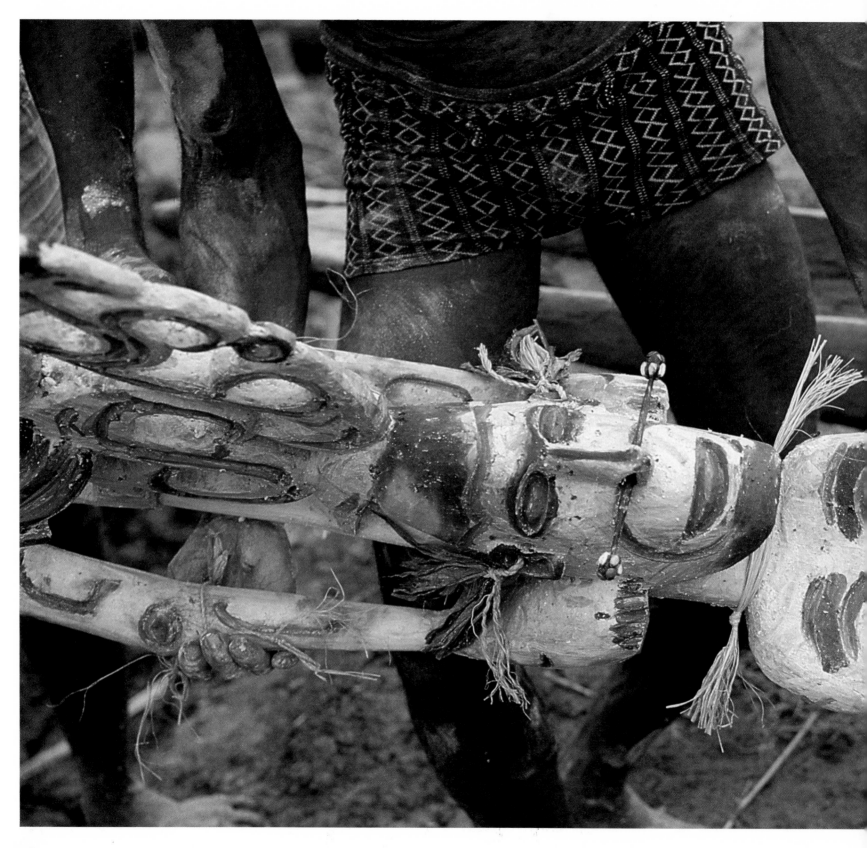

Left and below: *Carvings depicting deceased relatives are lifted onto a stage at Buepis.*

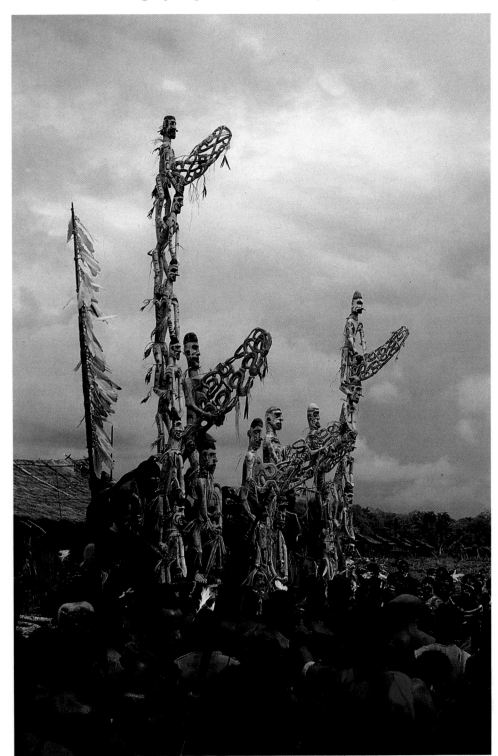

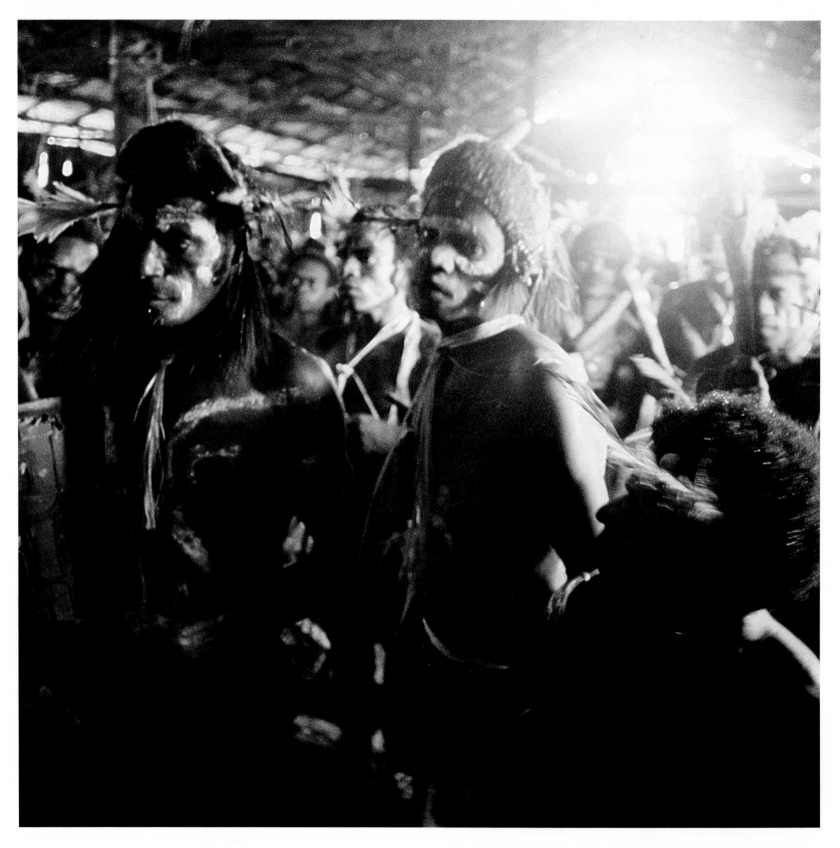

The wood-carving warriors

The airstrip looked like a village soccer field that had been set up in a hurry. It was small, very bumpy, and very soft. The landing was not promising but when the plane finally stopped we were relieved enough not to notice the swarms of people approaching us. As the sound of their rhythmic *huah-huah-huah* grew louder and louder, we were reminded that we had finally landed at Basiem, an Asmat village and landing strip, far to the southwest of Jayapura, the capital of Irian Jaya province. After two hours of breathtaking flight in a small Norman Islander over huge mountain ridges and deep ravines and thick jungles, it seemed like a dream when about 100 Asmat warriors welcomed us in Basiem with spears, bows and arrows, bone daggers, and fierce-looking facial makeup.

We were escorted to the front of the airstrip office by the Asmat warriors who constantly chanted *huah-huah-huah*, while 10 to 15 Asmats circled us and danced to the *huah-huah-huah* rhythm. In front of the office we were greeted by the village head. The chanting suddenly stopped. Then the village head said something in his language to the deputy governor of Irian Jaya province who had accompanied us on this trip. Apparently the Basiem village head had adopted the deputy governor as his son and, as such, he was entitled to wear the honorary attributes. The deputy governor received a *fatim* (a headdress) made of a *kus-kus* skin, a *yurikus* (necklace) made of wild boar's teeth, and a dagger made of a *casuari* (bird bone). The *yurikus* was valued as equal to one enemy's head since it was made of wild boar's teeth.

The deputy governor was asked to sit on a canoe and suddenly 12 men lifted it, put it on their shoulders and took it, again with the *huah-huah-huah* chanting, to the bank of the river. It was a big river whose waters looked dark and deep. We were then invited to move to several motorboats and continued our trip through the Fajit river to the village of Buepis. Along the river we were escorted by 12 canoes with standing Asmats, rowing and chanting the *huah-huah-huah*.

* * *

The Asmat region is an isolated, jungle marshland in southwest Irian Jaya, the easternmost province of Indonesia. To the west, the Asmat region borders the Arafuru sea but to the east, deep mangrove and sago palm jungles penetrate the interior, with large and small rivers obscuring clear-cut regional borders. Along the coast and along the river banks are about 110 Asmat villages with an approximate population of 30,000 people. The marshlands have made agriculture impossible and made sago palms grow in abundance, providing the Asmats with an ample supply of carbohydrates. The rivers and marshes offer fish and crocodiles while the jungle provides abundant sources of protein – *kus-kus*, *casuari* birds, and boars.

The vast region, about 200 kilometers from north to south and about 100 kilometers to the interior jungles, is isolated, however, and can only be reached by long journeys by sea, through the Asmat rivers, and by air via the small planes of the Catholic mission.

The region's capital is Agats, a small town of several thousand, built on poles and planks, where the government offices, schools, and the Catholic missionary are located. Scattered over the rest of the region are villages located along the banks of rivers in the interior or near the mouths by the sea coast. The villages vary in population between 100 and 2000 people. Despite the region's isolation the Asmat excel, and by now are famous, in wood carving. Through the wood carving the Asmats express their perception of their intimate and intertwined relationship with the cosmos in which the family network, ancestral spirits, animals, and the jungle are inseparable elements. The Asmats believe that these intimate relationships that sustain the cosmos must always be renewed and enriched, which they accomplish through a variety of rituals. These include the *pirpokmbuy*, the sago grubs ritual; the *ndatpokmbuy*, the spirit masks ritual; the *cipokmbuy*, the ritual for the launching of new canoes; and finally, the *mbispokmbuy*, the *mbis* poles ritual. Of all these rituals or feasts the *mbispokmbuy* is probably the most directly related to the basic Asmat belief in the worship of ancestors' spirits as sources of renewal and enrichment of life in the cosmos. The *mbis* or *bis* is a pole about three meters high which is carved with images of their deceased relatives. The *mbis* is believed to be the source of the family's strength since the images on the pole usually represent the victims of previous wars with other villages. The *mbis*, then, also symbolizes the commitment by the family or community to avenge their ancestors and relatives. The *mbis* is worshipped as a reminder of this commitment and also as a source of renewal and enrichment of the family's or community's life forces. Often, the *mbispokmbuy* also served as an occasion to launch an attack against the enemy village. Nowadays, due to the efforts of Catholic missionaries and the government, warfare between the villages has ceased. The Catholic missionary's strategy is to retain the feasts and the importance of the Asmat concept of "life renewal" but without the spirit of revenge and warfare.

The Asmat wood carving is basically a "mini concept" of the *mbis*. It depicts intimate family relationships as a source of life renewal and enrichment. Even their carvings of spears, shields, and necklaces contain family clusters and often depict their relationship with the crocodile and the *casuari* bird.

* * *

Our motorboats approached Buepis, escorted by the 12 Asmat canoes with the ever enthusiastic *huah-huah-huah* chanting of the

Asmats. The bank of the river Fajit was so muddy and soft that we had to be carried by sturdy Asmats to the village clearing. Suddenly I was thrown to the ground. The village head shouted to me in his language and pointed to two men and two women who stood in a row in front of me. Then he gestured for me to crawl between their legs. When I had done so, I had to stand in front of one of the men and one of the women. These were to be my adopted Asmat parents. As was the case with the deputy governor I received a *fatim*, a *yurikus*, and a *casuari*-bone dagger. Then they gave me a new name: Kawati.

After the ritual all of us were invited to enter into the *Jew*, the men's – or bachelors' – house to witness the re-enactment of a *mbispokmbuy*. In fact, the re-enactment began in the middle of the ceremony with the actual carving of the wood. Normally the ritual might begin in the *Jew* with the community leaders and elders gathering around the fireplace to discuss the right day for going to the jungle to find the suitable wood. The discussions would also determine whose image would be carved on the *bis*. After the decision they would go to the jungle to look for *tenau* (mangrove) wood. When they returned with their chosen wood they would be welcomed by the villagers, mostly women, and would stage a mock fight in which they pretended to reject the wood. Only after this would the actual carving in the *Jew* start.

The *Jew* is an important Asmat institution. It is a long rectangular building about 20 meters in length, divided by eight doors. Parallel with the doors are the fireplaces where people like to gather. Each door and fireplace belongs to a man and his line of genealogical succession, since the *Jew* is considered as the foot of the patrilineal line of the Asmat family structure. Each *Jew* is shared by a man's cousins. And surrounding the *Jew* are the family houses where the mother and children live. The *Jew* is thus an all-purpose men's house. Socially its function is to be the center of orientation of the man's family line, and it also functions as a center of rituals and entertainment. It is in the *Jew* that war plans are discussed, rituals prepared, *mbis* and other wood are carved, and songs and dances performed.

When we entered the *Jew* at Buepis the long rectangular hall was full of people. They still chanted *huah-huah-huah*, while men and women danced rhythmically to the chant. Tobacco was distributed. On the floor 12 carvers were working on two *mbis* and several others were in the process of being carved. Several wood-carvers from the village of Bitsenep were specially invited to work on the *mbis*, since the village is famous for its *wow-ipits'* carvings.

Each wood-carver worked on a human figure – apparently a deceased relative. The figures began to take shape and the carvers were about to add the finishing touches. They shaped the eyes and the penis, then they put strings and beads on the noses of the figures. They next brushed the figures with brushes made by hand from young sago leaves and started to paint the figures with black, white, and red – basic colors for many ethnic groups in the archipelago. The paints were made of charcoal, *yak*, for black; from shell skin, *bi*, for white; and from mud, *udase*, for red.

While the *wow-ipits* finished the *mbis* carving, women and children were allowed to enter the *Jew* and stood near the working carvers. During the last stage of the work women and men sang and danced to the *bisi* and *pirawat*, special songs and melodies for the occasion.

After the ears of the carved figures were tied with strings and beads, the *mbis* poles were lifted and carried out into the open spot in front of the *Jew*. Several platforms were built at that spot. Six *mbis* poles were erected in front of the stages. Then one by one old warriors were invited to climb the stage and deliver their oratories. They would tell of the deceased relatives represented on the *mbis* pole, the wars they had died in, and the villages they had fought against. Finally each warrior would challenge the enemy village to a new war. He would shout that this was his commitment to avenge his ancestors.

After the old warriors had delivered their oratories, the re-enactment of the *mbispokmbuy* ended rather abruptly. It was a civilized anticlimax to the noisy ritual which, in former times, might have been followed by an actual raid on the enemy village.

* * *

Agats, the Asmat regional capital, was also an anticlimax after the dramatic Norman Islander flights, *huah-huah-huah* shouting, and emotion-filled *mbis* ritual. The town – or village – looked very tranquil in the hour before twilight. The contemporary-style houses that were connected by wooden planks tied on poles which served as "streets" of the town seemed unreal after the cluster of *Jews* and family houses in the villages of Basiem and Buepis.

It was also a strange sensation to enter the Asmat Art Shop in the middle of town. The Asmat wood carvings looked out of place in their orderly stacks in this well-lit room. Spears, shields, canoes' heads, *mbis*, human figures, and family clusters were out of context with their natural environment. But, of course, the purpose of the shop was to serve as a showroom of Asmat wood carvings. The shop was originally a part of the Asmat Art project under the

auspices of the Indonesian government and the Fund of the United Nations for the Development of West Irian (FUNDWI). The purpose of the project was to promote the production and sale of the Asmat wood carving and maintain the high standard of the carving. The project, which was continued by the Indonesian government after the expiration of the FUNDWI, has had remarkable results. The shop served as the buying center for the wood carving and its owners carefully and selectively bought the wood carvings from the *wow-ipits* from the villages. Carvings which were considered to be substandard were rejected and the *wow-ipits* were encouraged to work more patiently and meticulously, with a resulting improvement in quality and more orders from museums and art shops all over the world. Of even greater importance has been the elevation of the carvers' prestige in the communities due to continued orders for wood carvings from the shop and from the missionary's ethnographic museum in Agats.

Browsing around the shop you notice that the wood carvings have become more decorative and ornamental. Now that warfare between the village has stopped in the past two decades, such weapons as spears, shields, and daggers are no longer made for fighting but for rituals and decoration. The spears and especially the shields have become more *halus*, refined, and ornamental than before. We also found in the shop more decorative household utensils such as wooden plates and bowls. There were also wooden panels with more *halus* and intricate carvings. The panels seemed to have more of a market with art shops which sold them as decorations for city homes. Sculptures of family clusters were also in abundance and were still the most important element in the ornamental designs, but more sculptures of solitary or two human figures were being made. Moreover, although the carving basically was stylized, abstract "primitive" art, more realistic three-dimensional human figures were appearing on the scene.

From the wood carvings in the shop we could see that the Asmat art did not remain static. There was some subtle shift of emphasis in the carvings. Apparently this was due to at least two influences. The first was the strong guidance of the Asmat Art Shop which encouraged the *wow-ipits* to shift more to the *halus* finishing of the carvings rather than the rugged style of the old Asmat tradition. Technically this was made possible by the shift of the carving tools from bones to steel and iron. The shop has provided *wow-ipits* with the new kind of tool kits and encouraged them to be more skillful with the tools. Nowadays *wow-ipits* would prefer to use steel and iron tools rather than the traditional bones.

The second change in the art derived from the change in the community itself. Now that Asmat villages had stopped their feuds the *mbis* pole that represented the life force of the Asmat community began to lose its meaning. With that, gradually, would also go the tradition of large wood carvings or sculpting in Asmat. The carvings of war weapons would dwindle and would be shifted to more decorative weaponry, as was already apparent in the shop in Agats. No such change was evident in the family-cluster sculptures which to me were miniature *mbis* symbolizing the relationship of the family network with the ancestors' spirits. At least for the time being this still reflected the close family system in the village. But change and development of the sculptures of the Asmats would also depend on how the Asmats would make their cultural adjustments to the new belief system – Christianity. How could they, for instance, reconcile their concept of ancestors' spirits with the new religious concepts? It would also depend on how the Asmats will view their participation in the new nation-state of Indonesia and the national culture. Finally, there is the question of how the Asmat region is to be integrated into the provincial or even the national economy. In this kind of economic setting what would it mean to be a "highly respected *wow-ipits* in the community" – especially a *wow-ipits* who is also an entrepreneur?

* * *

Agats was an atypical Asmat community. The *camat*, region head, was a Moluccan, the Art Shop director a Bugis, the soldiers Javanese, and the missionaries the American Crosier Fathers. The town had become truly Indonesian – maybe even international. Once or twice a month a ship might come from Merauke. The Asmats were not that isolated after all. Even in the village of Basiem the village representative made his request to the deputy governor of the province of Irian Jaya in halting Indonesian: *Please, don't protect the crocodiles. Let us hunt them again because crocodiles are part of our life . . .*

And on that last evening on the veranda of the guest house in Agats, while gazing at the starry sky I asked an Asmat boy who stood next to me whether he would be interested in becoming a *wow-ipits*. Firmly he said "no." He wanted to be a *tentara*, an army soldier.

* * *

Epilogue

So the Bakung schoolchildren no longer sing their traditional songs, but *Sorak-sorak Bergembira*, a song of joy (in Indonesian) about the freedom of Indonesia. The Asmat boy does not want to be a *wow-ipits*, the highly respected wood sculptor in the deep jungle of Asmat, but a soldier in the Indonesian National Army. And Soba, the young Nias sculptor of Bawömataluö, is anxious to see more tourists invade his tranquil village, hoping they will buy up his wood carvings.

New nationhood breaks old boundaries and lifts up new horizons. While physically they are still isolated in their environments, the Bakung children, the Asmat boy, and the Nias sculptor develop new dreams and perceptions which do not exist in the minds of their parents. In a matter of decades ideas that have been fixed for generations have broken down. And the change has been far-reaching – a leap to entirely different concepts of communities with their network linkages, working ethos, and relationships with the outer world.

Nobody knows for sure what will be the mechanism for realizing their dreams, though. In the middle of the East Kalimantan jungle, the Bakung children among the longhouses of their forefathers, through their school, radio, and occasional visitors, are introduced to the big new nation, Indonesia, to which they now belong. Gradually they get accustomed to the idea of the new relationship and linkage. And soon they understand that nationhood also demands from them participation in the culture of the new nation. They do not stop at singing *Sorak-sorak Bergembira* but go to the high schools, to towns and cities, and move further and further away from their traditional migrating pattern in the jungle established by their ancestors. Their parents, though, seem to smell the change in the air. As decided by Pelugan and Merang Apue, they are going to migrate not along the old pattern of the ancestors but along the educational track of their children, toward the nation's culture and economy.

And the Asmat boy who wants to join the national army is presently living in Agats, the district capital, as servant to the district's guest house and the village guards. He and his older brother left their village after their parents were killed in a tribal war years ago. The older brother has left him to join the army in Jayapura, the provincial capital, and promised to fetch him someday. While waiting for the brother to come, he dreams – through his brother, through visitors to the guest house, through the Javanese soldier whom he serves and whose shoes he shines; he dreams about being a soldier, about being in Jayapura, in Jakarta. His mind has broken through his village's culture cordon and moves away toward the nation's culture, leaving behind a working rhythm and pattern framed by tribal rituals.

And Soba, the Nias sculptor? What kind of mechanism or venue would he take for the realization of his dream? Bawömataluö has been for some time a regular tourist stop. The village head and majority of the villagers welcome tourism as a solution to the village economy. Soba has developed along with the nation's culture and economy. Perhaps his dreams are about taking a bigger part in the nation's culture by selling more of his wood carvings and earning more cash money so that he can join the tiny Bawömataluö elite which has been to Medan and Jakarta.

* * *

On the other hand, *didong* and *seudati* have picked up the government's messages on family planning and added *dangdut* music to their repertoires without distorting the original forms. And *wayang kulit* and *randai* have been flexible enough to absorb the government's messages without destroying the art form. In those cultural milieus the people still give their enthusiastic support. But side by side with this enthusiasm people in Takengon and Central Java complain about the high cost of having a *didong* and a *wayang-kulit* performance. When they feel they can no longer afford the performance they turn to cassettes.

Tradition can take strong root in a society and at the same time be flexible and accommodating to new influences. Traditional arts such as *seudati*, *didong*, *randai*, and *wayang kulit* have such strong roots. They can afford to absorb new influences without breaking away from the old form because they are still confident of their audience's support. They can still confine themselves within their respective cultural milieus, picking up influences from the national culture. But if they were no longer confident of support they would have to make more liberal concessions, absorbing many of the new influences into the old form. In cases such as the *lenong* and the *pinissi* boat of South Sulawesi, the old form becomes

obsolete and its texture's threads begin to decay. In other cases, the traditional arts may turn more and more inward when they are no longer confident about their audience's support.

The national economy also exerts a strong unifying pressure on the traditional arts. Cash money has become more important to the traditional milieus and more urban goods have become rural goods as well. So *didong* singers, *seudati* dancers, *randai* players, and *wayang-kulit* puppeteers and their *gamelan* crew demand higher cash fees. The national economy has also introduced the miracles of modern trade and modern technology. Where the audiences – call them art consumers – no longer can afford to buy their own arts, modern inventions such as cassettes allow them to remain loyal to their traditional arts. Suddenly traditional arts have become modern trade merchandise in mass consumption packages to be sold at (relatively) cheap prices. But while this change places the traditional arts such as *didong* and *wayang kulit* (and probably also *seudati* and *randai*) within the reach of the people again, the art form does not remain the same. It is no longer an art that can be enjoyed visually but only audibly.

With their new economic prestige, the *didong* singers and *wayang-kulit* puppeteers are now accessible to a more limited audience. This is especially true of the *wayang kulit*, since only rich people in the cities can afford to have the performance of a super *dalang* such as Nartosabdo, Timbul, or Anom Suroto. This leads to a strange phenomenon as rural traditional art has become an urban "middle class" entertainment. And paradoxically this art, which originally was a community art, has become an expensive art – more expensive than the popular urban art.

* * *

Modernity, the twin brother of the new nation-state, can be very harsh to traditional arts. It has created efficiency, which has reduced not only the rhythm and length of traditional arts but in effect the very basic concept of the arts. Thus *wayang kulit* on cassettes has become a different form of art; touristic, naïve Kamasan paintings have changed the meaning of a community art, which once made for solidarity, into a merely commercial form; efficient trade has pushed the traditional *pinissi* from the sea; the modern urban life style has reduced the *lenong* into a smaller cultural enclave.

But modernity's essence is reorganizing structures considered obsolete. When diverse communities agree to form a new nation-state they in fact accept the very principle of modernity. And once it is accepted, modernity does the reorganizing job thoroughly and ruthlessly. It does not stop at reforming the shape of government but reorganizing the whole social and cultural structure – including the arts. To become a new nation-state then is to accept this thorough reorganization.

But a new nation-state does not start with a blank canvas. Old cultural milieus, which are the starting capital of the nation-state, are not blank canvases but richly decorated textiles. This "obsolete structure" is the starting point for any reorganization effort; and, even more, it will help to define the future quality of the new nation-state.

Indonesia is no exception. It has started with a very richly decorated textile. In accepting modernity, with its reorganizing dynamics, it has also insisted that the new idiom must be born out of a creative development of the old idiom. One still has to see, though, how successful this insistence will be. One difficulty lies in the fact that the traditional arts vary widely in quality and complexity but at the same time enjoy equal status as partners in the state. Cultural milieus with less strongly rooted traditions tend to make more generous concessions to – if not completely embracing – the reorganization process. The more strongly rooted traditional cultural milieus may either be more flexible and creative or more stubborn and resistant to the reorganizing process. And this diversity of attitudes could create cultural disequilibrium in the new state. The success of Japan as a nation that interpreted modernity without losing its cultural identity lies in the fact that it is sustained by a homogeneous cultural milieu.

Perhaps the suitable strategy for new nation-states such as Indonesia should be one of encouraging the respective cultural milieus to find their own creative dynamics within the framework of the new nation-state. This is, of course, easier to express theoretically than to execute in terms. The Bakungs, for instance, are on their way to losing their identity, leaving an impressive cultural legacy in the jungle; the village of Bawömataluö is on the brink of becoming an enclave for tourism; the *pinissi* has been the immediate victim of the reorganizing process

* * *

So what kind of "soul" are we talking about in this book? A fractured soul of a new nation-state? I don't think so. I think we are talking here about the very basic soul of this archipelago, which still is waiting for the body to transform itself into creative modernity. While it waits, it constantly whispers.

Selected reading

ACEH

Djakfar Ismail Ben Aceh. *Makalah Kesenian Tradisional Seudati*. Kandep Dikbud
 Kabupaten Aceh Utara.

Djakfar Ismail and Ibrahim Asyeik. *Diktat Seudati Dan Laweut*. Mimeograph.

Kesenian Tradisional Aceh, Hasil Lokakarya 4 s/d 8 Januari 1981 di Banda Aceh.
 Dep. Pendidikan dan Kebudayaan, Kantor Wilayah Propinsi Daerah
 Istimewa Aceh, 1980/1981.

*Laporan Hasil Diskusi Kesenian Tradisional Seudati Tingkat Kabupaten Aceh Utara,
 Tanggal 3 September 1983 di Lhok Seumawe*. Departemen Pendidikan dan
 Kebudayaan Wilayah Propinsi Daerah Istimewa Aceh, Kabupaten Aceh
 Utara.

Hurgronje, C. Snouck. *The Achehnese*. Translated by A. W. S. O'Sullivan.
 2 vols. Leyden: Late E. J. Brill, 1906.

Siegel, James T. *The Rope of God*. Berkeley, Los Angeles, London: University
 of California Press, 1969.

Zentgraaf, H. C. *Aceh*. Terjemahan Abu Bakar. Jakarta: Penerbit Beuna,
 1983.

NIAS

Marschall, W. *Enggano And Nias*, Art of The Archaic Indonesians, Dallas
 Museum Of Fine Arts, 1982. pp. 19–27.

RANDAI

Chairul Harun. *Kesenian Randai di Minangkabau*. Unpublished Manuscript.
 1983.
— *Si Malanca*. Jakarta: Pustaka Jaya, 1983.

LENONG

Serial Informasi Kesenian Tradisional Betawi, Rebana, Musik, Tari, Teater. Dinas
 Kebudayaan D.K.I. Jakarta.

S.M. Ardan, *Nyai Dasima*. Jakarta: Pustaka Jaya, 1965.

WAYANG KULIT

Anderson, Benedict R. O'G. *Mythology And The Tolerance Of The Javanese*.
 Monograph Series. Ithaca, New York: Cornell Modern Indonesia Project,
 Third Printing.

Pak Hardjowirogo. *Sedjarah Wajang Purwa*. Djakarta: P. N. Balai Pustaka,
 1968.

Lindsay, Jennifer. *Javanese Gamelan*. Kuala Lumpur: Oxford In Asia
 Paperbacks, Oxford University Press, 1979.

Mangkunagara VII, K.G.P.A.A. *Serat Padhalangan Ringgit Purwa*. Yogya:
 U.P. Indonesia, 1965.

Moebirman. *Wayang Purwa, The Shadow Play of Indonesia*. Jakarta: Yayasan
 Pelita Wisata.

Sri Mulyono, Ir. *Sebuah Tinjauan Filosofis, Simbolisme Dan Mistikisme Dalam
 Wayang*. Jakarta: Gunung Agung.

Ensiklopedi Wayang Purwa I (Compendium). Proyek Pembinaan Kesenian,
 Direktorat Pembinaan Kesenian, Direktorat Jendral Kebudayaan,
 Departemen P & K.

BALI

Alit Widiastuti. *Pergeseran Tema-Tema Lukisan Gaya Wayang Kamasan Di Desa
 Kamasan, Klungkung*. B. A. Skripsi. Fakultas Sastra Universitas Udayana.
 Denpasar, 1977.

Forge, Anthony. *Balinese Traditional Paintings*. A Selection From The Forge
 Collection of the The Australian Museum, Sydney. Sydney:
 The Australian Museum, 1978.

I Made Kanta. *Proses Melukis Tradisionil Wayang Kamasan*. Proyek Sasana
 Budaya Bali. Denpasar, 1977/1978.

Umar Kayam. *Banjar Sangging, Kamasan (Sebuah Laporan Penelitian)*. Universitas
 Gadjah-Mada, Yogyakarta: Lembaga Pengkajian Kebudayaan Indonesia,
 1979.

ASMAT

Gerbrands, Adrian A. *Wow-Ipits, Eight Asmat Woodcarvers Of New Guinea*.
 The Hague, Paris: Mouton & Co. Publishers, 1967.

Trenkenschuh, F. OSC. (ed). *An Asmat Sketch Book*. 4 vols. Agats, Irian Jaya:
 The Asmat Museum Of Culture and Progress.

Ukiran-Ukiran Kayu Irian Jaya – The Art of Woodcarving in Irian Jaya.
 Jayapura: The regional Government of Irian Jaya, 1977.

*70 Jaar Asmat Houtsnijkunst – 70 Tahun Seni Pahat Asmat – 70 Years Of Asmat
 Woodcarving*. In Het Volkenkundig Museum, Justinus Van Nassau, Breda,
 December 1976 – Mei 1977. Rijksmueseum Voor Volkenkunde, Afd. Breda.

PINISSI

Usman Pelly. "*Symbolic Aspects Of The Bugis Ship And Shipbuilding*," Journal Of
 The Steward Anthropological Society, Vol. 8, No. 2, Spring, 1977.

— *Ara Dengan Perahu Bugisnya (Sebuah Studi Mengenai Pewarisan Keahlian Orang
 Ara Dan Keturunannya)*. Ujung Pandang: Pusat Latihan Penelitian Ilmu-
 ilmu Sosial, Desember, 1975.

MAHAK DUMUK

Ave, J. B. "*The Dayak Of Borneo, Their View Of Life And Death, And Their Art*,"
 Art of the Archaic Indonesians, Dallas Museum of Fine Arts, 1982,
 pp. 95–100.

Hose, Charles, D. Sc. and McDougall, William, M.B., F.R.S. *The Pagan Tribes
 of Borneo*. 2 vols. London: Macmillan and Co. Limited, 1912.

GENERAL

Geertz, Clifford. *The Interpretation of Cultures*. New York: Basic Books Inc.,
 1973.

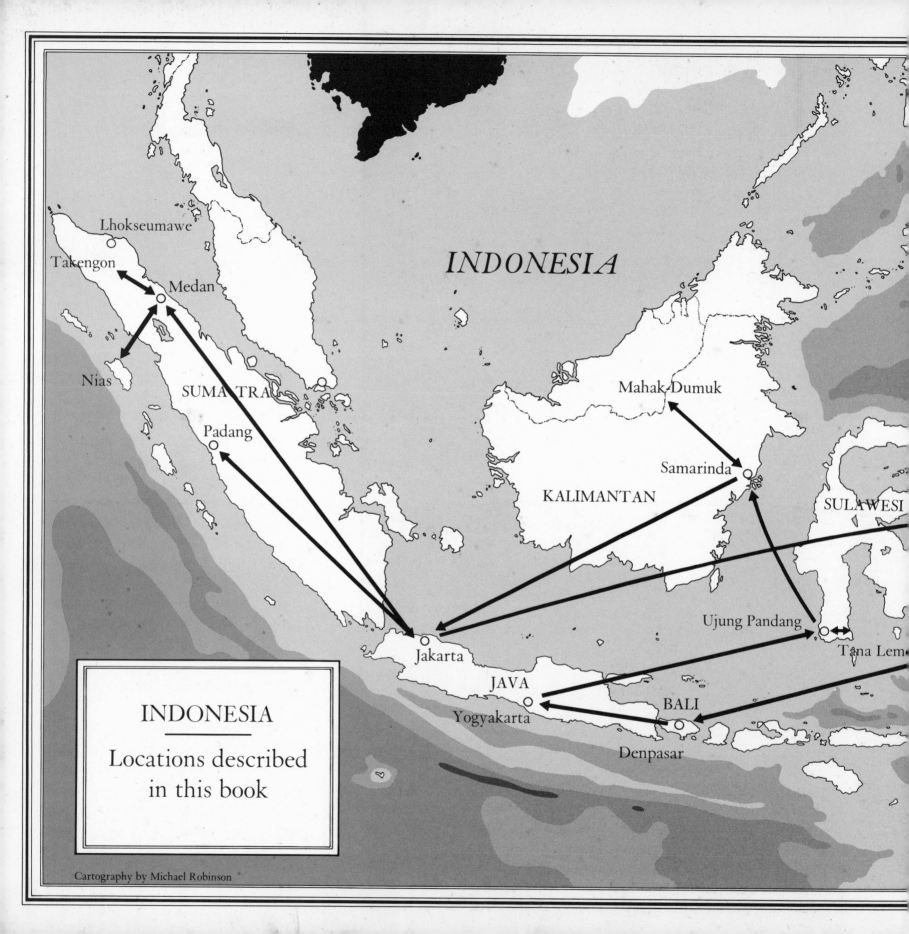

INDONESIA

Lhokseumawe

Takengon

Medan

Nias

SUMATRA

Padang

INDONESIA
———
Locations described
in this book

Mahak Dumuk

Samarinda

KALIMANTAN

SULAWESI

Ujung Pandang

Tana Lem

Jakarta

JAVA

Yogyakarta

BALI

Denpasar

Cartography by Michael Robinson